The American Landscape Tradition

The

E. P. DUTTON, INC. | NEW YORK

American Landscape Tradition

A STUDY AND GALLERY OF PAINTINGS

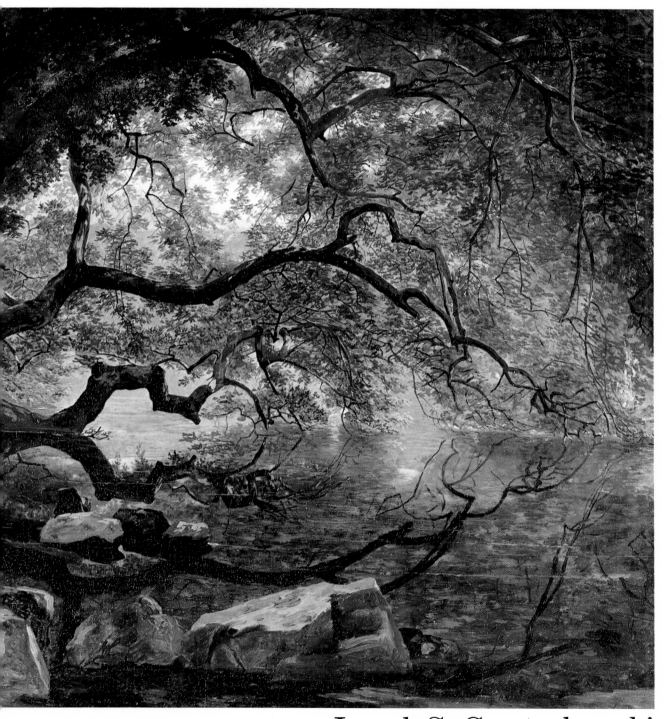

Joseph S. Czestochowski

First published, 1982,
in the United States by E.P. Dutton, Inc., New York.

For information contact: E.P. Dutton, Inc.
2 Park Avenue, New York, N.Y. 10016

Library of Congress Catalog Card Number: 79-53343

Printed and bound by
Dai Nippon Printing Co., Ltd., Tokyo, Japan.
ISBN: 0-525-93206-2 (cloth)
0-525-47674-1 (DP)
Published simultaneously in Canada by
Clarke, Irwin & Company Limited,
Toronto and Vancouver

Designed by The Etheredges

10 9 8 7 6 5 4 3 2 1

First Edition

(*Preceding page*) John F. Kensett (1816–1872): *Tree Reaching Out over a Lake.* c. 1850. Oil on canvas, 17½″ x 24⅞″. This exquisite study by one of the great masters of American landscape (see pls. 10, 78, and 98) is alive with light, color, and detail. The mirror image, so deftly rendered, gives an almost hypnotic quality to the painting. (*Collection of Mr. and Mrs. Vincent A. Carrozza; photograph courtesy Hirschl & Adler Galleries, Inc.*)

Contents

Acknowledgments

The completion of this project depended on the generous cooperation of many individuals. First and foremost was the continued and generous support of Debra N. Czestochowski. Her enthusiasm and constant encouragement are greatly appreciated. Several distinguished scholars provided patience and their insights at numerous junctures: John I. H. Baur, Edgar P. Richardson, Joshua C. Taylor, and John Wilmerding. Lawrence A. Fleischman is owed particular thanks for his advice and willingness to listen during the time this book was in preparation. Also, I wish to express my appreciation to Cyril I. Nelson at E.P. Dutton for his active participation in this project.

Finally, the following individuals need to be thanked for their time and cooperation in responding to my numerous inquiries: Anne Adams, Rachel M. Allen, Mr. and Mrs. Arthur G. Altschul, Linda Ayres, Ira Bartfield, Lynn Kahler Berg, Fred Bernatski, Claudia Bismark, Richard J. Boyle, Lillian Brenwasser, Mr. and Mrs. Herbert Baer Brill, Ellen A. Buie, Ronald J. Burch, Christopher Cook, Deanne Cross, Louisa Cunningham, John H. Dobkin, Mary F. Doherty, Anita Duquette, Edward H. Dwight, Pat Eargle, Nancy J. Emison, Janet Feemster, Stuart P. Feld, Doris Fletcher, Marjorie C. Freytag, Michael Green, Audrey S. Gryder, Delbert R. Gutridge, Robert Harmon, Cynthia Newman Helms, William Hennessey, Abbie F. Hodges, William W. Jeffries, Naomi J. Johnson, Barbara S. Krulik, Maebetty Langdon, Thomas P. Lee, Charles D. Long, Patricia C. F. Mandel, James Maroney, Betty C. Monkman, James E. Mooney, Robert Musacchio, M. P. Naud, Barbara Odevseff, Marius B. Peladeau, Sandra L. Petrie, Ronald G. Pisano, Christine Bauer Podmaniczky, Nancy Press, Beth Rahe, Evelyn Raskopf, Governor and Mrs. John D. Rockefeller IV, Mr. and Mrs. Wilbur L. Ross, Jr., Bertha Saunders, Robert W. Schlageter, Richard Schneiderman, L. Vance Shrum, Myrna Smoot, Theodore E. Stebbins, Jr., Mary Ann Steiner, Mr. and Mrs. Joseph Tanenbaum, Nicki Thiras, Fearn C. Thurlow, Carol Troyen, Gudmund Vigtel, Robert C. Vose, Jr., Louise Walker, Bret Waller, Mr. and Mrs. Frederick R. Weisman, Allen S. Weller, Patricia J. Whitesides, Diane Wise, Robert Yassin, and Eric Zafran.

I am happy to acknowledge here the many individuals and institutions who agreed to share their collections with me.

Addison Gallery of American Art, Phillips Academy, Andover, Massachusetts;

Albright-Knox Art Gallery, The Buffalo Fine Arts Academy, Buffalo, New York; The Art Institute of Chicago, Chicago, Illinois; Cary F. Baker, Jr.; The Baltimore Museum of Art, Baltimore, Maryland; The Brooklyn Museum, Brooklyn, New York; Amon Carter Museum, Fort Worth, Texas; Cedar Rapids Museum of Art, Cedar Rapids, Iowa; Chapellier Galleries, Inc., New York; Childs Gallery, Boston, Massachusetts; Cincinnati Art Museum, Cincinnati, Ohio; The Cleveland Museum of Art, Cleveland, Ohio; The Corcoran Gallery of Art, Washington, D.C.; Crandall Library, Glens Falls, New York; Cummer Gallery of Art, Jacksonville, Florida; Dallas Museum of Fine Arts, Dallas, Texas; The Detroit Institute of Arts, Detroit, Michigan; William A. Farnsworth Library and Art Museum, Rockland, Maine; The Fine Arts Museums of San Francisco, San Francisco, California; Freer Gallery of Art, Washington, D.C.; Georgia Museum of Art, The University of Georgia, Athens, Georgia; The High Museum of Art, Atlanta, Georgia; Hirschl & Adler Galleries, Inc., New York; Historical Society of Pennsylvania, Philadelphia, Pennsylvania; Indianapolis Museum of Art, Indianapolis, Indiana; Joslyn Art Museum, Omaha, Nebraska; Kennedy Galleries, Inc., New York; Los Angeles County Museum of Art, Los Angeles, California; Maine State Museum, Augusta, Maine; Memorial Art Gallery of the University of Rochester, Rochester, New York; Memorial Hall Museum, Pocumtuck Valley Memorial Association, Deerfield, Massachusetts; The Metropolitan Museum of Art, New York; Mount Vernon Ladies' Association of the Union, Mount Vernon, Virginia; Munson-Williams-Proctor Institute, Utica, New York; Museum of Fine Arts, Boston, Massachusetts; The Museum of Modern Art, New York; National Academy of Design, New York; National Gallery of Art, Washington, D.C.; National Museum of American Art, Smithsonian Institution, Washington, D.C.; The Newark Museum, Newark, New Jersey; New York Historical Association, Cooperstown, New York; The New-York Historical Society, New York; The New York Public Library, New York; The Parrish Art Museum, Southampton, New York; The Peabody Institute, Baltimore, Maryland; Pennsylvania Academy of the Fine Arts, Philadelphia, Pennsylvania; Philadelphia Museum of Art, Philadelphia, Pennsylvania; The Phillips Collection, Washington, D.C.; Reynolda House, Inc., Winston-Salem, North Carolina; Saint Johnsbury Athenaeum, St. Johnsbury, Vermont; The St. Louis Art Museum, St. Louis, Missouri; Smith College Museum of Art, Northampton, Massachusetts; Sotheby Parke Bernet, New York; Timken Art Gallery, San Diego, California; The Toledo Museum of Art, Toledo, Ohio; United States Naval Academy Museum, Annapolis, Maryland; Vassar College Art Gallery, Poughkeepsie, New York; Vose Galleries of Boston, Inc., Boston, Massachusetts; Wadsworth Atheneum, Hartford, Connecticut; The Warner Collection of Gulf States Paper Corporation, Tuscaloosa, Alabama; The White House Collection, Washington, D.C.; Whitney Museum of American Art, New York; Wichita Art Museum, Wichita, Kansas; Wildenstein & Co. Inc., New York; Henry Francis du Pont Winterthur Museum, Winterthur, Delaware; Worcester Art Museum, Worcester, Massachusetts; Yale University Art Gallery, New Haven, Connecticut; and several private collectors.

The American Landscape Tradition

In recent years there has been a tremendous resurgence of interest in works of art that reflect the American experience. Although precise reasons for such a change in attitude are difficult to pinpoint, it seems reasonable to assume that this renewed appreciation stems from nostalgia for an irretrievable past, which was prompted by the Bicentennial atmosphere of self-preoccupation. As a result, after decades of neglect in favor of modernism, landscape painting is undergoing a widespread popular revitalization. Once again Americans are recognizing the timeless appeal of the landscape to our sense of nationalism as well as to more universal sentiments.

A factor contributing to this situation was the international success of the American Abstract Expressionist movement in this century. Like the nineteenth-century landscapists, these native artists earned our respect by successfully challenging European aesthetic supremacy. Within the course of a generation the nineteenth-century landscapists created a new and exciting visualization of nature and, in particular, the American landscape. Their explorations paralleled the growth of the American spirit and clearly established the landscape as this country's most vital cultural icon.

Today, we rarely think twice when we see a landscape painting. Although we may respond emotionally to the pleasing aesthetics or note the sentiments evoked by the place it depicts, the painted landscape, the object itself, is commonplace and to a large extent taken for granted. However, landscape has not always been so easily accepted as subject matter. Prior to the close of the eighteenth century, artists refused even to recognize a pure landscape as worthy of painting. They felt it lacked relevance to daily life and should serve merely to embellish a portrait or signal a literary association. All this changed when philosophical attitudes shifted from neoclassicism to romanticism, with its attendant emphasis on the sublime, the picturesque, and the beautiful. Almost immediately, nature and its painted image assumed an unprecedented importance to writers, artists, and the general public. The dialogues were intense and passionate, establishing nature as the pervasive theme of the century with a societal function unprecedented in Western civilization.

As nature assumed the position of a secular religion, Americans began to view the painted landscape as an integral part of their cultural and aesthetic history. Nature was considered a source of virtue, a setting for contemplation, and an avenue to spiritual sustenance.[1] At the same time it became a symbol of the new nation. Throughout the nineteenth century the message was clear: the destiny of America, as a people and a culture, was inextricably linked to the environment. Association with past achievements was lacking in this country, as were its customary physical manifesta-

tions, such as picturesque ruins. In their place the primordial wilderness became a visual metaphor that implied at one time a natural past, a heroically powerful present, and a promising future.

As a vehicle for cultural cohesiveness, the landscape painting was a decided expression of patriotism that was additionally valued for its civilizing influence. Pictures of the countryside were something to which our ancestors could relate. They nurtured pride and constituted a shared experience in an otherwise pluralist society. The nineteenth-century landscape spirit was organic, expressed with an intensity that matched its relevance to contemporary society. Paralleling the unfolding stories of geographical expansion and evolving historical events, our landscape tradition falls into distinct phases. As areas such as the Hudson River Valley, the New England coast, the Great Plains, and the Rocky Mountains were explored, a chronicle of views emerged that reflected the unique qualities of the individual geography and the subjective interests of its explorers.

Almost from the outset, a contradictory dialogue surrounded American landscape painting. A stylistic dichotomy existed between a conservatism that sought to preserve traditional aesthetic values and a stronger nationalism that sought to create a native visual identity. At the same time progress, or the march of civilization, triggered a view of nature as both poetry and property.[2] Although this difference was never resolved, it provided the framework for an exciting and meaningful landscape tradition. Artists working in this country were confronted with a physical environment new to art. Comparative examples did not exist, and the interpretation of the countryside according to preexisting forms was not satisfactory. A native vocabulary or a set of guidelines was needed to incorporate proven aesthetic values, while conveying the unique beauty of this environment. Also, a taste for American scenery needed to be cultivated, and as we shall see, this was a gradual process that was accomplished by many individuals.

This quest for credibility was approached traditionally. As a people, we logically gravitated to European traditions, for they were also ours. Despite physical isolation, the nineteenth-century landscapists remained acutely aware of European movements through their association with English aesthetics. Assimilation took time, and it was not until the 1820s that these artists really began to reflect the distinctive qualities of this country. Concurrently, it was widely realized that the primordial wilderness of the American landscape was the very embodiment of romanticism.

Since the 1800s, American landscape painting has changed significantly in function as well as in style. Crucial to our understanding of the American landscape tradition is an awareness that it encompassed complex psychological and spiritual values that, while existing in our past, possess striking relevance to the present. Of particular interest is the persistence of universal themes that address the human condition and its relationship to nature. Through this association the uniqueness of our culture as a social and environmental phenomenon was reaffirmed. As a result, we should emphasize the affinity of our artists for a state of mind that transcended the stylistic and valued thematic continuity in American art. Thus, the landscape spirit became a vital part of an ongoing search for a valid American mythology and iconography. A discussion of this preference for thematic continuity should broaden our appreciation of the American landscape tradition, as well as this pivotal phase in our aesthetic and cultural history.

The American landscape tradition has been the subject of several books, exhibitions, and critical reviews. While exploring the changing vocabulary of the American scene, our purpose will be to deal with the vision of our artists and their public of the native landscape and to offer a structure of ideas illustrating the diverse issues in any given period. The key pictures will be presented as well as the many others inspired by them. Similarly, not only will this volume include the few individuals who directly influenced the course of landscape painting but also the many who made important contributions to its history.

ONE

Early Landscape Painting

Discovery of the New World: Artist-Explorers

The American landscape possesses a timeless appeal. Even before its discovery, this country existed as an abstraction in the European imagination, symbolizing the fulfillment of a Judeo-Christian belief in an unspoiled Garden of Eden. It was not until the Renaissance that a new spirit of inquiry emerged, and attitudes began to change for a variety of intellectual, religious, economic, political, and social reasons. The accomplishments of this age are undisputed, and the names of Michelangelo, Alberti, Galileo, Copernicus, Huygens, and Newton are well known. Although their efforts differed considerably, they shared the common goal of seeking to measure or more fully define the realm of their experience, be it physical or spiritual, through such disciplines as physics, astronomy, architecture, anatomy, or art.

At the same time cartography played a significant role in charting the New World, defining its characteristics, and exploring the extent of its riches. During the latter half of the sixteenth century the English were the most active in this regard, being directed by an encouraging queen, Elizabeth I (1533–1603), and the exploratory ambitions of Sir Francis Drake (1540?–1596) and Sir Walter Raleigh (1552?–1618). Artists responded by making nature their studio, thus as-suming the dual role of explorers or surveyors. In particular, two individuals, who were serious students of nature, emerged as accomplished artists.

As early as 1564 Jacques Le Moyne de Morgues (d. 1588) was working in Florida. Twenty years later John White (active 1584–1593) accompanied a Raleigh expedition to Virginia. Through watercolors engraved in 1590/91 by Théodore de Bry (1528–1598) and distributed throughout the continent, the two artists enticed European curiosity with their early glimpses of the New World. Although a sense of immediacy was lost in the transition to engravings, these works were imbued with a spirit of both documentary observation and romantic license. The natural plenitude was clearly evident, and yet the printed image failed to express the actuality of the wilderness. Within the European imagination the New World remained an abstraction, tenaciously embodying an idyllic vision while gradually responding to the necessities of an emerging pragmatism. Although these artists did not revolutionize world art, their efforts did initiate an unfolding story of visual discoveries that would ultimately serve to define "America." At the same time they clearly established several qualities that would remain part of our aesthetic tradition. These qualities include a functionalism as it applies to the painted image, the prominent role of the engraved print

in the transmittal of a vital crafts basis, and the perceptive mixture of realism and idealism while maintaining a convincing "sense of place."[3]

The topographic view remained an important source of visual information about the New World. Artist-explorers continued their chronicle during the seventeenth century, but for some time after the founding of Jamestown and Plymouth Plantation in the early 1600s, the landscape remained a desolate wilderness. Struggling to build their homes and survive in the wilderness, the Colonists had little time or inclination to contemplate the aesthetics of their surroundings. Many of them, true to their working-class backgrounds, considered art a luxury and possessed no appreciation of beauty for its own sake. The Colonists also sought to maintain a cultural link with their native country, so when art was desired, the imported work was more meaningful and certainly more competent. In America art was very much an emerging craft, comparable to the service performed by the blacksmith and identified with signmaking, but still lacking trained practitioners and an active market. As late as 1767 John Singleton Copley lamented this pragmatic Colonial attitude: "A taste of painting is too wanting in Boston to afford any kind of help; and was it not for preserving the resemblance of particular persons, painting would not be known in the place. The people generally regard it [painting] no more than any usefull trade, as they sometimes term it, like that of carpenter, tailor, or shoemaker, not as one of the most noble Arts in the world."[4]

Portraiture was the predominant form of artistic expression. Stylistically, it derived from a Dutch Baroque tradition that was interpreted in England by Sir Godfrey Kneller (1646–1723), Sir Peter Lely (1618–1680), and Sir Anthony Van Dyck (1599–1641). The Colonies were beginning to prosper, and that was a result of the unique personalities of their inhabitants. Individuality and self-reliance were key ingredients, and artists were called upon as craftsmen to perform a function: to record an accurate likeness for posterity while clearly establishing the prestige and social status of the sitter. Authors estimate that between 50 and 400 pictures were done during the seventeenth century; collectively they indicate a more favorable attitude toward the practicing artist.

Landskips and the Topographic Tradition

Increasingly, the American Colonies along the Atlantic seaboard began to thrive. The Appalachian Mountains provided a natural deterrent to westward expansion, but also gave the Colonists time to strengthen their social structure. Population and wealth expanded as the threat to survival lessened, and the public directed greater attention to the appearance of things around them. Architecture became more spirited. Georgian forms, as seen in Wiliamsburg, Virginia, gradually replaced the earlier, more massive, and crudely constructed buildings. Furniture in the 1720s assumed the elegance and grace of the Queen Anne style. Tankards and other silver items became more decorative.

Although relatively few examples survive, other expressions of Baroque aesthetics were the *landskips,* painted ornamental panels, or wall decorations that were advertised increasingly in the major cities (see pl. 2).[5] Perhaps the best of these include the eleven wall panels for the Palladian house of William Clark in Boston (1712/14–1742); the panels from Marmion, King George County, Virginia; the hand-painted papers in the Jeremiah Lee House in Marblehead, Massachusetts; and at the Van Rensselaer Manor House, Albany, New York. Arriving in Philadelphia from Sweden in 1712, Gustavus Hesselius (1682–1755), best known for his mythological subjects and Indian portraits, advertised landskips in 1740 in the *Pennsylvania Gazette.* And in 1737 the Charleston, South Carolina, painter Bishop Roberts (d. 1739) advertised landscapes of any size to be used as overmantels. Landscapes were mentioned more frequently as the time of the Revolution approached, but they remained predominantly decorative in response to contemporary taste and almost entirely unrelated to the environment. It seems

likely that these early "landskips" were an alternative expression of interest in topographic views rather than an indication of popularity for landscape painting.

As prospects of financial success continued to attract Europeans to the Colonies, the resulting urban expansion called for topographic views. It was these views that became the first authentic landscapes of America. In about 1717 William Burgis (active in this country 1716–1732) arrived in Boston. Ten years later Peter Pelham (1697–1751) followed. Both were accomplished engravers. In 1743, Burgis, on three copperplates over four feet long, completed a bird's-eye view of a prosperous Boston harbor from the southeast.[6] The detail is quite impressive, but equally significant is Burgis's preference for the panoramic view. Pelham was trained as a mezzotinter, but finding the market limited, he applied his engraver's sensibilities to painting. Pelham and Burgis were also influential in the establishment of a strong graphic influence in our art. In much the same way that their views informed Europeans, engravings of masterpieces of world art were an important aesthetic resource for the Colonial painter. We find this ongoing graphic influence consistently determining a strong linearity and a contrast of light and dark. Pelham is largely remembered as the stepfather of John Singleton Copley, a pivotal figure in Colonial American art, through which this graphic emphasis was confirmed.

During the eighteenth century, the English continued to swell America's population and exert the predominant influence on her culture. Of particular note was the arrival of John Smibert (1688–1751). Arriving in 1729 at Newport, Rhode Island, Smibert was the first artist of true professional status to arrive in this country. He possessed a thorough knowledge of fashionable style and immediately sought commissions from Boston society. After painting the wife of

1. John Smibert (1688–1751): *Vew of Boston.* 1738. Oil on canvas, 30″ x 50″. English-born Smibert came to Boston in 1729, bringing a collection of old master engravings and antique casts. In contrast to the flat canvases of the Colonial limners, his paintings invited spectator participation through a convincing representation of three-dimensional space. Considered both here and abroad to be among the foremost painters of the day, Smibert provided an important example to younger painters and nurtured Colonial artistic patronage. (*Childs Gallery, Boston*)

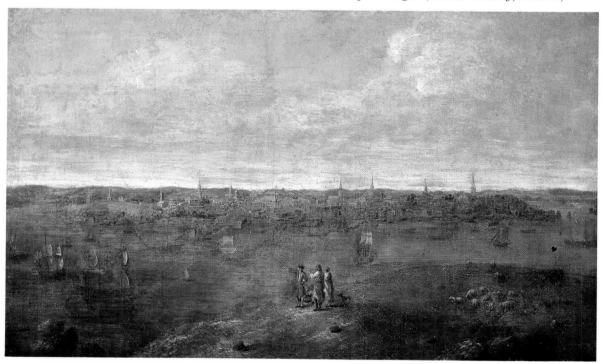

2. Unidentified artist: Overmantel from the Gardiner Gilman House, Exeter, New Hampshire. c. 1775. Oil on panel, 28" x 47¾". This handsome panel, showing an imaginary rather than an actual scene, is a splendid example of overmantel painting. It was not until the mid-eighteenth century that popular attitudes toward painted landscapes began to change. Patrons in their enthusiasm to decorate elegant homes quickly realized the landscape's decorative potential and elevated this new art form to a status symbol. (*Amon Carter Museum*)

the Governor, he completed his major work, *The Bermuda Group* (*Dean George Berkeley and His Family*, 1728–1729), which can be described as the first professionally painted group portrait in America. Despite modest financial success, Smibert was confronted by the reality of a limited market, forcing him to supplement his income by teaching and selling art supplies.

In the April 14, 1730, issue of the London *Daily Courant* one critic praised another side of Smibert's work: "Landskips how gay! arise in every Light,/And fresh Creation rush upon the Sight." Like Thomas Gainsborough, Smibert periodically painted a landscape for diversion when bored by his portraits. In 1749 he wrote an acquaintance that he "hath been diverting my self with somethings in the Landskip way which you know I always liked."[7] But until recently, this aspect of his work was unknown. *Vew of Boston* (1738, see pl. 1) is not unlike the Burgis engraving, stressing topographical accuracy, a feeling of space, and formal linearity. At the same time the foreground figural imagery recalls the

comments of a contemporary, Mark Catesby (1679?–1749) who, in referring to the Carolinas, praised the "variety of the blessings of Nature." These comments indicate that while nature had become less a tool of commerce, its values were yet unclear. Smibert continued to work, but the absence of professional standards greatly contributed to the artificial and staid qualities that characterize his later work.

Other immigrating Englishmen nurtured an interest in landscape by furthering a strong topographic tradition. Two works epitomize the skillful union of art and narrative science: Burgis's *Scenographia Americana* (1768) and J. F. W. Des Barres's *Atlantic Neptune* (1763–1784).[8] These works were prompted by European curiosity rather than Colonial demand. As a group, the Colonists were not yet prepared to investigate the virtues of their environment. It was left to these English spectators to point out its unique and inspiring qualities.

Meanwhile, in Europe, the influence of organized religion was on the decline.

Nature was discussed with unprecedented fervor, and landscape painting was beginning a significant transition. Traditionally, nature had been viewed as an expression of divine purpose, and landscape painting adhered to a classic attitude that stressed ideal proportion and formal relationships. Intellectualism superseded truth to visual reality. Accordingly, the physical landscape was structured to stress orderliness and to avoid any hint of imperfection. During the eighteenth century the theme of nature was further revived by Edmund Burke (1729–1797) in the widely read *A Philosophical Enquiry into the Origin of Our Ideas of the Sublime and Beautiful* (1757). He dealt with a theme in the psychology of artistic experience that stressed objects in the material world and their effect on our emotions and inner consciousness. Basically, Burke discussed nature within a framework based on such words as the *sublime* and the *beautiful*. Although the nomenclature was decidedly different, Burke was largely restating the traditional divisions of landscape painting as a genre, a concept that dates back to Longinus.[9] In 1708 the French art historian and theorist Roger de Piles (1635–1709) discussed these divisions as the heroic (sublime/natural) and the rural or pastoral (beautiful/picturesque). During the seventeenth century these two modes of viewing were embodied in the work of Salvator Rosa and Claude Lorrain. As embodied by Rosa, the heroic landscape emphasized the forces of nature by seeking to create a grand, extraordinary effect or an agreeable illusion. On the other hand Lorrain represented the rural or pastoral mode, emphasizing the peace and harmony of nature (the beautiful), the cultivated scene with its orderly arrangement of forms or nature in its original state (wilderness). These contrasting modes are often confusing, but in many respects the heroic versus pastoral conflict is equatable in simpler terms to that existing between the dynamic and the calm, the real and the ideal. Numerous individuals echoed Burke and his discussion of the sublime, including Immanuel Kant (1724–1804), *Critique of Judgment* (1790), and Archibald Alison (1757–1839), *Essays on the Nature and Principles of Taste* (1790). In 1783 Hugh Blair provided this cogent definition: "Nothing is more sublime than mighty power and strength. A stream that runs within its bank is a beautiful object; but when it rushes down with the impetuosity and noise of a torrent, it becomes a sublime one."[10]

The Beginnings of a Tradition: Romanticism

Shortly after the migratory wave from England that brought Smibert to this country, our first native artists were born, among them John Singleton Copley (1737–1815) and Benjamin West (1738–1820). The work that set Copley's career in motion was *The Boy with a Squirrel* (c. 1765), which drew a positive response from Sir Joshua Reynolds, who described it with such phrases as "hardness in the drawing, coldness in the shades, an over-minuteness." In contrast to current English painting, this work established qualities that were to characterize American art. John Wilmerding succinctly stated those qualities as "a preference for factuality, the almost scientific concern for the physical world, and the early graphic tradition characterized by such linear and tonal sharpness."[11]

These were years of mounting tensions between England and the Colonies, and Copley, strained by the situation here and encouraged by West, finally left for England. There he prospered, delving into history painting with a success that anticipated the onset of romanticism. West, meanwhile, pursued his fascination with the classical theories of the German archaeologist and art critic Johann J. Winckelmann (1717–1768). But like Copley, he applied these classical aesthetic attitudes to current events.[12] At the same time Reynolds was involved in the scientific search for the secrets of Renaissance color theory. In large part he determined the strong English interest in colorism as it predominated during the neoclassic period. Late in life West was greatly influenced by Burke's treatise on the sublime. West was an important painter who projected a mode of

history painting ideally suited to the new nation because it extolled contemporary events and heroes. In any case West's position was crucial, for he was the key transmitter of European aesthetic theories to his visiting American students. His London studio, a haven where individuality was stressed, provided an invigorating and instructive environment for such visiting Americans as Washington Allston, Matthew Pratt (1734–1805), Samuel F. B. Morse (1791–1872), John Trumbull (1756–1843), Gilbert Stuart (1755–1828), Charles Willson Peale (1741–1827), and less directly, John Vanderlyn (1775–1852).

For individuals both here and abroad the success of the American Revolution (1775–1783) indicated that history was at a turning point. But the effects on our society were delayed. As stated by Arthur M. Schlesinger in *The Birth of the Nation*,

> The American War for Independence was therefore limited in its aims and limited in its outcome. It freed the American state, but not yet the American mind. Nationalism and democracy, in their more ardent expression, followed rather than accompanied the Revolution. It was not until the early nineteenth century that a truly distinctive American civilization began to emerge.[13]

Optimism and a sense of destiny existed, but the prevailing social, cultural, moral, and intellectual heritage continued to bind the Colonies. Curiously, even after more than nine generations since Jamestown, the Colonists never lost their sense of being English.

The principles involved in the American Revolution were universal and their endurance provided an important catalyst that ultimately unleashed a series of world events of profound aesthetic significance. In particular, the French Revolution in 1789 disrupted earlier patterns of patronage and acceptable subject matter. A specialist emerged who no longer responded to private commissions, but served a larger and more diversified anonymous market. And more important, world events between 1793 and 1802 provided the circumstances for the emer-

gence of one of the most creative movements in Western civilization—romanticism.

As a state of mind romanticism marked a reaction in literature, philosophy, art, religion, and politics.[14] It replaced the Enlightenment philosophy, of which humanity was the focal point, and its emergence is dated to the publication, starting in 1798, of the *Lyrical Ballads* by Coleridge (1772–1834) and Wordsworth (1770–1850). Through Coleridge and Wordsworth these sentiments, dating to the seventeenth and eighteenth centuries, regained a striking relevance. As a result of the widespread human suffering and unpleasantness that accompanied the Industrial Revolution and the sudden growth of cities, the impact of their verses gained a wide following.

Romanticism is difficult to define because it was more a state of mind than a movement. The public, never completely swayed in its favor, retained some preference for various modes of classicism. Consequently, the divisions persisted; artists sought either a literal rendering of a scene in line with tradition (realism) or an interpretation of that scene according to a particular state of mind (idealism). Romanticism persisted through much of the nineteenth century, but as late as 1824 critics were still seeking an explanation of the term, with divergent and disappointing results. In retrospect the term served as a focal point for a new religious belief, with aesthetic and metaphysical meanings. It acknowledged the value of the individual in relation to the universe as a whole and it exalted nature and viewed it as a revelation of Truth, as the "living garment" of God. Its literature idealized rural life and expressed an enthusiasm for wilderness.

Romanticism found Americans ready to establish a landscape tradition. Lacking such influential tastemakers as the English nature poets, but possessing all the elements for the romantic mood, this country embraced the movement both aesthetically and philosophically. It was the primordial wilderness and not civilized Europe that best articulated this movement. Our concept of beauty

and our attitudes toward landscape painting were formulated within the tenets of romanticism and characterized by a vogue for the picturesque and an active pantheism. Throughout the nineteenth century romanticism provided Americans with a viable and multifaceted aesthetic tradition.

The emergence of an indigenous landscape tradition was inextricably tied to the gradual spread of romanticism, the availability of professional artists, and the public acceptance of meaning in our landscape. In this country its pace accompanied the tide of nationalism that culminated in the years after the War of 1812 with Andrew Jackson's election to the presidency in 1828. Meanwhile, the Colonial atmosphere of peace and opportunity attracted a wave of artists in the 1790s. Although trained in an English topographic tradition, they brought desperately needed insight and technical abilities, and directly influenced public aesthetic consciousness by their engraved "views." Although an object of curiosity, the countryside lacked the rich historical associations to which visiting Europeans were accustomed.

Among the first wave of artists were William Birch (1755–1834), William Winstanley (active 1792–1806), Francis Guy (1760–1820), William Groombridge (1748–1811), George Beck (1748/50–1812, see pl. 3), and Michele F. Cornè (1752–1832), who signaled two important and enduring qualities: Cornè's dependency upon "design," which was the staple of our folk tradition; and Beck's responsiveness to the natural wilderness of our environment. The second group in the 1810s included trained watercolorists such as Joshua Shaw (c. 1776–1860) and W. G. Wall (1782–1864), who toured the countryside creating works subsequently engraved by John Hill (1770–1850) for travel books such as *Picturesque Views of American Scenery* (1820) and *The Hudson River Portfolio* (1828), respectively. Hill states in his introduction, "The vast regions present to the eye every variety of the beautiful and sublime . . . striking however and original the features of nature are in the United States, they have rarely been made the subject of pictorial delineation. . . .

America only, of all the countries of civilized man is unsung and undescribed."[15]

Another English landscapist was Joshua Shaw, who arrived in 1817 and brought with him a romantic penchant for the sublime. Illustrating a scene from Genesis, *The Deluge* (c. 1813, see pl. 33) is an excellent example of a romantic composition, with all its accompanying devices to instill a sense of awe and terror in the spectator. Shaw was an innovator who, after 1817, began to respond to the unique atmospheric nuances of American light. At last the American countryside was being discovered and delineated with precise draftsmanship according to a picturesque mood. In his later paintings Shaw followed a mode described in 1804 by William Gilpin:

Nature should be copied, as an author should be translated. If, like Horace's

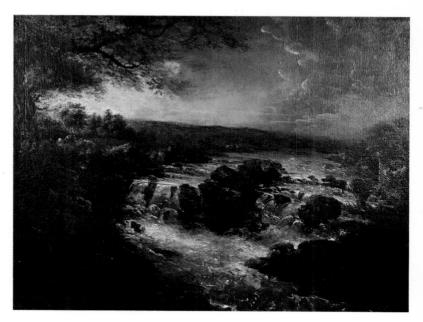

3. George Beck (1748/50–1812): *Great Falls of the Potomac.* 1796–1797. Oil on canvas, 42″ x 60″. A diversified talent, Beck arrived in this country from England in 1795. Like William Winstanley, he was fortunate to receive from George Washington in 1796 several commissions of the wild Potomac River as it broke through the Blue Ridge Mountains to the Great Falls. Upon his retirement Washington took the painting from the presidential mansion in Philadelphia to Mount Vernon. (*Mount Vernon Ladies' Association of the Union*)

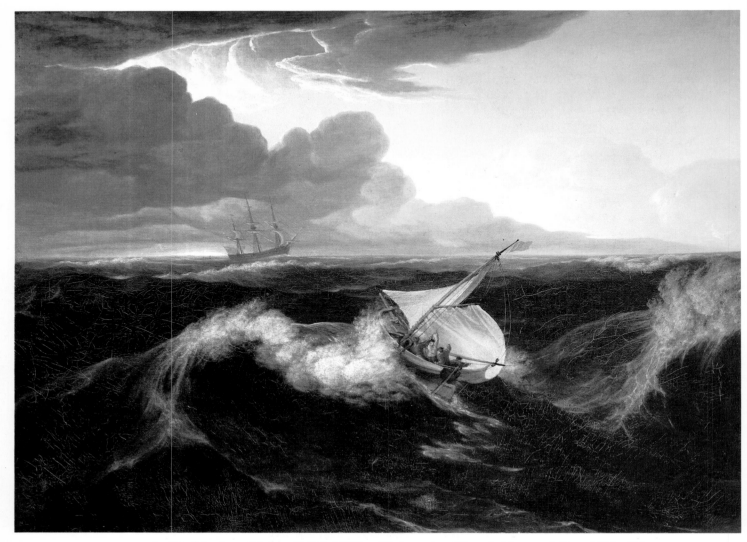

4. Washington Allston (1779–1843): *Rising of a Thunderstorm at Sea.* 1804. Oil on canvas, 38½″ x 51″. After several years as a pupil of Benjamin West in London, Allston traveled extensively through France, Switzerland, and Italy before reaching Rome in 1805. Capturing an observed spectacle of nature, this painting was done in Paris in 1804. The canvas reflects not only his discovery of the stormy seascapes of Joseph Vernet but also his emerging fascination with a romantic spirit through which nature's awesome power and inspiring beauty are poignantly joined. This romantic inclination was strengthened during the next three years in Rome by his close friendship with Washington Irving and Samuel Taylor Coleridge. (*Museum of Fine Arts, Boston; Everett Fund*)

translator, you give word for word, your work will necessarily be insipid. But if you catch the meaning of your author, and give it freely, in the idiom of the language into which you translate, your translation may have both the spirit and truth of the original. Translate nature in the same way. Nature has its idiom, as well as language; and so has painting.[16]

In 1818 the native-born Washington Allston (1779–1843) returned to this country. Like Trumbull and Vanderlyn after the War of 1812, Allston returned to join in what must have seemed a prosperous national destiny.[17] In any case he played a crucial role as the leading representative of English romanticism in this country. This individuality was shaped by the influence of his teacher, Benjamin West, and the romantic sensibilities of his close acquaintances, Coleridge and Wordsworth. Allston's personality was clearly suited to romanticism and its aes-

thetic alternatives. Painted during his first trip to Europe, *Rising of a Thunderstorm at Sea* (1804, see pl. 4) establishes Allston's place at the beginning of an American preference for romanticism. Unlike a history painting with its numerous associations, the landscape painting conveys its moral through the power and beauty of nature.

To Allston, art was an exploration of the vision that dwelled in his own mind.[18] After returning from his second European visit in 1818, Allston entered a new phase of his life, becoming more meditative and introspective. In time, he became increasingly interested in the painterly investigation of color and form over subject matter. Captivated by the Venetian technique of color glazing, Allston pursued a mood of reverie by creating paintings with a "luminous appearance. . . . what Titian calls the 'luce di dentro' or internal light."[19] Allston's colorist experiments culminated in one of his most lyrical and poetically sensitive works—*Moonlit Landscape* (1819, see pl. 34). After years abroad Allston recalled the moment of return, "A homesickness which . . . I could not overcome, brought me back to my own country in 1818. We made Boston Harbour on a clear evening in October. It was an evening to remember! The wind fell and left our ship almost stationary on a long low swell, as smooth as glass and undulating under one of our gorgeous autumnal skies like a prairie of amber. The moon looked down on us like a living

thing, as if to bid us welcome."[20]

Allston's special achievement resulted from his molding of color and light to the tenets of the romantic movement and, more important, to the American landscape. Each quality sought to inspire the imagination of the viewers, enabling them to reflect freely on their individuality and experiences. The Transcendentalist Margaret Fuller assessed his achievement in terms that recalled Allston's delight at discovering Titian: "The calm and meditative cast of those pictures, the ideal beauty that shone *through* rather than *in* them, and the harmony of coloring were unlike anything else I saw."[21] Allston hinted at painterly qualities that distinguished numerous nineteenth- and twentieth-century artists, from Thomas Cole to the luminists, and beyond to Winslow Homer, Albert Pinkham Ryder, and Charles Burchfield, among others. Increasingly, artists pursued a romantic vision that sought to establish the inherent union between nature and the human spirit. Of all the qualities in this country's vast wilderness, light emerges as a key factor in our iconic repertoire and as a metaphor for contemplative solitude. Through much of the nineteenth century, this country lacked an internal cohesiveness. We were still a country of island communities, with little communication between them. Artistic reputations were restricted, and as a result, Allston's innovations were only gradually embraced and practiced by others.

TWO

The Landscape as a Cultural Artifact

Mobility was greatly enhanced in America by the completion of the Erie Canal in October 1825. Begun in 1817 and derisively called Clinton's Ditch, the canal's completion represented the greatest engineering accomplishment of the time and mirrored the prevailing mood of nationalism. Almost immediately the Hudson River Valley became a site of leisure activity and the American wilderness an object of curiosity, and pride. A month after the canal opened, Richard Ray, on November 17, 1825, addressed the American Academy of the Fine Arts, clearly linking the arrival of romanticism to the newly discovered virtues of the Hudson River Valley. Asher B. Durand engraved the frontispiece to his published text, which stated in part,

> To the Artist . . . our country affords peculiar advantages: I mean the Landscape-painter. For him extends an unappropriated world, where the glance of genius may descry new combinations of colors, and new varieties of prospect. . . . Come then . . . your country points you to its stupendous cataracts, its highlands intersected with the majestic river, its ranging mountains, its softer and enchanting scenery. There, where Nature needs no ficticious charms, where the eye requires no borrowed assistance from the memory, place on the canvas the lovely landscape, and adorn our houses with American prospects and American skies.[22]

The cultural nationalism reflected in this passage was given added meaning by the sweeping popular election of Andrew Jackson, the "people's friend" and hero of the War of 1812, as president in 1828. His victory signaled an era of optimism that lasted until 1864. American culture was never so distinctively American. Suddenly, the wilderness landscape was valued for its Americanizing influence and its ability to transmit new energy to our society. It came to symbolize the manifest destiny of the young Republic. As recently stated, "To Americans, the power and potential of a working democracy seemed to be mirrored, even glorified, in the natural beauty of the continent itself."[23] Within this democracy, painting became a popular art and a favorite pastime. Following Allston's example, the painted landscape was assuming the former moral role of history painting, defining for its public both the native wonders of the American countryside and its sublime revelation of God's presence.[24]

Allston and, to a lesser extent, Joshua Shaw were transitional figures between Benjamin West's emphasis on historicism and Thomas Cole's moral allegories. In the interim several artists were becoming aware of the landscape's moral suggestiveness. By 1818/1820 Asher B. Durand was establishing a close tie with romanticism through the poetic verses of a favorite author—James

12

Thomson (1700–1748). His engravings of Autumn and Winter for a proposed edition of Thomson's *Seasons* were of a decided romantic sensibility and dealt with themes that would form the premises of our landscape tradition: the smallness of humanity before the grandeur of nature, the wilderness of the American forest, and the unaltered beauty of God's creation, sanctified as in a Garden of Eden.

At about the same time other artists could be found doing English-style landscapes. Alvan Fisher (1792–1863) was working in Boston, Thomas Birch (1779–1851) was in Philadelphia, and Thomas Doughty (1793–1856) frequented both cities. Changing attitudes in the 1820s are exemplified by Doughty, who abandoned a profitable business to become a full-time landscape painter. While often technically rivaling Thomas Cole, Doughty was unable to reconcile the dilemma of English forms with American subject matter. *A River Glimpse* (c. 1820–1821, see pl. 40) clearly demonstrates his response to the pastoral charm and romantic possibilities of the countryside. Doughty worked out-of-doors; however, his paintings were a composite view of a location rather than an unaltered response to the realities of a particular scene. His later works continued in this direction, opposing public taste and diminishing his popular appeal. In spite of this situation he took an important early step toward realizing the aesthetic and philosophical potentials of the American landscape.

As the ideals of Jacksonian democracy increasingly swayed civic sentiment, two artists in particular were recognized for their striking narratives: Thomas Cole and Asher B. Durand. Clearly, Cole was the forerunner who paved the way for Durand's appreciation of American scenery. At the same time Cole faced certain limitations that precluded complete objectivity to nature. Like Allston, Cole was greatly influenced by the English nature poets, but differed in his emphasis on "idea" over any technical considerations. He was entirely sympathetic to the portrayal of nature's sublime aspects, preoccupied with joining the

painted landscape to moral pantheist overtones. Cole's dilemma is especially perplexing when we realize that his "Essay on American Scenery" (1835) provided a vocabulary or series of explanations that enabled both spectator and artist alike to abandon traditional attitudes and respond solely to the landscape's distinctiveness.[25] The often-quoted 1825 exchanges between Cole and the Baltimore collector Robert Gilmor, Jr., indicate not only Cole's attitude but also a measure of emerging public taste. In unfavorably comparing one of Cole's paintings to a Doughty, Gilmor stated, "As long as Doughty painted and studied from Nature . . . his pictures were pleasing, because the scene was real, the foliage varied and unmannered and the broken ground and rocks and masses had the very impress of being after originals and not ideals. . . . I prefer real American scenes to compositions, leaving the distribution of light, choice of atmosphere and clouds, and in short all that is to render its natural effect as pleasing and spirited as the artist can feel permitted to do without violation of its truth."[26] Gilmor's pragmatism was well suited to the graphic technique of Durand and current fashion, but Cole was quick to respond, "If I am not misinformed, the first pictures which have been produced, both historical and landscapes, have been compositions, certainly the best antique statues are compositions; Raphael's pictures, those of all the great painters are something more than mere imitations of nature as they found it. . . . If the imagination is shackled, nothing is described but what we see, seldom will anything great be produced in Painting or Poetry."[27] Durand, as we shall see, accepted this aspect of public taste, largely because it agreed with his own attitudes. Unfortunately, Cole remained perplexed, for it was not until late in his life that he accepted the belief that an unprecedented quality of the sublime could be found in the commonplace of the American landscape.

English-born Thomas Cole (1801–1848) is credited with founding the Hudson River School when in 1825 three of his landscapes attracted the attention of

John Trumbull, William Dunlap, and Asher B. Durand. A school was not founded on this occasion; rather, an emerging spirit and an aesthetic preference were acknowledged, and the young Cole was given encouragement to pursue his individual interests.[28] His early works betray a debt to the landscapes of Thomas Doughty and Thomas Birch, which he studied in 1823. The works are fresh and innovative, drawing freely upon romantic sources, yet skillfully hinting at the realism of the American wilderness. Still, Cole was not content merely to create realistic narratives of American scenery; he felt compelled to use the landscape as a stage on which a moral allegory could be acted out. His *Expulsion from the Garden of Eden* (1828) directly parallels the engravings in John Martin's (1789–1854) edition of *Paradise Lost* (1824–1827) and displays his susceptibility to an apocalyptic vision through the dramatic treatment of lighted spatial voids. In 1829 Cole returned to England where he was captivated by The British Museum's extensive collection of landscape drawings by Claude Lorrain and etchings by Rembrandt. Their use of light to create a dramatic treatment of space especially impressed Cole, and their influence is evident in his oil sketches done while in Europe. After almost two years in London and Paris he turned to Italy, spending eight months in Florence and about three in Rome where, coincidentally, he worked in Claude Lorrain's studio. Cole was at ease in Florence because he felt the city's works of art reflected the truth and splendor of nature. However, Rome was especially rewarding because of the poignant associations between art and history, moral virtues, and the physical world. Rome provided a nurturing atmosphere for his romantic sensibility, furnishing a striking metaphor of the "golden age" and the emerging young Republic. Despite Italy's emotional appeal Cole was increasingly missing "the wilderness places of America." He returned to America in 1832 and showed a greater propensity for moral allegories, combining themes that dealt with the progress of civilization, the passage of time, moral virtues, human vulnerability,

and the wilderness of nature. Cole's ideas on the death of civilization were influenced by a book that had an immense following at the time: Comte de Volney's *Ruines; ou, Méditation sur les révolutions des empires* (1791). This book and current archaeological excavations "drew a picture of entire civilizations, dead, vanished, swept away upon the stream of time."[29] In response Cole conceptualized a series of canvases stressing nature as an enduring manifestation of God while emphasizing its inherent opposition to civilization. The 1830s witnessed four such commissioned series: *The Course of Empire* (1833–1836) for Luman Reed, *Departure and Return* (1837) for William P. Van Rensselaer, *Past and Present* (1838) for P. G. Stuyvesant, and *The Voyage of Life* (1839, see pl. 54) for Samuel Ward, Jr. Although impressive in size and effect, the works followed a formula derived from European prototypes and eventually lost Cole's earlier originality and spontaneity. The public appreciated the high moral content of these paintings, but for their homes they wanted realistic views of American scenes.

Done while he was working on *The Course of Empire* series, *The Oxbow* (*The Connecticut River near Northampton*) (1836, see pl. 5) is among Cole's finest works. It is a monumental history painting that, by consecrating a real place, clearly indicates the painterly and philosophical possibilities of the American landscape. All hints of intimacy are submerged in a panoramic view of the wilderness. Cole's sense of perspective— from above, a different vantage point from that of the artist—creates an illusion of vastness, anticipates the future by the suggestive distance, and directly involves the spectator in its sublime experience. The American countryside was ideally suited to panoramic treatment, the societal benefit of which was succinctly expressed by an anonymous contemporary of John Vanderlyn.

Panoramic exhibitions possess so much of the magic deceptions of the art, as irresistibly to captivate all classes of spectators, which gives them a decided advantage over every other description

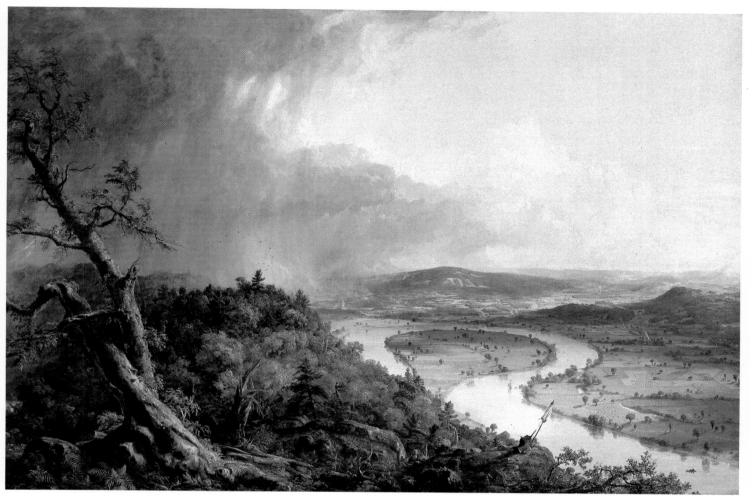

5. Thomas Cole (1801–1848): *The Oxbow (The Connecticut River near Northampton).* 1836. Oil on canvas, 51½″ x 76″. On the advice of his close friend and patron, Luman Reed, Cole in early 1836 set out to paint a picture specifically for exhibition. He was reluctant as "fancy pictures" sold poorly, but noted with pride an already begun view of Mount Holyoke. With extraordinary skill Cole consecrated a real place, choosing the moment after a thunderstorm to explore the panoramic possibilities from a promontory overlooking the Connecticut River. For Cole the storm brought "beauty in their train," and his confident rendering of the recently freshened luxuriant vegetation indeed rivals the landscape studies of his English contemporary John Constable. (*The Metropolitan Museum of Art; Gift of Mrs. Russell Sage, 1908*)

of pictures; for no study or cultivated taste is required fully to appreciate the merits of such representations. They have the further power of conveying much practical, and topographical information, such as can in no other way be supplied, except by actually visiting the scenes which they represent, and if instruction and mental gratification be the aim and object of painting, no class of pictures have a fairer claim to the public estimation than panoramas.[30]

In 1835, a year before Emerson discussed the moral influence of nature upon humanity in his *Nature,* Cole delivered the lecture "Essay on American Scenery," wherein he sought to differentiate

the parts of the landscape, to give them meaning, and, he hoped, greater public acceptance. The essay also represented a conscious attempt to break with traditional aesthetics by pointing out contrasts between the American and the European landscapes. After lamenting the rapid encroachment of civilization's destructive forces and reminding us that the wilderness still affords a contemplative reflection of the creator, Cole stated,

I will now venture a few remarks on what has been considered a grand defect in American scenery—the want of associations, such as arise amid the scenes of the old world. . . . Yet American

scenes are not destitute of historical and legendary associations—the great struggle for freedom has sanctified many a spot, and many a mountain, stream, and rock has its legend, worthy of poet's pen or the painter's pencil. But American associations are not so much of the past as of the present and the future . . . looking over the yet uncultivated scene, the mind's eye may see far into futurity. Where the wolf roams, the plough shall glisten; on the gray crag shall rise temple and tower—mighty deeds shall be done in the now pathless wilderness; and poets yet unborn shall sanctify the soil.[31]

Unfortunately, Cole was unable to reconcile the landscape's realities with his intended pictorial effect. His paintings remained composite impressions of the countryside, rather than realistic renderings of actual views. Not until shortly before his death in 1848 did Cole finally acknowledge the native sublimity of the landscape and allow the design actually to reflect its distinctive nuances.[32]

At the time of Cole's death Asher Brown Durand (1796–1886) had established successive reputations as this country's foremost engraver, an excellent portraitist, and an accomplished landscape painter. More important, he had served three years of a seventeen-year term as president of the prestigious National Academy of Design. "As president . . . from 1845 to 1861, Durand held a position of social responsibility. . . . It was his task to promote a form of art that conforms the spectator to a salutary and humanizing order."[33] Stylistically, Durand's work is in contrast to Cole's, which emphasizes the duality that existed in contemporary literature.

Cole paralleled Emerson in his preference for thematic overviews, while Durand and Thoreau, an Emerson disciple, sought similar results through a greater fidelity to observed reality. Although nature was the focal point of their theme, its interpretation differed markedly. While Cole favored an imaginative rendering of nature "waiting for time to draw a veil over the common details," Durand sought the specific rendering of nature, as observed out-of-doors, advising his students to "draw with

scrupulous fidelity the outline or contour of such subjects as you shall select, and . . . choose the most beautiful or characteristic of its kind. If your subject be a tree, observe particularly wherein it differs from those of other species."[34] Therefore, nature remained the contemplative retreat of artists and writers alike; but their approach emphasized truth to nature and not the demands of past European tradition.

To Durand and his generation observing the detail of nature was an accepted vehicle to understanding more universal truths. In his "Letters on Landscape Painting" (1855) Durand stated this belief very clearly:

> [Landscape painting] will be great in proportion as it declares the glory of God, by a representation of his works, and not of the works of man . . . every truthful study of near and simple objects will qualify you for the more difficult and complex; it is only thus you can learn to read the great book of Nature, to comprehend it, and eventually transcribe from its pages, and attach to the transcript your own commentaries.[35]

Although by no means diminishing Cole's importance to our landscape tradition, Durand's influence was more pervasive and enduring. Durand painted the landscape with an engraver's passion for detail and an ability to depict subtle tonal variations. In a very real sense his position was enviable because he reached maturity in the late 1840s and 1850s, a time of unprecedented public interest in landscape painting. In New York alone the American Art Union (dedicated to the nationalization, democratization, and propagation of native art to the widest possible audience), between 1842 and 1850, distributed more than 150,000 engravings and 3,300 paintings to a membership of over 16,000 individuals. And sufficient time had elapsed to witness another generation of native-born and European-experienced American artists, all of whom contributed to the popularity of landscapes. In fact, Durand became so popular that he was unable to satisfy the market for his works.

In many respects Durand's works displayed qualities that distinguished

John Constable's *Hay Wain* in the Paris Salon of 1824. Constable's work created a sensation because of its technical innovations: expressive qualities of light and tonal gradations and the juxtaposition of small dabs of pure pigment to make the canvas sparkle. Constable looked at nature with a historical reverence, actually responding to the undefined association that time's passage conferred upon it. In turn Durand attained an eloquence in his 1855 letters on landscape painting to *The Crayon*. In Letter II, published January 17, 1855, Durand stated,

> There is yet another motive for referring you to the study of Nature early —its influence on the mind and heart. The external appearance of this our dwelling-place, apart from its wondrous structure and functions that minister to our well-being, is fraught with lessons of high and holy meaning, only surpassed by the light of Revelation. It is impossible to contemplate with right-minded, reverent feeling, its inexpressible beauty and grandeur, forever assuming new forms of impressiveness under the varying phases of cloud and sunshine, time and season, without arriving at the conviction
>
> "That all which we behold
> is full of blessings"
>
> that the Great designer of these glorious pictures has placed them before us as types of the Divine attributes, and we insensibly, as it were, in our daily contemplations,
>
> "To the beautiful order of his works
> Learn to conform the order of
> our lives."

Durand's letters refined the sentiments in Cole's pioneering essay by further proposing a language of nature, correlating moral and cultural meaning to the landscape's distinctive "wildness." In glorifying American scenery, Durand emphasized two factors that were crucial to an artist's success. Predicated on his belief in working out-of-doors, they were the need to express convincingly the exact species of the flora and fauna of a region and to convey accurately the effects of light and atmosphere on those forms. On this point Durand believed "[atmosphere] above all other agencies carries us into the picture . . . it is *felt* in the foreground, *seen* beyond that, and *palpable* in the distance. . . . Sunshine is the joyous expression of Nature."[36] Durand's dictum on open-air sketching logically made contemporary artists more aware of sunlight's higher luminosities.

This increased sensitivity to sunlight became a pervasive characteristic of the next generation, directly contributing to an awareness that it was a unique quality of this country and ultimately serving to become an iconic symbol in the American landscape tradition.[37] Hence, an important transition had occurred, whereby artist and public alike acknowledged several factors: the distinctiveness of the American landscape, its desirability as an aesthetic subject, and its undisputed position as a cultural artifact.

At the same time landscape painting assumed a new and somewhat less philosophical purpose in America. Increasing industrialization and the realities of urban living necessitated a visual escape. Society was in a state of flux, and the quiet solitude of nature afforded a measure of comfort. This retreat operated on several levels. On one level there arose what Joshua Taylor has described as a type of landscape spirit, in which artist and viewer were content to arouse only a pleasurable state of mind, with no direction that encouraged an endless rumination in the natural environment.[38] The popular lithographs of Currier and Ives (Nathaniel Currier 1813–1888, J. Merritt Ives 1824–1895) exemplified this response, and of their contributors, George H. Durrie (1820–1863, see pl. 66) is generally considered the most gifted. On another level we encounter a generation of artists who were close friends, of similar ages, and stylistically attuned to the picturesque aspects of the countryside.

The Flourishing of a Landscape Tradition

America at mid-century was preoccupied with progress, the march of civilization, and industrialization. In 1844 the great artistic talent Samuel F. B. Morse (1791–1872) sent the first telegraph message; in 1846 the Swiss-born geologist and botanist Jean Louis Agassiz (1807–1873) arrived and proceeded to champion original research and natural history; in 1851 a side-wheeler named *Baltic* reached Liverpool from New York in about ten days, and the first cast-iron-frame building was constructed; the harvester was being manufactured by the thousands; and during the 1850s railroad mileage more than tripled. During 1853 and 1854 the iron-and-glass Crystal Palace exhibition in New York championed native ingenuity, and it was not a coincidence that at the same time Asher B. Durand created a canvas called *Progress* (1853, see pl. 6), while its accompanying painting by Kensett was simply called *Landscape with Deer* (1853, see pl. 78).

This situation was anticipated during the 1830s by that astute and sensitive observer, Alexis de Tocqueville. In *Journey to America* (1831) he establishes a metaphoric reference to silence, the luminist trademark.

> The noise of civilization and of industry will break the silence of the Saginaw. Its echo will be silent. . . . so great is the force that drives the white race to the complete conquest of the New World.

It is this consciousness of destruction, this arrière-pensée of quick and inevitable change, that gives, we feel, so peculiar a character and such a touching beauty to the solitudes of America. . . . Thoughts of the savage, natural grandeur that is going to come to an end become mingled with splendid anticipations of the triumphant march of civilization. One feels proud . . . yet at the same time one experiences I cannot say what bitter regret at the power that God has granted us over nature.[39]

Although we cannot help being impressed by this country's spiritual orientation during the years preceding the Civil War, we must realize that while landscape painting addressed this need, it also served more practical roles. It addressed the theme of progress, serving as a catalyst to exploit nature and it helped this country survive the divisiveness of the war, proposing a shared experience to unify our differences. Historically, this time was characterized by unprecedented artistic and literary activity. By 1856 Frederic E. Church had visited Niagara Falls; several important landscapists including Thomas Cole and Thomas Doughty had died; and a new generation of American artists including Thomas Eakins, Ralph A. Blakelock, Albert P. Ryder, Thomas W. Dewing, and John S. Sargent was born. Photography, with its ability to capture a transient moment of time, was exerting a tremendous

6. Asher B. Durand (1796–1886): *Progress*. 1853. Oil on canvas, 48″ x 71¹⁵⁄₁₆″. Also called *The Advance of Civilization*, this painting was the companion to John F. Kensett's *Landscape with Deer*. Exhibited as one of seven in the National Academy of Design exhibit of 1853, it was described by a reviewer in the July issue of the *Knickerbocker* as follows, "It is purely American. It tells an American story out of American facts, portrayed with true American feeling by a devoted and earnest student of Nature." (*The Warner Collection of the Gulf States Paper Corporation; photograph courtesy Hirschl & Adler Galleries, Inc.*)

influence, together with the rise of plein-air painting. At the same time the following works were published, John Ruskin's *Stones of Venice* (1851), Henry D. Thoreau's *Walden, or Life in the Woods* (1854), and Walt Whitman's *Leaves of Grass* (1855).

Also, working in several European cities were numerous artists including Sanford R. Gifford (1823–1880), Thomas Worthington Whittredge (1820–1910), William T. Richards (1833–1905), James Abbott McNeill Whistler (1834–1903), George Caleb Bingham (1811–1879), Albert Bierstadt (1830–1872), Elihu Vedder (1836–1923), John La Farge (1835–1910), Eastman Johnson (1824–1906), George Inness (1825–1894), and others. This activity reflected expanding artistic attitudes and abilities and pointed to the invigorating effect on our landscape tradition that this influx of European ideas would generate. Returning from Europe in 1859, Worthington Whittredge succinctly stated contemporary artistic ambitions:

We are looking and hoping for something distinctive to the art of our country, something which shall receive a new tinge from our peculiar form of Government, from our position on the globe, or something peculiar to our people, to distinguish it from the art of the other nations and to enable us to pronounce without shame the oft repeated phrase, "American Art."[40]

Despite the lack of extensive visual examples, the American interpretation of Pre-Raphaelitism experienced its greatest popularity during the 1850s and the 1860s. Formulated by John Ruskin in *Modern Painters* (c. 1845), these ideas won easy acceptance in this country. In fact, it was in this country that Ruskin's ideas found their most receptive and appreciative following. At the outset Americans were attracted by the extreme detail and the elaborate finish of the Pre-Raphaelites. Much of Asher B. Durand's work approached this aesthetic with its preference for the intimate and accidental view of nature. A sense of contem-

plative solitude was desired to serve as a vehicle between the humblest facts of physical nature and the spiritual enrichment of the spectator. Nature's moral virtues were popularized by Thoreau in *Walden,* and they became a pervasive theme of the century. But now artists were almost expected to assume the role of botanists and geologists, able to render convincingly specific species of flowers, grasses, and trees.

Here Andrew W. Warren (1823–1873) is an excellent example, but although we are immediately fascinated by his busy technical detail, we may also feel that his efforts are too contrived or cluttered, lacking in spirit or spontaneity. Indeed it was the critic Tuckerman who in writing of Kensett best expressed the important distinction between the English and American Pre-Raphaelites:

> In some of his pictures the dense growth of trees on a rocky ledge, with the dripping stones and mouldy lichens, are rendered with the literal minuteness of one of the old Flemish painters. It is on this account that Kensett enjoys an exceptional reputation among the extreme advocates of the Pre-Raphaelite school, who praise him while ignoring the claims of other American landscape artists. But this fidelity to detail is but a single element of his success. His best pictures exhibit a rare purity of feeling, an accuracy and delicacy, and especially a harmonious treatment, perfectly adapted to the subject.[41]

By the mid-1860s the novelty of this style was diminishing, and public reaction to Ruskin was increasingly hostile. More important, the movement ran counter to the American ideal of spaciousness and smooth pictorial transitions that the young generation of landscapists were pursuing.

Jasper F. Cropsey (1823–1900) was among the younger landscapists practicing at this time. Along with Thomas Worthington Whittredge, Frederic Edwin Church, and David Johnson, Cropsey was born during the 1820s (John Casilear and John F. Kensett had been born in the 1810s). A great admirer of Thomas Cole, Cropsey was also a devoted advocate of direct study from nature. Cole's influence, as well as Salvator

7. Jasper F. Cropsey (1823–1900): *Autumn—On the Hudson.* 1860. Oil on canvas, 60″ x 108″. The American autumn was Cropsey's favorite season; he viewed it as a challenge to his palette rather than as a melancholy symbol of time's passage. This canvas is the largest he attempted and took almost a year to finish. The bright autumnal color caused disbelief among startled English viewers, until actual leaves were produced. Poignantly aware of civilization's encroachment and the destruction of the wilderness landscape, Cropsey has chosen to place the opposing forces in peaceful harmony. The enthusiastic response to this monumental work is verified by his 1861 presentation to Queen Victoria and its sale in 1862 for $2,000, the highest price paid for a Cropsey to that date. (*National Gallery of Art; Gift of the Avalon Foundation*)

Rosa's, whose pictures he saw during an 1847 to 1849 trip to Italy, are readily visible in Cropsey's allegorical *Spirit of War* (1851, see pl. 74). The narrative detail and lively use of paint owe much to Cole, as does the handling of space, which keeps the viewer at a distance. In 1856 Cropsey again returned to Europe and remained there until 1863.

While in Europe, Cropsey became fascinated by the Pre-Raphaelite emphasis on evocative atmospheric light and on meticulous attention to nature's details. Already by the 1850s his use of changing seasonal effects was increasingly deliberate. He became best known for his paintings of autumn, this country's most colorful season and, in 1860, *Autumn— On the Hudson* (see pl. 7) was exhibited in his London studio. The coloring and brushwork were spectacular and one critic stated, "The singularly vivid colors of an American autumnal scene, the endless contrast . . . might easily tempt a painter to . . . revel in variety of hue and effect. . . . It will take the ordinary observer into another sphere and region."[42] Cropsey's technique was designed to be luminous, using a highly colored ground to emphasize texture and a feeling of panoramic airiness. His paintings celebrated the beauty of the countryside, and his public responded with enthusiasm. Completed after his European sojourn, *Starrucca Viaduct* (1865, see pl. 86) is one of his most telling works about the cultural and aesthetic undercurrent of the time. Although clearly celebratory, it "also indicates the increasingly tenuous balance between the pristine virtues of wilderness and the encroaching agents of civilization."[43] Nature shares our attention with a manmade achievement, the bridge near Lanesboro, Pennsylvania, which carried the Erie-Lackawanna Railroad over the Susquehanna River. Whereas nature or the wilderness was considered a symbol of the nation, its position here is compromised by a new metaphor for American progress—industry.

At the same time that Cropsey pursued his view of nature and landscape paintings, many others were working in a similar spirit. Largely self-taught, Rob-

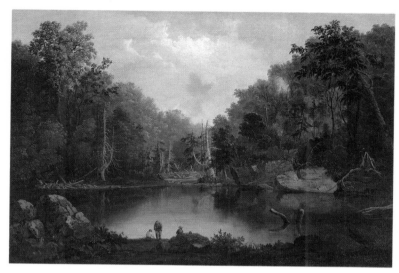

8. Robert S. Duncanson (1821–1872): *Blue Hole, Flood Waters, Little Miami River.* 1851. Oil on canvas, 29¼″ x 42¼″. Although he worked in Cincinnati, Duncanson's landscapes stylistically reflect those produced by the Hudson River artists. Before a trip abroad in 1853 with William Sonntag (1822–1900), Duncanson established his reputation through arduous self-training. Depicting a specific location, which remains today, this work was completed ". . . at an important transitional moment in American painting . . . recalling the poetic reveries of nature painted by a preceding generation while anticipating the coming interest in expansive lighting and atmospheric effects."[1] (*Cincinnati Art Museum; Gift of Norbert Heerman and Arthur Helbig*)

9. George Caleb Bingham (1811–1879): *Fishing on the Old Mill Dam.* 1853. Oil on canvas, 25″ x 30″. Active in Missouri as a painter and a politician, Bingham frequently traveled to the east. The American Art Union, New York, popularized his work not only by purchasing more than twenty paintings but also by distributing thousands of engraved scenes to its membership. Executed several years before Bingham's studies in Düsseldorf (1856–1858), this painting is one of fourteen landscapes done between 1845 and 1872 that survive today. Reflecting English pastoral modes, it is like a still life in which the forms and colors are modeled to the utmost perfection. (*Museum of Fine Arts, Boston; photograph courtesy Vose Galleries of Boston, Inc.*)

ert S. Duncanson (1821–1872) drew freely from Doughty and Durand in *Blue Hole, Flood Waters, Little Miami River* (1851, see pl. 8). Their example, as well as the colorist influence of Allston, anticipates the broadening interest of artists in exploring light and atmospheric effects. This interest was strengthened by the rampant mid-century popularity for the brilliant work of J. M. W. Turner, while George Caleb Bingham's (1811–1879) *Fishing on the Old Mill Dam* (1853, see pl. 9) reflects a quieter aspect of English pastoral modes.[44] Another interesting painter whose precision and detail defined the essence of the Hudson River style was David Johnson (1827–1908). His portraits of specific places (see pl. 84) offered a panoramic bird's-eye view of nature unfolding before the spectator. Finally, John Casilear's (1811–1893) painting of *Lake George* (1857, see pl. 68) is a stunning work that readily betrays his debt to Durand and his close friendship with John F. Kensett.

Kensett (1816–1872) began his career as an engraver of maps and bank notes. Along with Durand and Casilear, Kensett went abroad in 1840 and after extensive travel to London, Paris, and Rome he returned to New York in 1847, remaining there until his death. During this trip he came under the spell of Claude Lorrain's classical landscapes, which during the 1840s were quite popular with British lovers of the picturesque. On his return he worked with a dark palette, preferring intimate views and detailed studies of isolated woodlands untouched by civilization. His pastorals, reflecting the individual character of a scene, are lyrical and filled with such picturesque details as tangled brush, small ponds, and turbulent skies. All hints of romanticism vanish, leaving the viewer with a sense of open air.[45] While Kensett's pictures remained topographically exact, his sensitivity to color and atmospheric delicacy increased. In 1864 the critic James J. Jarves commented on his transition: "there is a phantom-like

10. John F. Kensett (1816–1872): *Marine off Big Rock.* 1869. Oil on canvas, 27¼″ x 44½″. The scene in this painting is Beacon Rock at Newport, Rhode Island. Following a repeated format, the canvas is divided into halves, with large trees and rocks on one side and a water view on the other. The crisp outlines and subtle tonal gradations create a scene of transcendent quietude where water, sky, and other details exist in complete harmony. In 1864 James Jackson Jarves described the effect of Kensett's late works in *The Art-Idea,* ". . . there is a phantom-like lightness and coldness of touch and tint which give them a somewhat unreal aspect."[2] Also, in commemorating a specific location rather than a composite of landscape views, Kensett has reaffirmed his generation's belief in the suitability of all nature as a spiritual retreat. (*Cummer Gallery of Art*)

lightness and coldness of touch and tint which gives them a somewhat unreal aspect, but they take all the more hold on the fancy for their lyrical qualities."[46] Unlike Durand, who remained an engraver in color, Kensett had truly become a painter. *Marine off Big Rock* (1869, see pl. 10) typifies his later style with its crisp simplicity and expressive luminosity. The absence of any human figures and the diffused light serve to amplify the permanent elements of land, sea, and sky. All the elements of the landscape are in harmony and carefully balanced to create a new, metaphoric vision of the American landscape. Unlike the tormented allegories of Cole these paintings convey a spiritualism of profound impact that simultaneously consecrates a real place. At the same time that Kensett's pale hues and subtle tonal gradations placed him within a luminist mode, his horizontal format with its panoramic view provided a contemporary interpretation of another quality that had inspired the English topographical artist: the impressive vastness of the countryside.

Kensett's sentiments were shared by others, including his close friend Thomas Worthington Whittredge (1820–1910). Like Kensett, Whittredge went to Europe in 1849 and remained for ten years. His experiences were varied, making it difficult to pinpoint any pervasive artistic influence. He studied at the Düsseldorf Academy, which between the late 1840s and the early 1860s had attracted such artists as George Caleb Bingham, Albert Bierstadt, William Stanley Haseltine (1835–1900), and William Trost Richards. At most, this training served to reinforce a strong American preference for precise draftsmanship, meticulous finish, and to a lesser extent, narrative subject matter.[47]

Whittredge traveled west for the first time in 1866 and returned in 1870 with Gifford and Kensett. An important result of the journey was his discovery of the great plains and prairies. In contrast to such earlier works as *The Old Hunting Ground* (1864, see pl. 11), *On the Plains, Colorado* (1877, see pl. 110) displays a new impression of open space

and quietism. About this aspect of the American landscape, Whittredge commented,

> I had never seen the plains or anything like them. They impressed me deeply. . . . Whoever crossed the plains at that period, . . . could hardly fail to be impressed with its vastness and silence and

11. Thomas Worthington Whittredge (1820–1910): *The Old Hunting Ground*. 1864. Oil on canvas, 36″ x 27″. On his return to America from Düsseldorf in the summer of 1859, Whittredge set up a studio in New York City. In the next year he began his long association with the National Academy of Design, becoming an elected member in 1861 and ultimately serving as its president from 1874 through 1877. Before his 1866 trip to Colorado and New Mexico Whittredge was perhaps best known for his meticulous views of woodland interiors illuminated by strong sunlight filtering into the deep woods. Described on one occasion by the critic Tuckerman as an "idyll," this painting is perhaps the finest woodland scene that Whittredge completed. (*Reynolda House, Inc.*)

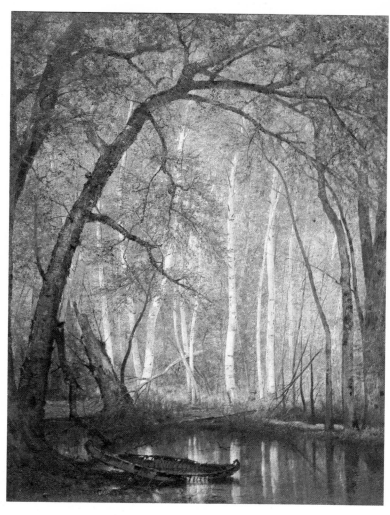

the appearance everywhere of an inno-
cent, primitive existence. . . . Often on
reaching an elevation we had a remark-
able view of the great plains. Due to the
curvature of the earth, no definite hori-
zon was visible, the whole line melting
away, even in that clear atmosphere, into
mere air.[48]

Like Whittredge, Walt Whitman was
equally impressed by the Great Plains,
referring in his *Specimen Days* (1882)
to it as sublime and as "North America's
characteristic landscape."[49]

A similar quality is shared by a se-
ries of works done by Whittredge at New-
port, Rhode Island. The scene along the
Rhode Island coast, *A Breezy Day—New-
port, Rhode Island* (1880, see pl. 113), is
incredible for its spacious perspective as
well as its visual and atmospheric integ-
rity. We experience the day's warmth
and from our vantage point, we are daz-
zled by the intimate foreground details
and fascinated by the ships on the low
horizon. Whittredge, Kensett, and others
dealt with an aesthetic format that em-
phasized the grandeur of horizontal space
and extolled the singular quality of
American light. Their aesthetic attitudes
characterized the 1850s and 1860s illus-
trating one direction that landscape
painting was following.[50] The earlier dia-
logues of Cole and Durand were by no
means abandoned, but were being inter-
preted on new expressive levels.

One such avenue of pursuit followed
by landscape painters was a stylistic phe-
nomenon called *luminism.* Traditionally,
luminism is described as an indigenous
mode of painting that prospered between
around 1850 and 1875 and reached its
apogee during the 1860s.[51] John I. H.
Baur, in his pioneering essay, "American
Luminism," described the artists as fol-
lows, "Technically they were extreme re-
alists, relying on infinitely subtle varia-
tions of light and tone to capture their
magical effects. Spiritually, they were
the lyrical poets of the American coun-
tryside and the most sensitive to its nu-
ances of mood."[52] Subsequently, Edgar P.
Richardson stated, "Luminism was an
intuitive search by American artists for
a style of light, growing out of the tonal
painting of the thirties and forties."[53]

And, most recently, John Wilmerding
commented,

By proposing luminism as the conclusive
development of early American land-
scape painting (in contrast to the more
traditional and often uneven Hudson
River school surveys), one can view it
as the central movement in American art
through the middle of the nineteenth
century. Indeed, its crystalline pictures
of the 1850s stand as supreme manifes-
tations of Jacksonian optimism and ex-
pansiveness—along with America's be-
lief in the transcendent spiritual beauty
of nature. Moreover, the apocalyptic
storm and twilight scenes of the 1860s—
so visually and thematically different,
yet conceptually and structurally related
—speak vividly of the turbulent Civil
War years and the poignant sense of
loss in the aftermath.[54]

As we have seen, many artists since
Allston have been luminists to some ex-
tent. However, among the luminists of
the 1860s we can detect a more refined
sensibility and widespread intent. Tonal
concerns were strongly reinforced by
several factors, including the death of
Turner in 1851, technical innovations
such as the introduction of new cadmium
colors, the competition with photogra-
phy, increased attention to the mechani-
cal and natural sciences, and the rampant
industrialization that characterized the
age. Changing societal concerns were ne-
cessitating a more up-to-date visual
image.

The luminist phase was character-
ized by an impulse to measure, which re-
placed the impulse to define what had
characterized much of landscape paint-
ing to this time.[55] Similar emotional
responses were anticipated from the spec-
tator, but now nature was being exam-
ined from a more technical point of view.
Quite simply, whereas the Pre-Raphael-
ites were concerned with meticulous and
tactile detail, the luminists sought to
evoke a state of mind through delicate
tonal variations and an almost mirrorlike
painting surface. Most of the canvases
are decidedly horizontal, and the picto-
rial illusion leaves us with a feeling that
we are gazing into infinity. Emerson elo-

quently defined this sensation: "Standing on the bare ground—my head bathed by the blithe air, and uplifted into infinite space—all mean egotism vanishes. I become a transparent eyeball; I am nothing; I see all; the currents of the Universal Being circulate through me; I am part or parcel of God."[56] We also feel that nature is somehow contained or perhaps subdued.

During the 1860s Frederick Law Olmsted (1822–1903)—the successor to the environmental philosophy of Andrew J. Dowling (1815–1878)—created several controlled settings such as Central Park in Manhattan and Prospect Park in Brooklyn. In itself, the creation of these parks was a significant statement. Nature was still valued for its moral influence and civilizing effect; however, industrial progress had clearly indicated that we were in charge of the situation. American society was not intimidated by nature's threatening forces or its wilderness. Therefore the luminist landscape hints at nature's domestication, and progress, as much if not more than transcendence, is its secret message. Recently, one critic best expressed this view, ". . . if we examine the Luminist scene, one quickly realizes that it is peopled with very little—ships, anonymous people, some land, sea and sky, and more sea and sky, all of this illuminated as though it were a permanent paradise, the nineteenth century American dream of village life come true."[57] Although numerous American artists participated in this contemporary luminist vision, only a few individuals formulated overt opinions about this stylistic preference.[58]

Fitz Hugh Lane was born in 1804 (d. 1865), making him a contemporary of Thomas Cole and presumably subject to similar influences; especially, seventeenth-century Dutch paintings and the marine scenes of Robert Salmon. Until the mid-1840s Lane had little time to paint, being entirely preoccupied by his own lithographic company. His views of city and harbor prospects reflected the prosperity and level of ordered activity that characterized Jacksonian America. Lane was unique among his contemporaries in that he continued to produce accomplished lithographs while he pursued a similarly distinguished career as a painter. After 1848 he traveled the upper New England coast, and his subsequent work began to reflect a greater spaciousness, an intensified luminosity, a quality of contemplative quiet and isolation, and most important, a feeling of closer harmony with nature.

In the 1850s and early 1860s hints of human presence are diminished, and in turn the distant horizon occupies a greater area of canvas. As he grew older, Lane's vision intensified to a point at which his work was establishing a canon of luminist painting. The carefully structured *View of Gloucester from Brookbank* (1850s, see pl. 87) presents an intricate relationship among form, space, light, and color that immediately transcends topographic exactitude. Strikingly reminiscent of his lithographs, this painting arrests our attention by its serenity and yet animates our curiosity by its prudent placement of the single-masted sailboat and the curve of the shore. One critic summarized Lane's achievement as follows, "A sense of vacuum prevails, as Lane distills and finally suspends time itself. . . . His pale hues and glassy surfaces of water are elements of a material and spiritual universe which we—now indeed 'bathed by the blithe air, and uplifted into infinite space'—at once look at and look through."[59]

Lane's personal view of nature and luminism was not easily matched, but the tenets of the style were further explored by Martin J. Heade (1819–1904) and Sanford Gifford (1823–1880). Heade's career was the longest of his generation, yet the extent of his reputation was not what one might expect. Only in recent years has he been recognized as an important artist. This recognition in part resulted from his close friendship with Frederic E. Church and the singular success of several paintings. His early work, usually realistic and picturesque views of nature, was influenced by a Hudson River sensibility. His sense of observation was meticulous and betrays a familiarity with Pre-Raphaelite doctrines. At the same time the linear

precision and visual clarity of *Rhode Island Shore* (1858, see pl. 91) show an acquaintance with Lane's work and the general stylistic changes that occurred at this time. Heade's paintings become increasingly seductive, luring the viewer to witness the scene firsthand. Similarly, he became more involved with the act of painting and less concerned with the physical geography. After the Civil War, which shattered the idealism of Jacksonian democracy, Heade's works approached the sublimity of Cole's moral allegories. *Thunderstorm over Narragansett Bay* (1868, see pl. 13) is an excellent example, and yet it seems anachronistic within the aesthetic overview of the times.[60] Although the Civil War had raised profound uncertainties, public attitudes were not yet ready for this type of haunting imagery.

From the beginning of his career,

12. Fitz Hugh Lane (1804–1865): *Entrance to Somes Sound from Southwest Harbor.* 1852. Oil on canvas, 23¾″ x 35¾″. For Lane and others of his generation light was the artistic vehicle that expressed the widespread spirituality in America during the 1850s and 1860s. Silence and a feeling of contemplative solitude also conveyed this nineteenth-century quality. In his *Journey to America* (1831) Alexis de Tocqueville posed the question, "Who will ever paint a true picture of those rare moments in life when physical well-being prepares the way for calm of soul, and the universe seems before your eyes to have reached a perfect equilibrium; then the soul, half asleep, hovers between the present and the future, between the real and the possible, while with natural beauty all around and the air tranquil and mild, at peace with himself in the midst of universal peace, man listens to the even beating of his arteries that seems to him to mark the passage of time flowing drop by drop through eternity." (*Private collection; photograph courtesy National Gallery of Art*)

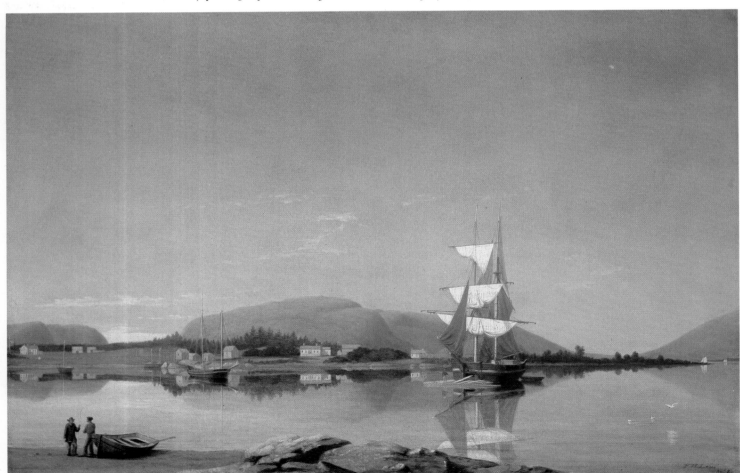

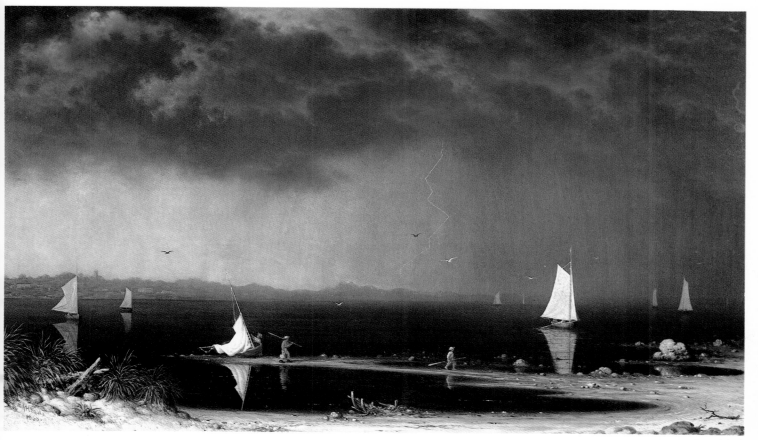

13. Martin Johnson Heade (1819–1904): *Thunderstorm over Narragansett Bay*. 1868. Oil on canvas, 32⅛″ x 53¾″. During the 1860s and 1870s landscape painting was inspired by the striking advances of science and developed along two polarities—luminism and objective naturalism. On the occasion of its 1868 exhibition at the National Academy of Design, Heade's eerily dramatic *Thunderstorm over Narragansett Bay* was described as being hard in color and execution, and chilling. This work clearly demonstrates that Heade, although approximating the characteristics of the Hudson River artists, more properly shares a romantic tradition with Washington Allston and Albert Ryder, creating an imagery evocative of inner feelings. Unfortunately, Heade secured his fate when in 1882 he moved to St. Augustine, Florida, as New York City became a thriving art center. Forgotten for almost sixty years, it was not until Heade's *Thunderstorm* was rediscovered in 1942 and exhibited in The Museum of Modern Art's "Romantic Painting in America" that interest was reawakened in this artist, ultimately establishing his reputation in American art history. (*Amon Carter Museum*)

Sanford Gifford possessed a strong interest in light's expressive qualities. As late as 1879 the critic G. W. Sheldon commented, "Perhaps no painter in this country has achieved a better mastery of the light giving properties of the sky."[61] Gifford turned to landscape painting during the 1840s, when artists were dedicated to a nationalistic and democratic propagation of American art. For some time Gifford was devoted to the Catskill landscape, preferring, like Cropsey, the seasonal effects of autumn. However, he responded to the changing times by choosing the role of a luminist. Although late in the luminist movement, *A Sunset on the Hudson* (1879, see pl. 112) addresses Gifford's belief that landscape painting should deal with atmospheric effects.

Similar qualities characterized the work of others during the 1860s and 1870s, when artistic differences were attributable to varying technical abilities and an awareness of stylistic innovations. For instance, Samuel Colman (1832–1920) is not usually considered a luminist, but *Storm King on the Hudson*

(1866, see pl. 102) shares many characteristics with Lane's work, although the degree of technical refinement differs. At the same time tonal considerations and the artistic fascination with photography were reflected in the Arctic scenes of William Bradford (1823–1892). Inspired by Lane and Dutch marine painting, Bradford—like Heade, Church, James Hamilton (1819–1878), and others—sought the new frontiers believed to lie outside this country's territorial limits. Bradford with one exception traveled to the north every summer between 1861 and 1869. In addition to his exquisite photographs, which were published in 1873, numerous paintings resulted, among them *Coast of Labrador* (1866, see pl. 104). Assuming the role of an artist-explorer, Bradford was not merely responding to the brilliant coloration and physical uniqueness of this remote region; he was seeking an element of transcendent spiritualism distinct from Lane's vision. As L. L. Noble, a friend of Cole who in 1859 accompanied Church to Labrador, said in his recollections *After Icebergs with a Painter* (1861), "Solemn, still and half-celestial scene! In its presence, cities, tented fields and fleets dwindled into toys. I said aloud, but low: 'The City of God! The sea of glass! The plains of heaven.' "[62]

FOUR

The Epic Landscape

From the artist's viewpoint an important aspect of the wilderness experience was the search for a native subject matter that possessed timeless and cosmic meaning. The Hudson River Valley continued to attract artists, but its painted image was gradually losing its fashionable appeal. Since the opening of the Erie Canal in October 1825, this area in upstate New York had remained a center of attention, its level of activity beginning to peak in the late 1840s. Put simply, the first phase of this country's intimacy with nature and the painted landscape was giving way to another that would carry to fruition many of the ideas that originated with Cole and Durand. In 1846 and 1848 the United States acquired the Oregon and California territories, respectively. The physical remoteness of these territories triggered plans for the first transcontinental railroad, which became a rallying point for this country's concept of manifest destiny. The pastoral mode of painting landscapes, promulgated in Cole's late paintings and most of Durand's, was no longer satisfactory. Similarly, Lane's luminist metaphor of progress did not represent the intense public determination that accompanied this age of westward expansion. A more overtly heroic view of nature and American culture seemed in order, and several artists responded to this new spirit.

Frederic Edwin Church (1826–1900) was a product of the 1850s and of the spirit of manifest destiny that characterized this decade. After being introduced by Daniel Wadsworth, Church became the only true student of Thomas Cole, painting landscapes with him in the mid-1840s. His debt to Cole was largely restricted to a tendency to allegorize the American wilderness experience, as his technique was more scientific. Like Bradford, Hamilton, and Heade, Church was compelled by the thrill of undiscovered frontiers and the exhilarating 1852 travel narratives of the German naturalist, Alexander von Humboldt (1769–1859).[63] In search of the exotic landscape that might convey a fresh view of God-in-nature or the pantheist spirit that Cole relentlessly pursued, Church shunned the European grand tour and in 1853 made the first of two trips to South America, and during the next two decades visited the Arctic and Near East. Traveling for more than six months, he was captivated by the spectacular geography and responded with almost scientific exactitude in numerous drawings and oil sketches. Increasingly, we can sense that he was heading toward a new kind of landscape painting, more monumental in conception and more dependent on nature's powerful imagery to convey its meaning

A crucial turning point occurred for Church during the winter of 1856, when he read Ruskin's *Modern Painters*. The book's merger of art, science, and poetry was in harmony with Church's own atti-

tudes, and it influenced him to study J. M. W. Turner and his light-filled atmospheric paintings. Ultimately this was the catalyst that turned Church's interest to one of the most dramatic and thoroughly American scenes, Niagara Falls, which after several visits in 1856 he painted in an almost Turneresque vocabulary. Completed in 1857 when Church was only thirty-one years old, *Niagara Falls* (see pl. 114) created a sensation and overwhelmingly established his reputation as one of this country's best painters. Sold by the thousands as a chromolithograph, this painting was exhibited both here and abroad with great success. Technically and compositionally, it expressed the uniqueness of the American landscape by capturing a fresh viewpoint of nature, proving a worthy successor to Cole's innovative panorama *The Oxbow* (1836, see pl. 5).[64]

Unlike Alvan Fisher's timid and classically formulated 1820 view of Niagara Falls (see pl. 38), Church's landscape is organic, sublime, and purely American. In it we can see the vast changes that characterized American landscape painting within the short span of twenty years. Through Cole and the influence of Turner, Church was arriving at a new aesthetic statement of the confrontation between humanity and transcendent nature.[65] The spectator's vantage point doesn't really exist, for Church places us beyond the precipice and absorbs us in nature's intense activity. Our experience is immediate, and so compelling is the sense of energy and drama that it prompts a strong emotional impact.

Church was clearly inspired by the success of the work and continued to paint in similar views. At about the same time he had captured the grandeur and sublimity of the countryside in a composition critics generally consider the apogee of the American heroic landscape: *Twilight in the Wilderness* (1860, see pl. 14).[66] Recently, one critic described this work as follows,

> The combined union of light, color, space, and silence in this painting celebrates an experience of sublimity unknown before its time in the world of

art. The painting defies simple categorization as a "luminist" work of art, but there can be no doubt that the subject of the picture is, literally, American light, symbolic of the new world Apocalypse. It is a compelling work of art which combines two aspects of the sublime, the traditional interest in nature as object and the transcendental concern for nature as experience, through color, space, and silence.[67]

Thus, this painting objectively epitomizes the primeval aspect of American wilderness, while signaling a new era of promise. Church's choice of a twilight landscape was partly in keeping with its sudden popularity following the introduction of cadmium colors in hot reds, yellows, and oranges. The work is also one of the most eloquent statements in our art, an elegiac image of meditation on the passage of time, the seasonal changes of decay and rebirth, and, ultimately, the brevity of human life. The scene provides a perfect accompaniment to the words of the fourteenth-century Italian poet Petrarch, "No place and no time is indeed better adapted to the contemplation of a rustic solitude and of the tranquillity of a calmer life, than sundown, when youthful fervor has passed, and the hour of high noon, one might say, is left behind."[68] The association between the evening sky and the end of labor is inescapable. Although visually in direct contrast with Lane's luminist views, Church's *Twilight in the Wilderness* similarly expresses the fulfillment of manifest destiny, the American attainment of a paradisal state. Accepting the thematic complexity of this work, we realize that Church has created a highly individualized romanticization of solitude in nature. As such, he has carried the romantic spirit and American pantheism to a new height of expressiveness. Technically he has managed a unique harmonization of minute detail and overall effect, which at the same time defines the enduring essence of our landscape.

A year earlier in 1859, the same year that Humboldt died and Darwin's *On the Origin of Species* was published, Church had also attained a new plateau of pictorial effects with his *Heart of the Andes*. Inspired by his South American visits, it

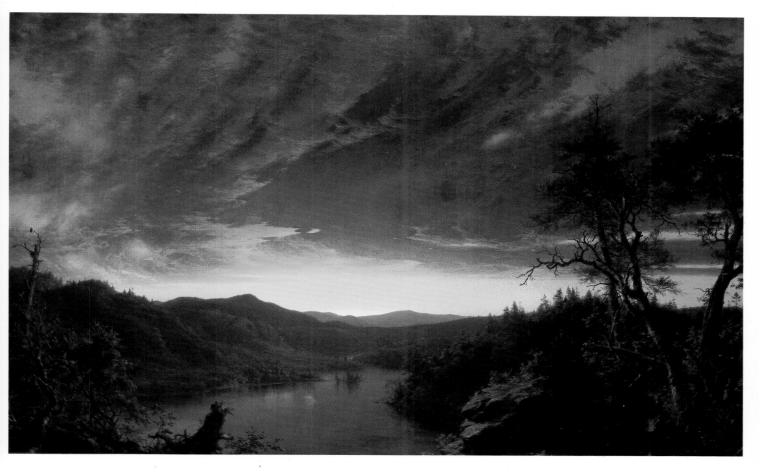

14. Frederic Edwin Church (1826–1900): *Twilight in the Wilderness.* 1860. Oil on canvas, 40″ x 64″. *Twilight in the Wilderness* has been described as Church's summary of the North American heroic landscape. Part of a series of sunset landscapes, this Adirondack scene is almost surreal because of the intense coloration and engravinglike sharp detail. Thematically complex, it complements this passage from *De vita solitaria* by the fourteenth-century Italian poet and humanist Petrarch: "No place and no time is indeed better adapted to the contemplation of a rustic solitude and of the tranquillity of a calmer life, than sundown, when youthful fervor has passed, and the hour of high noon . . . is left behind." The coincidence of an impending Civil War and the ongoing struggle between industrialization and nature heighten the contemporary relevance of Church's painting. Also, a significant influence was the introduction beginning in 1856 of a series of brilliant chemical pigments, replacing earlier mineral ones. This enabled artists to vary the hue (range of the spectrum from red to violet) of a canvas greatly, a reversal of the traditional order in which hue was limited and tone (range from light to dark) varied. So prevalent in the 1860s was the use of hot reds, yellows, and oranges that Jarves complained, "we are undergoing a virulent epidemic of sunsets."[3] These new cadmium pigments benefited the luminists by permitting a full exploration of light's effects. American artists maintained a sense of precise detail, while European counterparts pursued a direction that ultimately led to a stylistic dissolution of form, or Impressionism. (*The Cleveland Museum of Art; Purchase, Mr. and Mrs. William H. Marlatt Fund*)

synthesized his fascination with natural science in a detailed and monumental way. These visits also resulted in one of his more pervasive themes, that of Cotopaxi, a still-active volcano in north-central Ecuador (see pl. 116). He described it thus, "Cotopaxi is represented in continuous but not violent eruption. The discharges of thick smoke occur in successive but gradual jets . . . so that the newly risen sun flares with a lurid fire through its thick volumes."[69] Clearly, Church was addressing himself to the tenets of manifest destiny, asserting the hallowed belief of Thomas Jefferson that "America, North and South, has a set of interests distinct from those of Europe, and peculiarly her own."[70] All aspects of his composition deal with this recognition of our landscape's distinctiveness, its wilderness, and the destiny that its meaning implies.[71] Church's achievements were by no means the final statement on the artistic fascination with sublime effect; that was largely left to

Albert Bierstadt, who sought to rival Church during the 1860s and 1870s with ever more canvas depicting the American wilderness.

In 1857 after several years of intensive study in Düsseldorf (near Solingen where he was born) and Rome with Whittredge and Gifford, Albert Bierstadt (1830–1902) returned to the United States, fully trained in the techniques of sketching from nature. Two years later, he joined the famous Lander expedition of 1859, which was to survey the wagon trail to the Pacific coast. By June of that year, Bierstadt had set off to explore on his own. Like Church, he made hundreds of oil sketches from nature, abandoning Durand's pattern of sketching in pencil. Curiously, Bierstadt, like Cole in his 1835 "Essay," attempted to convince people of the worthiness of his subject: "The mountains are very fine; . . . they resemble very much the Bernese . . . the color . . . reminds one of Italy; in fact,

15. Albert Bierstadt (1830–1902): *The Sierra Nevada in California.* 1868. Oil on canvas, 72″ x 120″. During the mid-1860s, Bierstadt rivaled Frederic Church as America's most celebrated landscapist. Whereas *Niagara Falls* (1857) had established Church's preeminence among our painters, *The Rocky Mountains* (1863) promptly tilted the balance in favor of Bierstadt. Public taste clearly favored such inspiring and monumental scenes; and during the next several years Bierstadt introduced similar subjects to unprecedented success. *The Sierra Nevada in California* was painted in Europe during a spectacular two-year stay celebrating his recent marriage to the former wife of F. H. Ludlow, Rosalie. Once again large in size and painted with great skill, this subject captivated the attention of admiring Europeans by representing an unknown and new aspect of this country's landscape. (*National Museum of American Art, Smithsonian Institution; Bequest of the Estate of Helen Huntington Hull*)

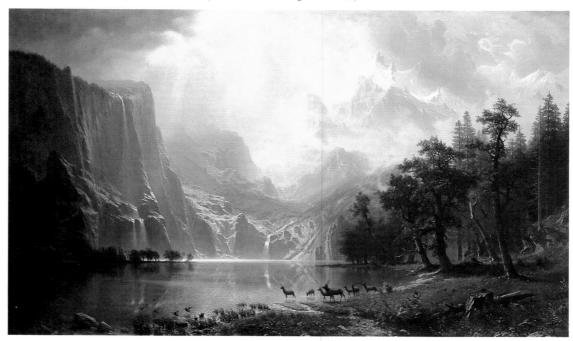

we have here the Italy of America in a primitive condition" (July 10, 1859, letter to *The Crayon*).

In 1863 Bierstadt made his second and most influential trip to the western wilderness, and in August of that year he entered the Yosemite Valley with the expectation of "going to the original site of the Garden of Eden."[72] His interest was sparked by the pioneering photography of Carleton Watkins in San Francisco, who had already been recognized for his views of Yosemite. During subsequent years Bierstadt finished a series of panoramic spectacles, the theatrics of which rivaled Church's on a popular level, although aesthetically they were in many respects anticlimactic. Works such as *The Domes of the Yosemite* (1867, see pl. 117), and *The Sierra Nevada in California* (1868, see pl. 15) are exquisite in the overall effect that they project and in a consummate expression of that unique "space" feeling that early American landscape painters sought to express as an emblem of this country. At the same time that we are impressed by his views, we readily recognize how contemporary perceptions of nature and particularly our landscape have changed. Bierstadt frequently took photographs to assist in his work and that of his brothers, who published stereoscopic views. Unlike Lane, who might have sought to arrest a transient moment and to establish an individual response to the subtleties of nature's details, Bierstadt sought the final effect. His compositions are like the wide-angle views so characteristic of the stereoscope, in which the foreground is full of picturesque detail with a generalized rapid succession into distant space. He freely modified his views, ultimately seeking the most favorable combination of pictorial elements to suit his desired result. Bierstadt's sweeping generalizations differ greatly from the works of Cole, Durand, Kensett, Cropsey, and many others who painted the more intimate Hudson River landscape, and yet he lived within and actually experienced this landscape. Although changing cultural attitudes contributed to Bierstadt's modification of Durand's vision of truth to nature, the self-sustaining grandeur and majestic sublimity of the western wilderness allowed him, as it did Cole, to draw a veil over distracting details in order to achieve an eloquent statement of our individual association with nature.

During the late 1860s and early 1870s Bierstadt was accorded unprecedented recognition and financial return. However, it would not be long before the impact of post–Civil War society so drastically altered public taste that Bierstadt met with indifference and financial ruin. In the interim his awe-inspiring views stimulated a similar panoramic treatment by Thomas Moran (1837–1926, see pls. 118, 119). In 1871 he accompanied the Ferdinand Vandeveer Hayden expedition to survey the Northwest Territories and produced telling impressions of his experience in watercolor. These convincing representations, along with his monumental summaries in oil, were sufficient to sway congressional opinion to set this area aside as the country's first national park.[73] In a very real sense the search for an indigenous American landscape spirit unknowingly begun by the earliest artist-explorers and refined by Durand and Cole had reached fruition in these mystic portrayals of nature's sublimity. The wilderness message could no longer be dealt with as in Cole's frightening moral allegories. Successive generations of individualists had replaced it with a landscape spirit that was more expressive and responsive to the visual reality of our surroundings.

Post-Civil War Society

Post–Civil War American society was characterized by dramatic transitions and changing perspectives.[74] The pervasive influence of manifest destiny was losing its impact; the landscape was losing much of its previous charm; Reconstruction was seen to have been a failure; and the phenomenal industrialization that would establish this country as a world power by 1900 was creating severe societal problems. Aesthetically, the Gilded Age also shattered old-fashioned ideals of patriotism, coming closest to an English romantic model where beauty was championed as an escape from the unpleasant realities of everyday existence. Since Andrew Jackson's presidency, America had become too insular and out of touch with a rapidly changing world. In many respects the 1876 Centennial Exposition in Philadelphia represents a turning point. Compared to the European section, the American paintings seemed undistinguished, thus prompting a discussion of our art in terms of European achievements. The change was by no means sudden, having been underway since overseas travel had become more accessible in the 1850s. European influences were subtle at first, oftentimes being disguised to ensure greater public acceptance. Also, it is difficult to distinguish these changes among so many overlapping talents. However, this gradual process of aesthetic adaptation can readily be seen in the work of George Inness.

Inness and the New Landscape

George Inness (1825–1894) owed his beginnings to the Hudson River style, yet he remained responsive to changing cultural attitudes and aesthetics. Specifically, he opened himself to European styles and assimilated their influence to his individual temperament. In 1854, a year after his contemporary Church journeyed to South America for epic subject matter, Inness was in Paris. Done after his return to New York City, *The Lackawanna Valley* (1855, see pl. 120) demonstrates the beginning of a transformation in his work that anticipates later developments. In itself the scene poignantly recorded industrialization in its early stages and the artist's changing relationship with the American countryside. One critic has noted his belief that *Lackawanna Valley* "may indeed represent Inness' declaration of independence from the current conventions (ideological and stylistic) of American landscape painting of the Hudson River School, and be an assertion of the modernity of his art, both through the novel artistic means that he employs, and equally through the glorification of the railroad, a well understood symbol of progress and 'the Present.' "[75] Inness's palette has lightened to emphasize current luminist and Barbizon attitudes. Overall, contemplative solitude prevails, as does a feeling of timelessness. Inness continued in a similar direction

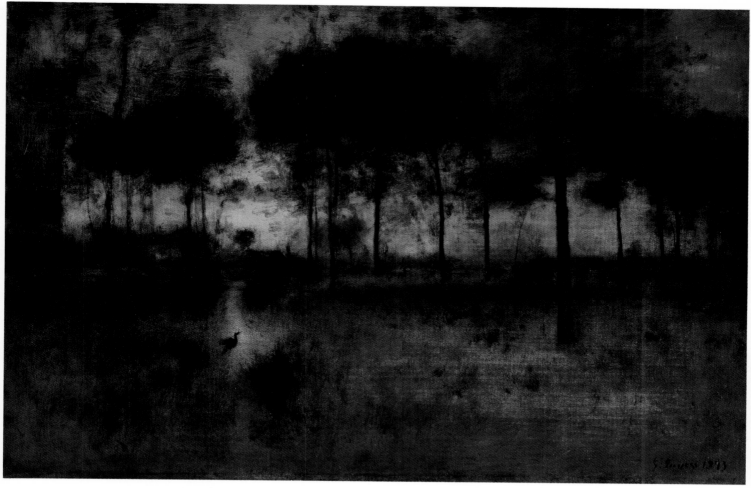

16. George Inness (1825–1894): *The Home of the Heron.* 1893. Oil on canvas, 30″ x 45″. This is an excellent example of Inness's late style: the scene is completely enveloped by the movement of air and light. Rich color harmonies orchestrate the composition, which superficially approaches French Impressionism, an association that Inness disdained. Here was the artist's finest attempt to approximate the spiritual counterpart of observed reality, utilizing the evocative poetry of color to express the spiritual ideas of Emmanuel Swedenborg. Although stated somewhat earlier, J. J. Jarves's comments are appropriate when he described the "attendant depth of feeling . . . [which] put the spectator on his feet at the very heart of the scene. He becomes an integral part of the landscape."[4] (*The Art Institute of Chicago; Edward B. Butler Collection*)

and with similar themes during the 1860s, applying tonal harmonies to panoramic vistas that were then popularized by Church and Bierstadt. At the same time he clearly imbued his paintings with an emotional and spiritual commitment that was reminiscent of Cole and others.

In 1870 Inness made a final trip to Europe and when he returned in 1874, his landscapes rejected the topographical exactitude of the Hudson River artists. Instead, he sought an introspective style that conveyed the universal spiritualism inherent in nature. In many respects Inness selected commonplace scenes, but tried to convey their hidden power. In 1878 he wrote, "the civilized landscape

. . . I love it more and think it more worthy of reproduction than that which is savage and untrained. It is more significant."[76] His reaction against the wilderness and its portrayal by Cole and Church marks an important transition that reflected contemporary attitudes.

The 1870s were a time of economic recession and widespread social disruption. Still a country of island communities, we were experiencing for the first time the problems of a larger society—overpopulation, crowded cities, monopolies, and so forth. Sweeping changes were necessitated by industrialization, mechanization, and urbanization. The success of our democracy was questioned. And,

as they sought to understand the essence of their problems, Americans gravitated to spiritualism, which was enjoying a considerable vogue. Concurrently, the power and vitality of the community eroded, resulting in a transition from local artistic reputations and autonomy to national considerations.

By 1885 Inness was perhaps the most sought-after artist on the American scene. James Jackson Jarves called him the Byron of our landscape, and for the next ten years he continued to produce a remarkable series of these works. His compositions were atmospheric and evocative of an "amorphous dream," which earlier had characterized the reveries of Allston. Here the spectator is an integral part of the scene, becoming completely enveloped by the movement of air and light. Something of Inness's purpose can be found in an 1878 statement, "If a painter could unite Meissonier's careful reproductions of details with Corot's inspirational power, he would be the very god of Art."[77] On another occasion Inness stated,

> The purpose of the painter is simply to reproduce in other minds the impression which a scene has made upon him. A work of art does not appeal to the intellect. It does not appeal to the moral sense. Its aim is not to instruct, not to edify, but to awaken an emotion. . . . It must be a single emotion if the work has unity, as every such work should have, and the true beauty of the work consists in the beauty of the sentiment or emotion which it inspires.[78]

Hence, we return to the basic romantic conflict between the real and the ideal, the objective and the subjective, the visual and the conceptual. Although this conflict preoccupied the Hudson River painters, Inness broke with their linear preference and sought to dissolve form in a poetic and colorful atmosphere. His blurred vision did maintain an openness or sense of spaciousness, but much had changed. The panoramic view was abandoned and, increasingly, the appeal of his works was based not on the beauty or distinctiveness of a particular location but on the effectiveness of aesthetic considerations such as harmonious color arrangements. The earlier landscape spirit no longer exists here. Cole's moralizing of the sublime was replaced by a more pastoral interest in beauty, which emphasized human detachment and heightened our psychological involvement through visual sensations. The differences evident in Inness's paintings indicate the changing aesthetic perceptions that characterized post–Civil War society. Alive with artistic activity, the last quarter of the century was a transitional period during which individuality rather than adherence to a norm was considered to be a hallmark of originality. The human condition remained a thematic interest, but was tempered by several factors, including a greater concern for aesthetic considerations and the projection of subjective meaning onto the painted canvas. By no means forgotten, nature was merely reinterpreted in a variety of alternative ways. As at the beginning of the century it continued to mean different things to different people. Pantheism persisted, but in most cases was overlooked in preference for more painterly explorations or more perceptive interpretations of visual reality. Spirituality, when displayed, came less from prescribed notions or associations than from the "interplay of light and shade and color as they presented themselves to the mind while contemplating nature."[79] In addition artists increasingly presented symbolic statements of nature's effect on their own character.

Native Realism

In many respects Thomas Eakins (1844–1916) represented the apogee of photographic and scientific realism in American art.[80] Hence, Durand's interest in the clarity of form and the interplay of light culminates in him. Eakins was, after Copley, perhaps our finest and most perceptive portraitist, but occasionally he painted a landscape that was usually peopled with his friends. The figure of *Max Schmitt in a Single Scull* (1871, see pl. 124) is such an example. All sense of animation is frozen in the poetic quietude of this work, with its mathematically precise perspective. About his painting, John Wilmerding states, "Eakins comes close

to the optical precision of photography. He chooses a day of utmost clarity, filled with light and emptied of atmosphere. He makes articulate use of reflections and the linear shapes of shells and oars to construct a complicated pictorial network."[81] In direct relation to the luminists Eakins's vision betrays a quality that simultaneously addresses itself to the passage of time and the brevity of human existence. At the same time his scientific precision succeeds in reintroducing the human figure to the confines of the drama. Eakins's innovation was a photographic exactitude that captured the moment of time between being and becoming, when our inner thoughts are visibly expressed by recognizable actions. In many respects his work represented another step toward the harmonization of an artist's inner sentiments and their materialization in the painted image.

During 1866–1867 Thomas Eakins and Winslow Homer (1836–1910) separately arrived in Paris. Although Homer remained less than a year, having gone primarily to view several works submitted to the Universal Exposition, the influence of the experience was unavoidable. His palette lightened and, thanks to Manet's canvases, his earlier wood-block ability to handle two-dimensional design was reinforced. Consequently his skills as a keen observer were sharpened, focusing on the essential aspects of a scene and exploiting the possibilities of line and tonal contrasts.[82] During the 1870s Homer's works came closest to the Impressionists (the word itself entering American critical vocabulary in 1878 as a designation of artists who combined the real and ideal) in attitude and aesthetic. Works such as *Houses on a Hillside* (1879, see pl. 130) share themes of pleasant holiday activities, but the rigorous coloring and brushwork demonstrate what it means to work in the open air. In 1881 Homer, perhaps in search of a more absorbing imagery, traveled to Tynemouth, a small English fishing village on the North Sea. There his work consisted almost entirely of watercolors, but they reveal a heroic element, a sense of humanity that preoccupied his later work. Once again Homer remained in England for two years, returning in 1883

to Prout's Neck, Maine, and remaining for the duration of his life in virtual isolation from society. His subsequent works brought him his greatest acclaim and rightly so. With the human figure virtually eliminated, they concentrated on the historical drama of the physical world, once again invigorating the American landscape with a profound meaning. Homer's skills were best displayed in his watercolors, which were spontaneous and dynamic. Late in life much of this confident spontaneity was replaced by an abandonment to the mysteries of nature. His later works are a hauntingly evocative revelation of the artist's state of mind. Here the pictorial drama reflects the artist's mood, rather than, like Cole, seeking a spectator response. In these canvases all sentiment vanished, leaving the "sensation of vigorous motion objectively recorded." At the time of his death Homer was considered to be our greatest artist. His reputation rested on the epic seascapes (see pl. 17) in which the forces of elemental nature were carried to new levels of interpretative meaning.[83]

The Impact of Impressionism

During the 1890s a proliferation of preferences was entertained—realism, tonalism, Symbolism, and Impressionism, among others. In itself, Impressionism was largely derived from Europe. The first Paris exhibit was held in 1874, although the extent of its influence on America is difficult to determine. Many subsequent efforts came close to an impressionistic vocabulary—including the works of William Morris Hunt (1824–1879), John La Farge, Childe Hassam, John H. Twachtman, and John Singer Sargent—but it was not until the late 1880s that a direct response to the movement was clearly evident.[84] A revived interest in photography prompted artists to search for original ways to compete with its visual effect. Two such ways were a greater concern for the very act of painting and an innovative use of pigment. James Abbott McNeill Whistler (1834–1903), who was an ardent spokesman for the "art for art's sake" movement, stated, "Art should stand alone, and appeal to the artistic sense of eye

or ear, without confounding this with emotions . . . as patriotism. . . . The imitator is a poor kind of creature. If the man who paints only the tree, or flower, or other surface he sees . . . the king of artists would be the photographer. It is for the artist to do something beyond this."[85] In his 1893 series of lectures John La Farge (1835–1910) further discussed art as an expression of sensation, devoid of associative symbolism, and in 1896 George Santayana stated, "Science . . . in it we ask for . . . nothing but the truth. Art is the response to the demand for entertainment, for the stimulation of our senses and imagination, and truth enters into it only as it subserves these ends!"[86]

Scientific progress had resulted in new pigments, and artists of the 1890s were affected, as Church had been in his Twilight scenes:

Their pictures became brighter as hue replaced tone as the principal means of representing light and atmosphere on canvas. They supplanted theoretical knowledge with optical experience . . . and substituted that "fleeting moment" in time and fragments of continuous space, signifying movement. Hence, the changing elements, [and] the representation of an overall light and atmosphere became their common concern.[87]

A realist in the tradition of Eastman Johnson (1824–1906) and Winslow Homer before his visit with Claude Monet at Giverny in 1887, Theodore Robinson (1852–1896) worked most consistently in an impressionistic style with its varie-

17. Winslow Homer (1836–1910): *Northeaster*. 1895. Oil on canvas, 34⅜" x 50¼". After his move to Prout's Neck, Maine, Homer concentrated exclusively on painting the sea. Meticulous in his observation, Homer worked directly from nature; his expressive talents were matched only by the vigorous sea before him. Projecting a subjective meaning onto his surroundings, he touches on momentary and universal themes, anticipating in his use of pure form the stylistic achievements of several twentieth-century artists. In many respects the overall impression is very reminiscent of Willem de Kooning who also found inspiration in the sea: "The sea . . . is a perfect 'medium' for the abstract all-over look . . . [it] destroys the boundaries that inhibit the field and its flow, and . . . seems to release us into the unconscious, and becomes itself emblematic of the dynamics of that unconscious."[5] (*The Metropolitan Museum of Art; Gift of George A. Hearn, 1910*)

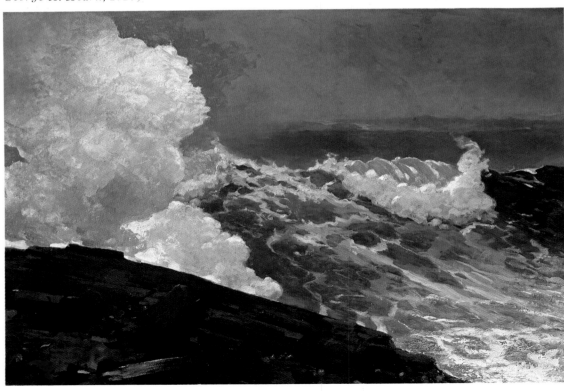

gated color and spontaneous brushwork. But he also exemplified the American inability to dissolve the object totally in light and atmosphere. His respect for precise draftsmanship and a desire to preserve the basic integrity of the object were distinctly American qualities, which prevented a total abstraction and an inability to assimilate the French style fully.[88] Julian Alden Weir (1852–1919) painted with Robinson and Twachtman during the late 1880s and the 1890s and was also a member of "The Ten," a group of American Impressionists. His landscapes were carefully designed with a receding diagonal perspective that, while imposing structural restrictions, enhanced the effect of a scene. His *Red Bridge* (1895, see pl. 143) is a striking reminder of the reality of industrialization in our everyday lives, yet its natural opulence creates a romantic metaphor that is optimistic, enjoyable, and visually exciting. The picture also provides an interesting complement to the less energetic, more pastoral view of *Port Ben, Delaware and Hudson Canal* (1893, see pl. 141), painted by Robinson.

Childe Hassam (1859–1935) was clearly the most dynamic member of The Ten and perhaps not unexpectedly, his style represents the synthesis of several aesthetic strains. His shimmering surface brilliantly expresses the sunlight as it undulates across *Bridge at Old Lyme* (1908, see pl. 146), appreciating nature for its visual stimulation alone. Acknowledging his debt to Monet, Hassam carefully fuses all aspects of his composition through his strokes of applied color. However, while the final result is not totally realistic, Hassam maintains a poetic intimacy with his surroundings that derives from an earlier landscape spirit. Hassam's works were quintessentially "native," devoid of overt spirituality, yet they were timeless views that captured the essence of the American countryside. They were meant only to be enjoyed by the spectator, and therein lies their basic difference from the spirit that guided the Hudson River painters.

Impressionism provided an opportunity that was sensitively pursued by John

H. Twachtman (1853–1902). His winter landscapes (see pl. 18) were unique in their subtle variations of color, their scintillating surface effect, and their profound introspection. A critic once described them as "fragile dreams in color," and in many respects their poetic abstraction parallels the very different approach of Ryder. Like Ryder, Twachtman lived in isolation from society and was not easily understood. Although his work is valued highly today, in 1901 he said, "Do you know, that I have exhibited eighty-five pictures this year and have not sold one?"[89] Twachtman died the following year, but in retrospect, he occupied an important place in our landscape tradition. Specifically, his paintings revealed an individual who found in nature a source of contemplative retreat, a solitude, and an isolation from humanity, which in the next century would revitalize the romantic spirit and the active pantheism that once existed in our landscape tradition. Finally, William Merritt Chase (1849–1916) is distinguished by his ability to express the warmth of sunlight as it pervades his plein-air landscapes of Shinnecock Hills (see pl. 19), Long Island. However, in spite of his brilliant contributions to our interpretation of Impressionism, Chase's significance rests ultimately on his important role as a teacher of Edward Hopper (1882–1967), Marsden Hartley (1877–1943), Charles Demuth (1883–1935), Charles Sheeler (1883–1965), Georgia O'Keeffe (b. 1887), and other key talents.

Mystics

During the closing decades of the nineteenth century several individuals, including Albert Pinkham Ryder (1847–1917) and Ralph Blakelock (1847–1919), operated outside of the mainstream of American art. Ryder transformed his art into a series of romantic images that bordered on abstraction yet were seductively poetic in their lyricism. He was one of those talents who had a small contemporary following, yet late in life provided a strong influence to a younger generation of artists.[90] Ryder visualizes his inner sentiments and synthesizes them, as Homer did, into solid masses of color and

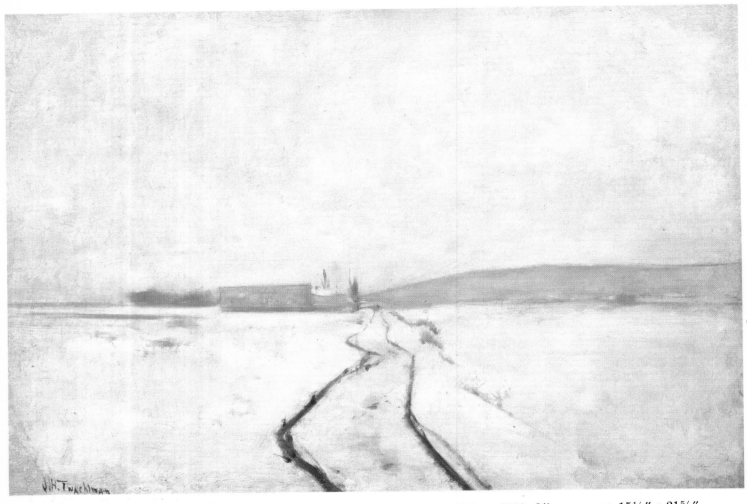

18. John Henry Twachtman (1853–1902): *Along the River.* 1889. Oil on canvas, 15⅛″ x 21⅝″. Twachtman is consistently among the first Americans to be identified with French Impressionism. A short time after his return to this country in the mid-1880s, he purchased in 1889 a farm near Greenwich, Connecticut. Behind the house at the bottom of a steep hill was part of Horseneck or Blue Brook (flowed southward from Putnam Lake through Round Hill to Greenwich Harbor), which wound through Twachtman's rocky land over natural waterfalls to a large basin named Hemlock Pool. Paralleling James Abbott McNeill Whistler's nocturnes, Twachtman's snow scenes of this location are carefully harmonized color studies that are almost exclusively design oriented, resulting in a mysterious and poetic imagery. Like Monet, Twachtman frequently returned to the same subject, painting it under varying weather conditions. However, instead of depicting the reality of the scene, he increasingly chose to depict elements of design and mood. Late in life, the "sketchlike" quality—equated to spontaneity—of his work increased to a point that compositional detail was all but eliminated. (*The High Museum of Art; J. J. Haverty Collection*)

19. William Merritt Chase (1849–1916): *The Bayberry Bush (The Big Bayberry Bush, Chase Homestead: Shinnecock Hills).* 1895. Oil on canvas, 25½″ x 33⅛″. Like James Abbott McNeill Whistler, Chase was an important personality in American art and culture, a brilliant virtuoso who championed Impressionism in this country. In 1891 he established the Art Village, an art school at Shinnecock Hills, Long Island, that was the first to teach painting out-of-doors. The summer classes continued until 1902. Sunlight was his expressive vehicle, the life of his paintings. In contrast to Hudson River landscapes Chase's paintings lack a sense of place; rather, they concentrate on the time of day and the effect of light and color.

This painting is characteristic of his 1890s outdoor scenes, where he focuses on children playing on the beaches or dunes on Long Island. As observed by Katherine Metcalf Roof, "No one has appreciated as he has the value of the small decisive human note in relation to large spaces of sea and earth and sky, the significant accent of that small spot of red or blue or black. The 'spot' was usually one of his decorative children."[6] (*The Parrish Art Museum; Littlejohn Collection*)

form, ignoring time, place, and event in preference for the emotive drama of his abstract forms, anticipating mid-twentieth-century expressionism. To Ryder painting was a projection of his own existence: "The artist should fear to become the slave of detail. . . . What avails a storm cloud accurate in form and color if the storm is not therein?"[91] Ryder's retreat from external reality was shared by Ralph Blakelock. Blakelock's early work was close to the late Hudson River style of Cropsey, but like Inness, he gradually began to respond to the emerging Barbizon influence. His mature works were contemplative landscapes, products of his imagination, sensuously animated by a rich impasto and warmly inviting in their glowing tonal contrasts. Like Ryder Blakelock was propelled by an inner vision at once poetic and tragic, poignantly reflecting the uncertainties of his age. At the same time he was deeply involved with the process of painting rather than with creating a convincing representation of reality typical of early American landscapes. Artists were freed from literal description and moralizing as nature became a vehicle for visualizing their inner feelings.

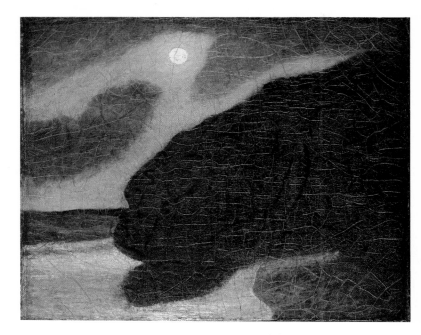

20. Albert Pinkham Ryder (1847–1917): *Moonlit Cove.* 1890s. Oil on canvas, 14″ x 17″. Ryder represents a decisive transition from a landscape tradition that advocated truth to nature to one that viewed nature as a communicative vehicle for subjective expression of universal sentiments. With detail all but eliminated, Ryder utilizes rhythmic patterns of color and masses of form to create a pictorial vision of nature's dynamic forces. Evocative of inner moods rather than reflecting observed reality, Ryder's paintings greatly influenced the development of modern expressionism. Thoroughly romantic, Ryder summed up his attitude, "The artist should fear to become the slave of detail. He should strive to express his thought and not the surface of [things]. What avails a storm-cloud accurate in form and detail if the storm is not therein?"[7] (*The Phillips Collection*)

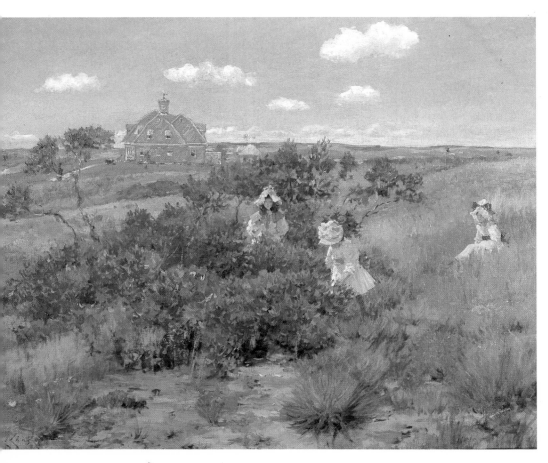

The Twentieth Century: New Directions

The search for truth that dominated the nineteenth-century landscape tradition continued into this century, but drastically altered perspectives required a more contemporary imagery. The extensive industrialization as well as the unprecedented economic and population growth since 1890 resulted in an urban rather than a rural emphasis.[92] These substantial turn-of-the-century changes propelled a search to express artistically a new image of "nature" that was less pragmatic and more universal in meaning. An initial step in this transition to modernism was represented by a group of artists called "The Eight," who jointly exhibited their works in 1908—the same year that Alfred Stieglitz (1864–1946) first featured Rodin and Matisse in his New York gallery.

The philosophy of The Eight was predicated on artistic individuality, qualified only by Thomas Anshutz's (1851–1912) dictum that subject matter should reflect the commonplace. Robert Henri (1865–1925), considered the leader of the group, expressed this attitude: "And so it seems that the basis of future American art lies in our artist's appreciation of the value of the human quality all about them, which is no thing more or less than seeing the truth and expressing it according to their individual understanding of it."[93] At the same time that this group embraced traditional forms, it advocated a revolution of subject matter, emphasizing the unconventional aspects of urban life. Also, Henri was profoundly interested in a painting's final effect, advocating speedy execution and summary treatment of details. Thus, a more generalized if not an altogether universal expression was being sought. The social revolution of The Eight prevailed until 1913 when the Armory Show opened at the Sixty-ninth Regiment Armory on Lexington Avenue in New York City. The ensuing controversy created a widespread public consciousness of modern art, accelerating its acceptance in America.

A member of The Eight, Arthur Bowen Davies (1862–1928) became a leading proponent of modernism through his organization of the Armory Show. Yet curiously, his art represents a visionary retreat from reality, which explains his preference for Ryder over Homer or Eakins in this exhibit. Paralleling Davies's support of modernism was Alfred Stieglitz. Through his various publications, such as *Camera Notes* and *Camera Work*, Stieglitz reinstated photography as an influential force on American art. And through exhibitions between 1905 and 1917 at his gallery at 291 Fifth Avenue, Stieglitz sponsored many young American and European artists, including Marsden Hartley, Max Weber, Arthur G. Dove, Georgia O'Keeffe, Henri Matisse, Pablo Picasso, Auguste Rodin, and Paul Cézanne. Stieglitz's fascination with his environment was similar to

21. John Marin (1870–1953) : *The Red Sun—Brooklyn Bridge*. 1922. Watercolor, 21½″ x 27¼″. Once Marin described his purpose accordingly: "If these buildings move me they too must have life. Thus the whole city is alive; buildings, people, all are alive; and the more they move me the more I feel them to be alive. . . . I see great forces at work; great movements; . . . influences of one mass on another greater or smaller mass. Feelings are aroused which give me the desire to express the reaction of these pull forces . . . While these powers are at work . . . there is great music being played. And so I try to express graphically what a great city is doing."[8] As did Thomas Cole, Marin used compositional devices as the frame within a frame to increase the pictorial tension or suggestion of movement. (*The Art Institute of Chicago; The Alfred Stieglitz Collection*)

Henri's, as he constantly urged artists to express subjective feelings and not aesthetic theories. But, unlike Henri, he viewed the process of artistic creation as an end in itself.[94] And, he constantly emphasized both a heightened awareness of design patterns and the interrelationships among forms in space. Increasingly, we detect nature and its painted image as an expression of universal sentiments rather than nineteenth-century concepts of pantheism or nationalism.

While modernism championed American interpretations of French Cubism, which was pursued by many artists, qualities of nineteenth-century pantheism did manage to linger on. This can be found in the work of John Marin (1870–1953), who became in 1909 an important member of the Stieglitz circle. In many respects Homer's emotional and all-consuming interest in the sea at the expense of design anticipates Marin's energetic works. His Maine watercolors (see pl. 159) were powerful, pulsating with a fragmented energy and "an excitement at being *in* nature" that recalls Ryder.[95] His scenes were usually contained by a framing device of vigorous lines, yet the force that the scene reflects, both of a physical and a psychological nature, seems on the verge of overcoming the imposed limitation. But Marin was a product of this century and shared a prevailing fascination with the architecture of the city. In the cityscape, Marin found an organic and inspirational power that equaled what Durand and Inness had sought in the landscape (see pl. 21).

Largely because of Stieglitz and the examining eye of Paul Strand, Georgia O'Keeffe (b. 1887) by the mid-1920s was producing stunning closeup views of nature's varied details. These sharply focused views clearly recall the foreground details of many Pre-Raphaelite landscapes. In a defensive tone reminiscent of Cole's 1835 "Essay on American Scenery" and Durand's 1855 "Letters on Landscape Painting," O'Keeffe in 1939 justified her subject selection accordingly.

> A flower is relatively small. . . . Everyone has many associations with a flower —the idea of flowers. . . . Still—in a way—nobody sees a flower—really—it's so small—we haven't time—and to see takes time like to have a friend takes

22. Georgia O'Keeffe (b. 1887) : *White Calico Flower*. 1931. Oil on canvas, 30″ x 36″. O'Keeffe has been persistent in using nature as the source of her imagery, continuing to create new insights as in Oriental art where a similar theme appears again and again with new beauty. A student of the unorthodox Arthur Dow, O'Keeffe was strongly influenced by his design emphasis and rejection of realism for simplicity and flat patterns. Soon after her 1924 marriage to Alfred Stieglitz, O'Keeffe began a sensitive series of flower close-ups that recall the extreme detail of Pre-Raphaelite landscapes. O'Keeffe stated, 'I'll tell you how I happened to make the blown up flowers. In the twenties, huge buildings sometimes seemed to be going up overnight in New York. At that time, I saw a painting by Fantin-Latour, a still-life with flowers I found very beautiful, but I realized were I to paint the same flowers so small, no one would look at them because I was unknown. So I thought I'll make them like the huge buildings going up. People will be startled, they'll have to look at them—and they did."[9] Since 1945 she has lived in an adobe house in Abiquiu, New Mexico, continuing her fascination with the surrounding brilliant landscape, capturing its sense of solitude, beauty, and spiritualism. (*Whitney Museum of American Art*)

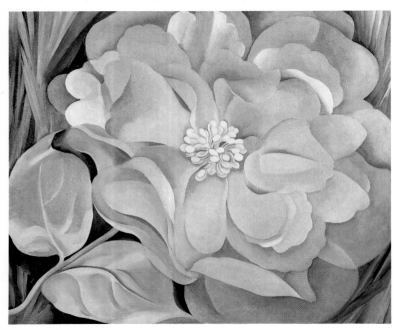

time. If I could paint the flower exactly as I see it no one would see what I see because I would paint it small like the flower is small. So I said to myself—I'll paint what I see—what the flower is to me but I'll paint it big and they will be surprised into taking time to look at it —I will make even busy New Yorkers take time to see what I see of flowers.[96]

Charles Sheeler (1883–1965) brought sharp detail and photographic illusion to fruition in a style termed *precisionism*. An admirer of Shaker furniture and an avid photographer, Sheeler carried an ongoing interest in harmonizing art and science to a new expressive level in *American Landscape* (1930, see pl. 23). About this work, Leo Marx has stated,

> On closer inspection, we observe that Sheeler has eliminated all evidence of the frenzied movement and clamor we associate with the industrial scene. The silence is awesome. The function of the ladder (an archaic implement) is not revealed; it points nowhere. Only the miniscule human figure, the smoke, and the slight ripples on the water suggest motion. And the very faintness of these signs of life intensifies the eerie, static, surrealist quality of the painting. This "American Landscape" is the industrial landscape pastoralized.[97]

Within *American Landscape* Sheeler created a contemporary statement enshrining American industry in a tradition that dates back to Cole. Individual components of Sheeler's composition are isolated and treated with an unprecedented precision and formal clarity. The comparison to the photograph is unmistakable, yet our awareness of reality is substantially heightened by the dramatic and inspiring structures. Sheeler's role in developing a new vocabulary of the American Scene was summarized as follows : "The detached clarity and organic unity of parts came out of the earlier artistic traditions of American luminism, neo-classicism, and trompe l'oeil still life. Sheeler is the worthy heir of Lane . . . no less the forebear of the realist movement of the 1930s and 1960s."[98]

As a movement, the American Scene

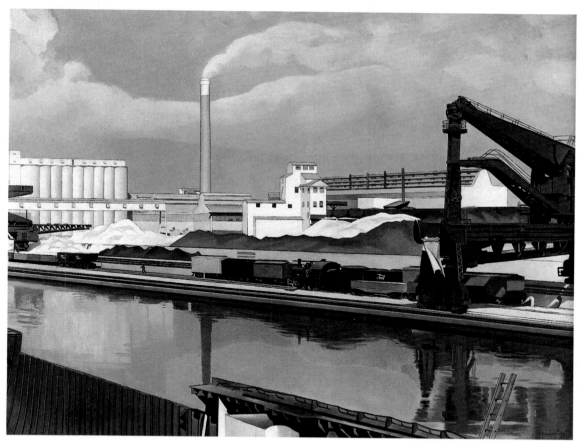

23. Charles Sheeler (1883–1965): *American Landscape.* 1930. Oil on canvas, 24″ x 31″. A student of William Merritt Chase, Sheeler was more heavily influenced by his 1909 trip to Paris, where Picasso and Braque were making art history with their cubist experiments. Especially fascinated with Georges Braque's L'Estaque landscapes of 1908, Sheeler transferred his perception of objects as a "series of planes, curves and internal directions" to the landscapes around Doylestown, Pennsylvania, where he shared a house with the painter Morton Schamberg. Increasingly, his work showed an insistence on simplification and photographic clarity. He moved close to an object, selecting one part of a larger unit and by emphasizing an unusual angle and lighting, he created a new impression of the whole unit—a seemingly abstract composition. The Ford River Rouge Plant (Michigan) commission resulted in a series of photographs and paintings that mark an important change in his style; Sheeler gradually lost the distinction between painting and photography and moved toward a literal transcription of reality. *American Landscape* is characteristic of the style that established his leadership among the precisionist painters of the American Scene. Among the most appreciated artists of his generation, Sheeler made a significant contribution to American landscape paintings by adapting "native traditions to the structural characteristics of European modernism." (*Collection, The Museum of Modern Art, New York; Gift of Abby Aldrich Rockefeller*)

is not easily defined.[99] Technically, it encompasses all the works of art that reflect this native environment, although in 1933 it was adopted as the theme of the government recuperative program initiated in the wake of the Great Depression. The program by 1935 reflected a widespread belief in the crucial role art could play in contemporary society. As such, this effort paralleled those of nineteenth-century artists in enhancing the spirit of national solidarity. Regionalism was a phenomenon of the 1920s and the early 1930s, a period of profound transition and crisis in this country. Although the complexity of these years discourages generalizations, the prevailing mood was decidedly one of mission. This concept prompted a popular interest in the nature of our society and its adaptability to the changing times. Precipitated by the disillusionment of World War I and its shattering of Wilsonian idealism, a revival of Americanism swept the country. Americans looked to the past with an earnest hope of understanding and rationalizing the present. At this same time the quest for security in a rapidly changing society

sought to stress qualities of continuity and vitality.

Landscapes as a symbol of national vitality provided justification for the existence of much of nineteenth-century landscape painting. Similarly, the writings of the 1920s reflect the belief that art and culture function best when they reflect our native heritage and emphasize the traditional values that exemplified past achievements. John Steuart Curry (1897–1946) and Grant Wood (1892–1942) were among the first distinguished painters of the twentieth century who conveyed a strong impression of the America west of the Hudson River. Their images, as well as those of others such as Marvin D. Cone (1891–1965), were optimistic, clearly seeking to emphasize what is good about American culture and society. Primordial nature captivated Wood, who on one occasion

stated, "The naked earth in its massive contours asserts itself through anything that is laid upon it."[100] His statement elucidates an important and enduring aspect of this country's view of nature: the individual's character is closely identified with the environment. Once again, as in the nineteenth century, we encounter a mythic image of America as a fertile land inhabited by heroic people.

Even as the theme of the American Scene was being promoted by an active press, the cause of a modern art was being advanced by this country's international posture and the influx of European painters, disturbed at the events leading up to World War II. Among the many European artists making their way to New York were Arshile Gorky (1904–1948), Hans Hofmann (1880–1966), Mark Rothko (1903–1970), and Willem de Kooning (b. 1904)—all of whom formulated the basic language of a decisive movement of modern art—Abstract Expressionism.[101]

It is evident on viewing these works that qualities of the sublime or of transcendence were by no means restricted to the nineteenth century. Indeed, nature remains the subject of these scenes, though in a very tangential way. Through forms and earthy colors these individuals created what one critic describes as a "moody atmosphere that was linked to nature yet free of the limits posed by recognizable objects."[102] Or, as Mark Rothko himself stated, "The progression of a painter's work, as it travels in time from point to point, will be toward clarity; toward the elimination of all obstacles between the painter and the idea, and between the idea and the observer."[103] In discussing the myriad associations between Abstract Expressionism and nineteenth-century luminism, John Wilmerding recently concluded that

Luminism is the culmination of the country's first nationalist expression in painting, the Hudson River School, while Abstract Expressionism towers as a central development of twentieth-century art, continuing to possess vital influence today. In their consciousness of the spiritual as well as physical presence of the country's landscape, their celebration of an expansive continental and pic-

24. Grant Wood (1892–1942): *Stone City, Iowa*. 1930. Oil on panel, 30¼″ x 40″. Along with Thomas Hart Benton and John Steuart Curry, Grant Wood was considered a leading regionalist of the 1930s. Working primarily in his native Iowa, Wood embraced the tradition of American Scene painting that had prospered during the nineteenth century. Accompanied by Marvin Cone, he traveled to Europe in 1928 where he was especially fascinated by the meticulous Flemish and German paintings seen in Munich. Returning to Cedar Rapids, he applied comparable care in viewing the surrounding landscape and people, painting in 1930 both *American Gothic* and *Stone City, Iowa*. Located near Cedar Rapids, Stone City was in Wood's youth an active quarrying center, now quiet and barely visible. Here, serenity prevails to the point of being disturbing, as if to return the viewer's attention to the prevailing economic turmoil. In both color and compositional format Wood painted the scene as a sixteenth-century northern landscape, creating a scene that combined precise observation and pure design. (*Joslyn Art Museum*)

torial scale, their evocation of both personal and national energies, the two movements present telling distillations of the American character. . . . Americans of both centuries adopted a strongly contemplative and spiritual, occasionally even religious, attitude toward their landscape.[104]

The spiritual associations of nature were during this century eloquently treated in the evocative watercolors (see pl. 26) of Charles Burchfield (1893–1967).[105] From his surroundings Burchfield sought an expression of the "beneficent God-in-nature," a phrase frequently found in his journals. Among his works we find numerous scenes of primeval nature, which suggests that Burchfield recaptured a spirit of viewing nature that had inspired the landscapists of the previous century. Despite the time difference Burchfield and his nineteenth-century counterparts sought a spirituality derived from nature that was unique to themselves. A similar elusiveness charac-

terizes the sun-filled landscapes of Edward Hopper (1882–1967). Ultimately their image of contemplative solitude in nature retains a validity and importance equivalent to Durand's *Landscape-Scene from "Thanatopsis"* (1850, see pl. 64) and Cole's *Voyage of Life* series (1839–1840, see pl. 54).

Burchfield pursued this vision of nature for the duration of his life, becoming increasingly absorbed in further probings of the secrets of life, nature, and the world of the spirit. His works were a visual representation of his inner feelings, attempting, as stated by William Cullen Bryant, "a sincere communication of his moral and intellectual being." At the same time that he consciously sought an exposition of primeval nature, he provided a rich memoir of his personal search for God in our environment. Wolfgang Born completed his pioneering study *American Landscape Painting* (1948) with the following statement: "There is, however, enough

25. Jackson Pollock (1912–1956): *Autumn Rhythm (November 30, 1950)*. 1950. Oil and enamel on canvas, 106″ x 207″. Establishing a direct link to romanticism, Pollock once stated his belief that Ryder was the only American painter who interested him. This emphasis on individual emotion was conveyed to his method of painting. He stated in 1947, "My painting does not come from the easel . . . I prefer . . . the hard wall or the floor. . . . I feel nearer, more a part of the painting, since this way I can walk around it, work from the four sides and literally be *in* the painting. This is akin to the method of the Indian sand painters of the West. . . . When I am *in* my painting, I'm not aware of what I'm doing. It is only after a sort of 'get acquainted' period that I see what I have been about. I have no fears about making changes, destroying the image, etc., because the painting has a life of its own. I try to let it come through. It is only when I lose contact with the painting that the result is a mess. Otherwise there is pure harmony, an easy give and take, and the painting comes out well."[10] (*The Metropolitan Museum of Art; George A. Hearn Fund, 1957*)

26. Charles E. Burchfield (1893–1967): *Autumnal Fantasy*. 1917–1944. Watercolor on paper, 37″ x 52½″. A poet and naturalist, Burchfield was inspired by the splendor and mysteries of nature, finding in these wonders an expression of the presence of God. By creating an individualized romanticization of solitude in nature, Burchfield provides a vital link between the nineteenth and twentieth centuries, especially in terms of his place in the evolution of a pantheist tradition and a unique American iconography. His works were visual representations of his inner feelings, attempting, as stated by William Cullen Bryant, "a sincere communication of his own moral and intellectual being." At the same time that he consciously sought an exposition of primeval nature, he provided a vision of his elemental self before being influenced by external artistic movements. Thus, Burchfield has created a striking definition of nature, its sublimity, and its relationship to his own character. (*Private collection; photograph courtesy Kennedy Galleries, Inc.*)

of the timeless America left that delighted the Hudson River men and the painters of the American expansion. It patiently waits for the truly modern American landscape painter to approach it in a spirit that is authentic and at the same time universal."[106] As is the case with the Abstract Expressionists, Charles Burchfield in many respects provided an answer to Born's statement, indicating the enduring qualities that characterize our landscape tradition.

Conclusion

The question what are the precise qualities that characterize our art and especially our landscape tradition inevitably arises. Although an all-encompassing answer has not been found, Lloyd Goodrich, in his searching essay "What Is American in American Art," comes closest. "There are many diverse qualities that can be called characteristically American; for ours is a pluralist art, the expression of a democratic society, giving free rein to wide individualism in artistic creation."[107] Indeed, this quality of individualism was the most commented-upon element in our society and the hallmark that distinguished our landscape achievement.

Throughout its history, American landscape painting has fallen into phases, its changes in style and function reflecting the subjective interests of the contemporary society. The painted landscape is an integral part of our cultural past. It is symbolically inspirational and has been a proven vehicle for cultural cohesiveness. At the same time artists such as Cole, Durand, and others transcended the imposed limitations of European aesthet-ics and arrived at a visual statement previously unencountered by responding to realities of our geography and the realization that sublimity existed in the American commonplace. The landscape tradition was largely a nineteenth-century phenomenon. However, its spirit is organic and Born's comments poignantly remind us our national consciousness is firmly attuned to the future.

Thus, as we have seen, the American landscapists have created a striking definition of nature, its sublimity, and its relationship to their own character. Our native environment enabled many artists to arrive at certain truths. Clearly, there were the innovators, who proposed new aesthetic formats that inspired others. But what the landscapists shared most profoundly was the search for a visual definition of America, a search that inaugurated a new phase of our continuing intimacy with our surroundings. Ultimately, the landscape paintings exemplify the persistence of native themes and values, and they are a rich memoir of individual expressions in the ongoing quest for a valid American aesthetic.

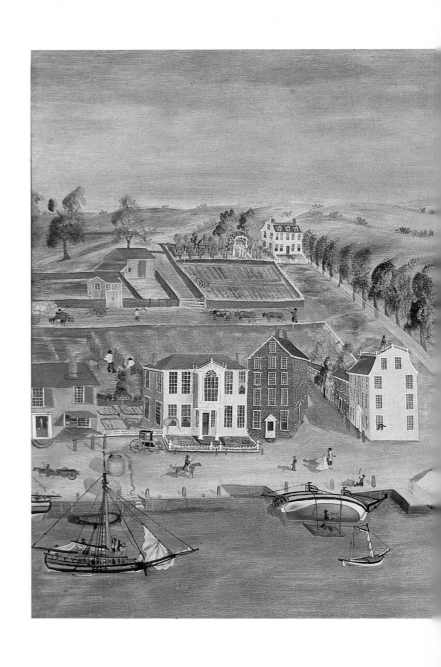

27. Jonathan Budington (active 1792–1812): *View of the Cannon House and Wharf*. 1792. Oil on wood panel, 44″ x 80″. Budington was listed in the New York City directories from 1800 to 1805 and again from 1809 to 1812. He was also active in Connecticut, where he probably painted four portraits that bear his signature. This picture was probably painted for John Cannon (b. 1725), son of Captain John Cannon, Jr. (1703–1761), who was one of the most prominent merchants in New York and who owned Cannon Wharf in lower Manhattan. Although traditionally described in the Cannon family as a view of John Cannon, Jr.'s, house and wharf in New York, the painting was actually executed after the elder Cannon's death and probably represents the home and fleet of his son. The picture is one of the most important American views of the eighteenth century. (*Richard Dietrich; photograph courtesy Hirschl & Adler Galleries, Inc.*)

28. William Winstanley (active 1792–1806): *Evening on the Hudson River.* c. 1792–1793. Oil on canvas, 35½″ x 59″. An early landscape enthusiast since 1757, George Washington purchased this and another painting in April 1793 for thirty guineas. Although Winstanley's landscapes did not reflect wild American scenery, Washington remained a fond admirer of his canvases, purchasing several others in the next year. (*Mount Vernon Ladies' Association of the Union*)

29. Ralph Earl (1751–1801): *Looking East from Denny Hill, near Leicester, Massachusetts.* 1800. Oil on canvas, 45¾″ x 79⅜″. A sympathetic Loyalist, Earl deserted his wife and children in 1778 and departed for England. He remained there for seven years and received instruction from several leading painters, including Benjamin West. Although primarily a portraitist, Earl painted several New England landscapes in which he continued his preoccupation with carefully rendered details. (*Worcester Art Museum; Purchase*)

30. William Groombridge (1748–1811): *Fairmount, Schuylkill River.* 1800. Oil on canvas, 24″ x 36″. Born in England, Groombridge arrived in Philadelphia in 1794. He already possessed a fully developed style derived from an eighteenth-century picturesque tradition—decorative autumnal scenes, sunsets, winding rivers, and other scenes. (*Historical Society of Pennsylvania*)

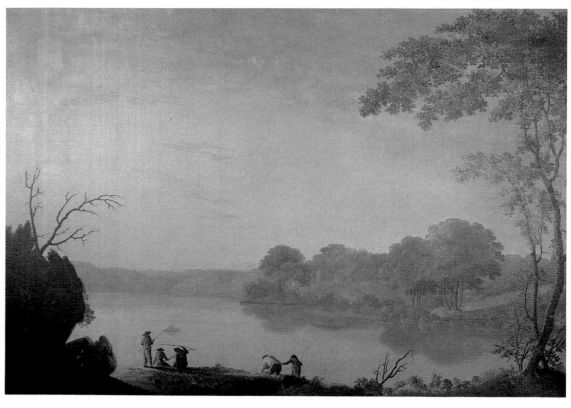

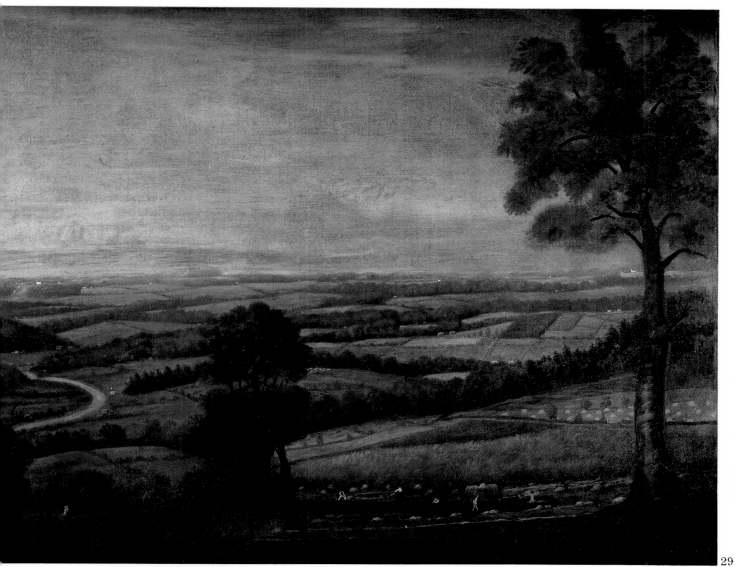

29

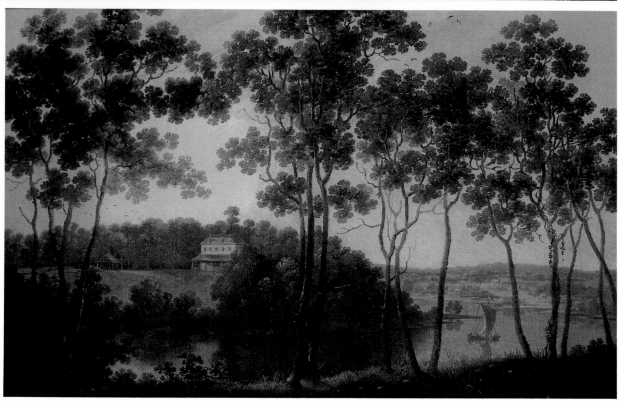

30

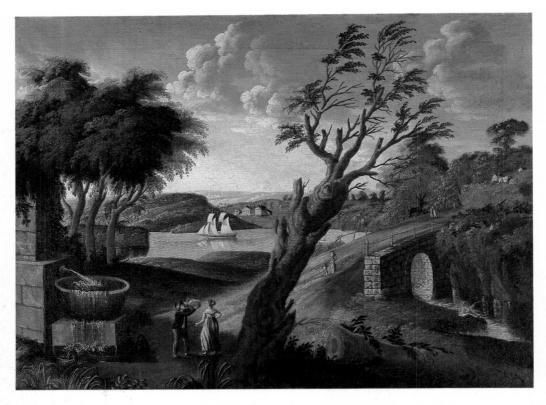

31. Michele Felice Cornè (1752–1832): *Romantic Landscape and Figure.* c. 1804. Oil on canvas, 30¾" x 40½". Cornè was one of many immigrating artists who arrived during the 1790s, attracted by the atmosphere of peace and opportunity in this country. He came from the island of Elba and settled in Salem, Massachusetts. *(Kennedy Galleries, Inc.)*

32. Attributed to Jared Jessup: Overmantel from Burk Tavern. c. 1812. Oil on board, 46½" x 76½". Painted at Burk Tavern, Bernardston, Massachusetts. The Burk Tavern was kept by Major John Burk as early as 1763. The painting depicts a view of Boston harbor and is believed to have been painted by Jessup, a guest of the tavern, who was afterward arrested as a British spy. The large hole in the center of the overmantel was made to accommodate the pipe from a heating stove in the nineteenth century. *(Memorial Hall Museum, Pocumtuck Valley Memorial Association, Deerfield)*

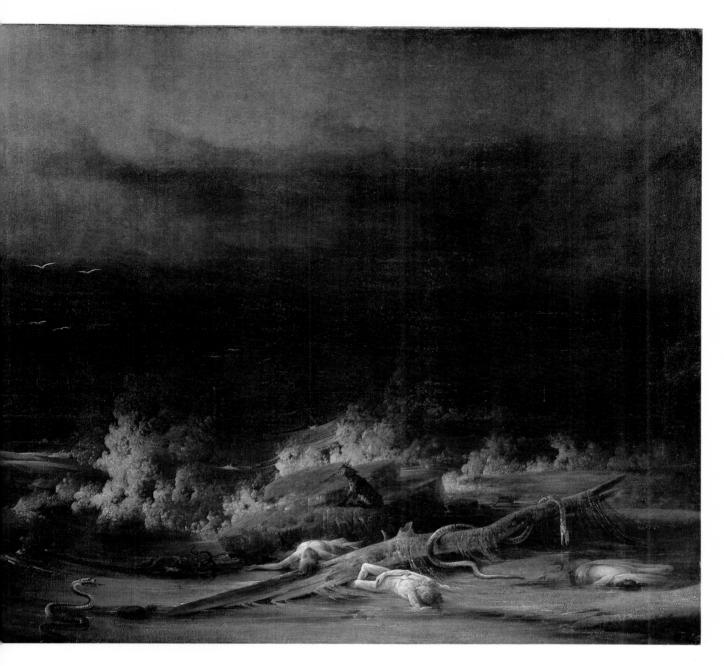

33. Joshua Shaw (c. 1777–1860): *The Deluge*. c. 1813. Oil on canvas, 48¼″ x 66″. Long considered to be a work by Allston, *The Deluge* relates the biblical story of Noah (Gen. 7:21–22): "And all flesh died that moved upon the earth, . . . and every man: everything on the dry land in whose nostrils was the breath of life died." Inspired by Baroque precedents, Shaw's painting possesses all the requisite qualities of Sir Edmund Burke's concept of the sublime: dramatic contrast of light and dark, terror, wilderness, desolation, destruction, and vastness. (*The Metropolitan Museum of Art; Gift of William Merritt Chase, 1909*)

34. Washington Allston: *Moonlit Landscape*. 1819. Oil on wood panel, 24″ x 35″. *Moonlit Landscape* was painted soon after Allston made his final return from Europe, homesick and beset with financial difficulties. Concentrating on color and light, it anticipates the atmospheric paintings of mid-century luminism. Ironically, while Allston's subsequent work suffered due to this country's limited artistic activity, his presence in the new nation provided a strong encouragement to young artists and the development of a romantic tradition in our art. (*Museum of Fine Arts, Boston; Gift of Dr. W. S. Bigelow*)

35. Edward Hicks (1780–1849): *The Falls of Niagara*. 1825. Oil on wood panel, 31½″ x 38″. A so-called primitive painter, Hicks was one of several early nineteenth-century painters who provided rural areas with works of art. Possessing an original sense of color and design, Hicks achieved considerable success as an artist. However, at the time of his death he was remembered as the most popular preacher of the Society of Friends. Although Hicks visited Niagara in 1819, it has been suggested that he was more influenced by John Vanderlyn's painting of the same subject. Around this view of the falls, Hicks painted eight lines from ornithologist Alexander Wilson's narrative poem "The Foresters." This poem appeared as a serial in the Philadelphia periodical *The Port Folio* between June 1809 and March 1810. (*The Metropolitan Museum of Art; Gift of Edgar William and Bernice Chrysler Garbisch, 1962*)

where'er the astonished eye

old, new opening wonders lie,

This great o'erwhelming work of awful Time

In all its dread magnificence sublime,

ur view, amid a crashing roar

us kneel, and Time's great God adore.

36

38

36. Unidentified artist: *Memorial to Perez, Mabel, and Rebecka White.* 1810–1825. Watercolor on paper, 18″ x 22¼″. In the early nineteenth century well-to-do families sent their daughters to local "seminaries" to become accomplished in music, needlework, and painting. One of the most fashionable forms of painting learned at these finishing schools was creating memorials for the members of one's family to hang in the front parlor. In this excellent example of this type of American folk art the requisite symbols of weeping willows, a tomb with neoclassic urns, and mourners have been skillfully rendered; yet the breadth of the view that includes various trees and plants, a lake, and distant mountains makes one suspect that the young artist was chiefly interested in exhibiting her skill in painting a landscape, imaginary though it probably was. *(Private collection; photograph courtesy George E. Schoellkopf Gallery)*

37

37. Emmeline Dildine (1814–1838): *White House with Picket Fence.* c. 1830. Watercolor on paper, 17″ x 23½″. The creator of this charming landscape with a house portrait and fisherman lived in Harmony Vale, New Jersey, and she undoubtedly did this painting while attending the Reverend Edward Allen's school there. *(George E. Schoellkopf Gallery)*

38. Alvan Fisher (1792–1863): *A General View of the Falls of Niagara.* 1820. Oil on canvas, 34⅜″ x 48⅛″. A popular and prolific artist, Fisher's notebooks indicate sales of over 1,000 canvases between 1826 and 1863. Except for a brief time from 1822 to 1826, he maintained a Boston studio throughout his life. An early pioneer of American landscape painting, he is particularly noted for his ambitious views of Niagara Falls, which he first visited in 1818. *(National Museum of American Art, Smithsonian Institution; Purchase)*

39

41

39. Thomas Birch (1779–1851): *Fairmount Water Works.* 1821. Oil on canvas, 20¼″ x 30¼″. Son of the distinguished engraver William Birch, Thomas arrived in America with his father in 1794. Trained in a topographic landscape tradition by his father, Thomas collaborated with him on the 1799–1800 publication of a set of engravings, *Views of Philadelphia.* Although he relied heavily on compositional formulas, Birch achieved considerable recognition as a landscape, marine, and historical painter. (*Pennsylvania Academy of the Fine Arts; Charles Graff Estate Bequest*)

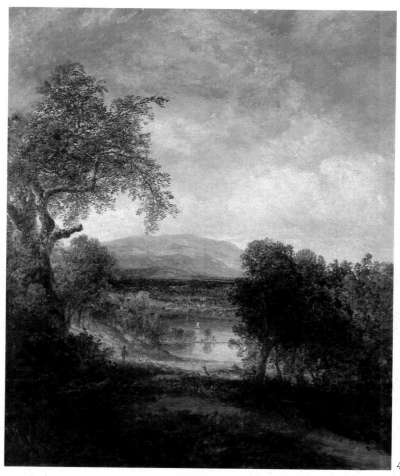

40

40. Thomas Doughty (1793–1856): *A River Glimpse.* c. 1820–1821. Oil on canvas, 30¼″ x 25″. Although apprenticed as a leather currier, Doughty, motivated by a love of nature, devoted himself exclusively to landscape painting in 1820. Although *A River Glimpse* represents a composite view of landscape elements, it retains a distinctive American feeling. Through the use of a diffuse, silvery light and delicate colors, Doughty succeeds in transforming the commonplace of an unidentified river view into an inspiring monument to American nature. (*The Metropolitan Museum of Art; Gift of Samuel P. Avery, 1895*)

41. Jonathan Fisher (1768–1847): *A Morning View of Blue Hill Village.* c. 1824. Oil on canvas, 25⅝″ x 52¼″. Like the Pennsylvania Quaker Edward Hicks, Fisher was a minister who combined interests in art, natural science, and religion. In addition to landscape views, he painted scenes of birds and individual flowers. Blue Hill, Maine, was his home. (*William A. Farnsworth Library and Art Museum*)

42. Unidentified artist: *The Plantation.* c. 1825. Oil on wood, 19⅛″ x 29½″. Reminiscent of needlework, this portrait of a place is entirely concerned with patterns of design, constructed to direct attention to the Palladian home atop the hill. For the folk artist, portraits of estates, ships, or noteworthy locations were as popular as figure portraits. Here, an unidentified artist has rhythmically combined several elements in a brightly colored and animated design. (*The Metropolitan Museum of Art; Gift of Edgar William and Bernice Chrysler Garbisch, 1963*)

43. Rufus Porter (1792–1884): *House with Orchard.* c. 1830. Detail of a wall fresco from the house of Captain Samuel Benjamin, Jr., Winthrop, Maine. An itinerant limner and landscape painter, Porter in 1845 founded and edited *Scientific American.* The author of several articles on painting, Porter on one occasion stated, "In finishing up scenery, it is neither necessary nor expedient, in all cases, to imitate nature. There are a great variety of beautiful designs, which are easily and quickly produced with the brush, and which excell nature itself in picturesque brilliancy, and richly embellish the work, though not in perfect imitation of anything." (*Maine State Museum*)

44. Thomas Cole: *Kaaterskill Falls*. 1826. Oil on canvas, 43″ x 36″. Based on drawings made during Cole's first trip to the Catskill Mountains in the summer of 1825, this painting probably belonged to William Cullen Bryant. It depicts a frequently painted site and one that Cole in 1835 described as follows: "The waterfall . . . at once presents to the mind the beautiful, but apparently incongruous idea, of fixedness and motion—a single existence in which we perceive unceasing change and everlasting duration. The waterfall may be called the voice of the landscape, for, unlike the rocks and woods which offer sounds as the passive instruments played upon by the elements, the waterfall strikes its own chords, and rocks and mountains re-echo in rich unison. . . ."[11] (*The Warner Collection of the Gulf States Paper Corporation*)

45

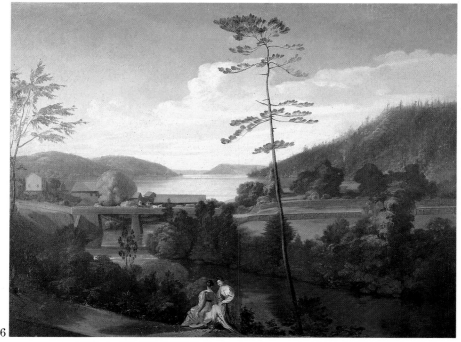

64

46

45. Thomas Cole: *Sunrise in the Catskills*. 1826. Oil on canvas, 25″ x 35¼″. Through such canvases as this, Cole imbued American nature with a moral meaning that rivaled the associations of the European countryside. A student of romanticism, he convincingly combined the historicism of Benjamin West's vision with the theory of the sublime of Edmund Burke, unveiling to his generation the beauty and distinctiveness of the native landscape. Completed in the same year that his friend James Fenimore Cooper published his popular *The Last of the Mohicans*, *Sunrise* allegorically captured sentiments widespread in society, expressing them in an innovative fashion. (*Private collection; photograph courtesy Kennedy Galleries, Inc.*)

46. Samuel F. B. Morse (1791–1872): *View from Apple Hill, Cooperstown, New York*. c. 1829. Oil on canvas, 22″ x 29″. A student of Benjamin West and Washington Allston, Morse was among the most gifted individuals of his generation. Although instrumental in founding the National Academy of Design and serving as its first president (1826–1845), Morse during the 1830s increasingly devoted himself to science, especially to the invention of the telegraph. Since 1814 Morse had lamented the Colonial preference for portraiture over history painting and the overall inability to earn a living from this profession. This realistic view of Otsego Lake from Apple Hill celebrates the commonplace beauty of American scenery, anticipating its role as a cultural artifact. (*The Clark Estates*)

47. Samuel F. B. Morse: *The Chapel of the Virgin at Subiaco*. 1830–1831. Oil on canvas, 29¹⁵⁄₁₆″ x 37″. Morse was strongly influenced by German landscapists during a second stay in Rome (1829–1832). This canvas reflects that influence by combining the lyrical qualities of a romantic mood: dramatic visual contrasts, glowing colors, and spatial infinity. It is unfortunate that Morse, after creating such a consummate expression of romanticism, abandoned painting altogether in 1837. Morse considered his picture of Subiaco, Italy, the best landscape he ever painted. "It was enchanting in spite of the sirocco. The hills covered with woods, at a distance, reminded me of my own country. . . . It was altogether a place suited to meditation, and, were it consistent with those duties which man owes his fellow man, here would be the spot to which one, fond of study and averse to the noise and bustle of the world, would love to retire." (*Worcester Art Museum; Bequest of Stephen Salisbury III*)

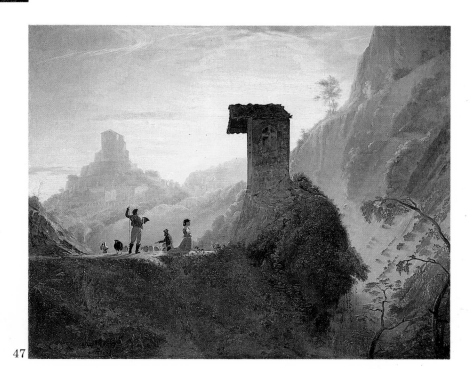

47

48. William Price (active 1830s): *The Sidewheeler Sunny.* 1831. Detail of a wall fresco from the lower stairhall of the Carroll House, Springfield, New York. This delightful and highly imaginary landscape is part of the ornate frescoes painted for the Carroll House, which was once a turnpike tavern. The frescoes are now installed at the Winterthur Museum and the New York State Historical Association. (*Henry Francis du Pont Winterthur Museum*)

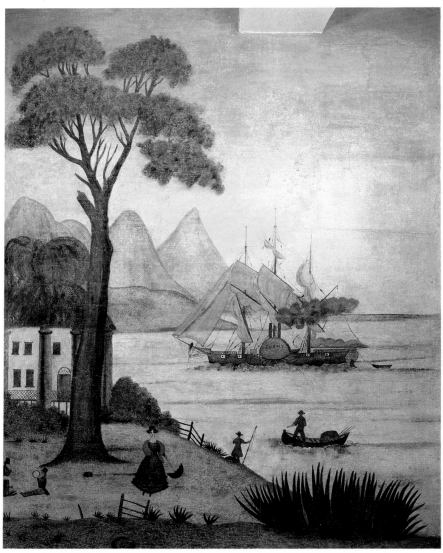

48

49. George Catlin (1796–1872): *Brick Kilns, Clay Bluffs, 1,900 Miles Above St. Louis.* 1832. Oil on canvas, 11¼″ x 14⅜″. A historian of the native wilderness landscape, Catlin completed this exquisite painting during an 1832 journey up the Missouri River on the steamer *Yellowstone.* In it we can detect a discerning sense of brilliant color and simplified patterns, qualities that enhance viewer fascination with this strange environment. (*National Museum of American Art, Smithsonian Institution*)

50. Robert Salmon (c. 1775–c. 1845): *Boston Harbor from Constitution Wharf.* 1833. Oil on canvas, 26¾″ x 40¾″. Jacksonian democracy epitomized the young nation's prosperity and well-being. Arriving in Boston from Liverpool in 1828, Salmon was a mature artist who quickly recognized the potential market for scenes that reflected this healthy state. He proceeded to capture the energetic pulse of the city through the animated activity of the harbor and other points of local topography. An immediate success, Salmon provided a significant influence on a younger generation of artists, including Fitz Hugh Lane. (*United States Naval Academy Museum*)

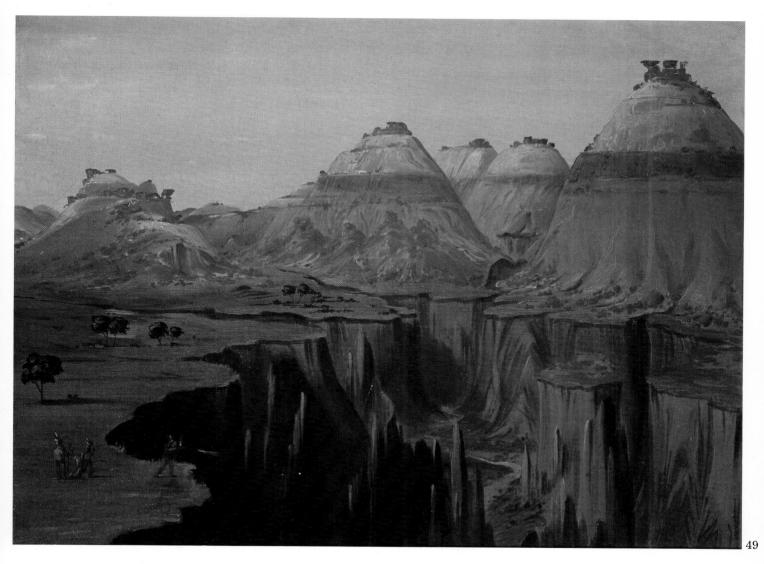

49

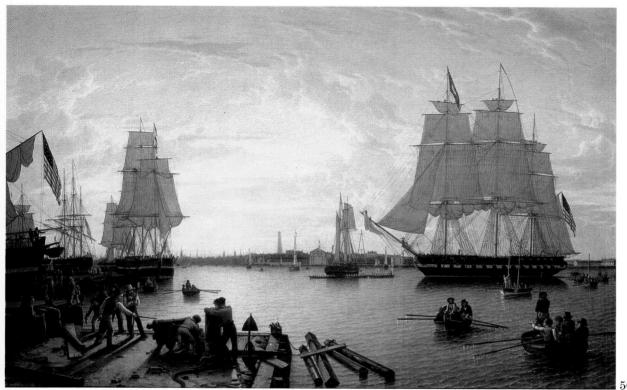

50

51

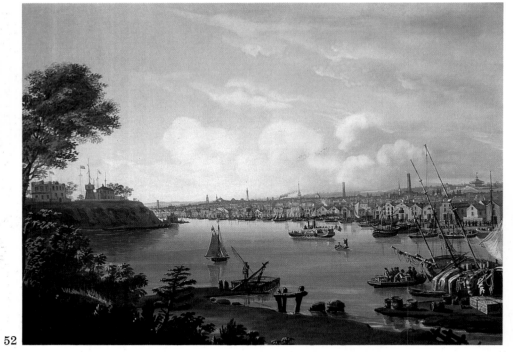

52

53

51. Samuel M. Lee (active 1826–1841): *Hidden Bayou Pool.* 1830–1840. Oil on canvas, 39⅛″ x 53″. Few biographical facts are recorded concerning Lee or his activities as a painter. However, we do know that between 1826 and 1841 he completed several panoramas and stage designs, while working in Cincinnati, Louisville, and New Orleans. (*National Museum of American Art, Smithsonian Institution; Purchase*)

52. Nicolino V. Calyo (1799–1884): *View of the Port of Baltimore.* 1836. Gouache on paper, 37″ x 50½″. Fleeing the outbreak of the Spanish civil war, Calyo arrived in this country in the early 1830s and was working in Baltimore by 1834. As an artist, his reputation was secured by his dramatic views of New York's devastating great fire of December 16–17, 1835. His topographic views of Baltimore, New York, and Philadelphia are carefully organized according to picturesque formulas that emphasize the charm and commonplace qualities of a specific locale. This work, executed in 1836, is representative of the artist's best period—1836–1840. Although the draftsmanship remains superb, there is a new fluidity to the style, which differs from the rather tight, precise technique that marks his earlier work. (*The Baltimore Museum of Art; Purchased by the Women's Committee*)

53. Thomas Cole: *Schroon Mountain, Adirondacks.* 1838. Oil on canvas, 39⅜″ x 63″. In contrast to his moral allegories *Schroon Mountain, Adirondacks,* realistically reaffirms the monumental vastness and untamed grandeur of the American wilderness landscape. Although certain compositional details, such as the gnarled trees, are emphasized for effect, the overall scene remains true, so as to convey the untouched creation of God-in-nature. Here in the wilderness, nature became a source of virtue, a place to contemplate the sublime, an avenue for spiritual sustenance. (*The Cleveland Museum of Art; Hinman B. Hurlbut Collection, 1917*)

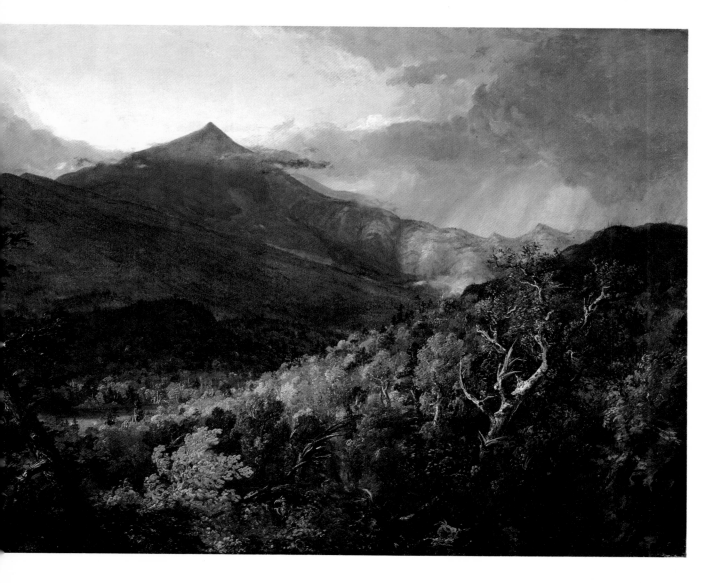

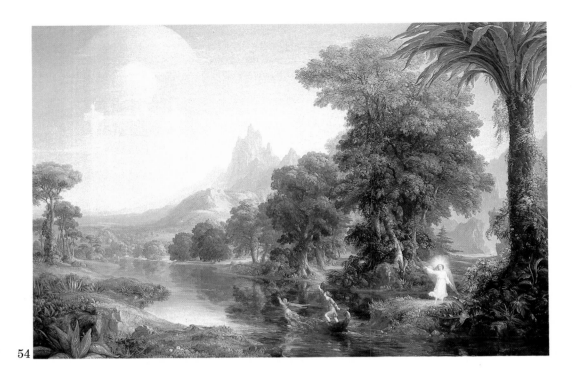

54

70 55

54. Thomas Cole: *The Voyage of Life: Youth.* 1840. Oil on canvas, 52½″ x 78½″. Cole's travels in Europe (1829–1832) left an indelible impression on the young artist. Already an admirer of the romantic poets Byron and Wordsworth, Cole was receptive to themes dealing with the passage of time, the brevity of life, and the lessons of past civilizations. Although greatly impressed by his visits to The British Museum and the Louvre, it was the ruins of Rome—the monuments of humanity's past—that were most striking. When he returned to the United States, he produced a series of romantic allegories on the passage of time, commissioned by discriminating collectors and engraved to popular success. Increasingly, the public desired scenes of observed reality uninfluenced by romantic stereotypes. Cole's last allegory, *The Cross of the World,* remained unfinished at the time of his death. (*Munson-Williams-Proctor Institute; Purchase*)

55. Robert Salmon: *Moonlight Coastal Scene.* 1836. Oil on panel, 16⁹⁄₁₆″ x 24³⁄₁₆″. This canvas is one of several moonlight scenes that Salmon painted in 1836. Suggesting an awareness of Washington Allston's 1819 *Moonlit Landscape,* it presents a skillful synthesis of the English topographic tradition and romanticism. The evocative tonality, reminiscent of seventeenth-century Dutch marine painting, and the stylized precision, reminiscent of the popular travelogues of Canaletto, anticipate both the vision of the mid-century luminists and the haunting expressions of Albert Pinkham Ryder and Ralph Blakelock. (*The St. Louis Art Museum; Purchase: Funds provided by Mr. and Mrs. Duncan C. Dobson, contributions made in the memory of Henry B. Pflager, Tax Funds 1973 and Eliza McMillan Fund*)

56. Alfred Jacob Miller (1810–1874): *Trappers Around a Campfire.* 1838. Oil on canvas, 38¼″ x 32⅛″. Miller is best known for his quick sketches of the scenery and life of America's Far West. After moving from Baltimore to New Orleans in 1837, he was engaged by the veteran explorer William Drummond Stewart to accompany his last trip to the Rockies. His role as artist-explorer not only contributed to an important tradition in our history but also points to our methodical impulse to measure and define. Related to a strong tradition of engraving or printmaking, this impulse partly explains the elusive yet precise renderings of the luminists. (*The Warner Collection of the Gulf States Paper Corporation*)

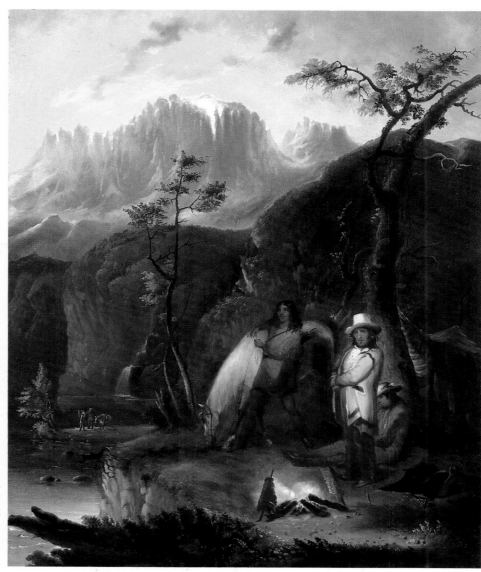

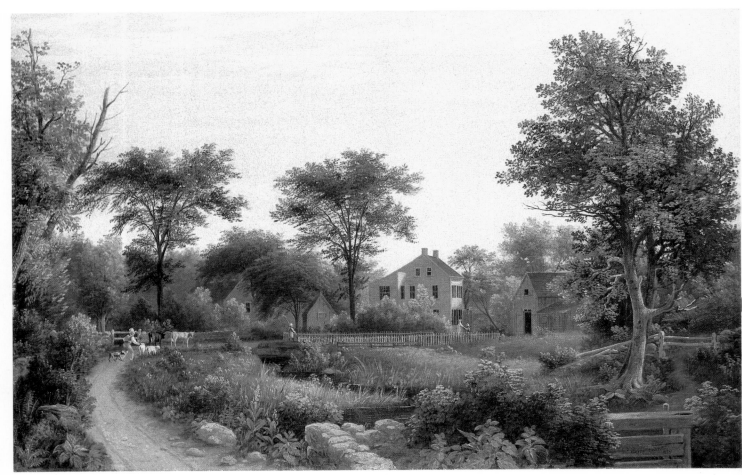

57

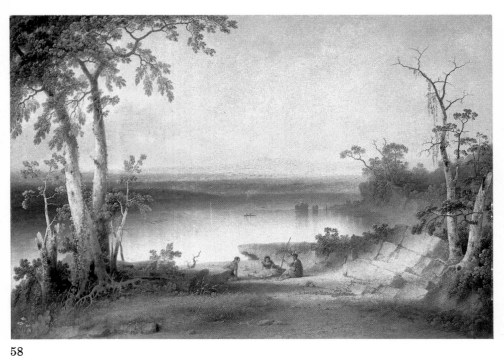

58

59

57. Samuel L. Gerry (1813–1891): *New England Homestead*. 1839. Oil on canvas, 24″ x 36¼″. Born in Boston, Gerry was largely self-taught. After traveling in Europe for three years, he set up his studio in Boston, where he was a frequent exhibitor at the Athenaeum. Recently, John I. H. Baur in *A Mirror of Creation—150 Years of American Nature Painting* stated, "The beginnings of the movement [luminism] can be found as early as 1839, when Samuel Gerry painted his lyrical *New England Homestead*."[12] Gerry was best known as a portrait, genre, landscape, and animal painter. (*The Brooklyn Museum; Dick S. Ramsay Fund*)

58. Joshua Shaw: *On the Susquehanna*. 1839. Oil on canvas, 39″ x 55½″. After his 1817 arrival in this country, Shaw's work concentrated on the beautiful and sublime aspects of this unique landscape. Many of these scenes were engraved by John Hill in *Picturesque Views of American Scenery* (1820–1821) the introduction of which extolled the unsung virtues of the American landscape. Somewhat later, the perceptive John Sartain wrote in *Reminiscences of a Very Old Man* (1899), "His style was somewhat formal and mechanical . . . but his touch was firm, his tints pure and the composition . . . noble and effective." (*Museum of Fine Arts, Boston; M. and M. Karolik Collection*)

59. Charles Hubbard (1801–1876): *Sea View of Cape Poge Lighthouse*. c. 1840–1849. Oil on wood, 15⅝″ x 21⅝″. Hubbard was known primarily as a portrait painter, however, like his contemporaries and probable acquaintances, Robert Salmon and Fitz Hugh Lane, he was also an accomplished marine painter. Working principally in Chelsea, Massachusetts, Hubbard was also active in city politics and served as a director of the Winnisimmet Company, the local ferry works. (*National Museum of American Art, Smithsonian Institution; Purchase*)

60. Thomas Chambers (c. 1808–after 1866): *Hudson River Scene*. 1840s. Oil on canvas, 21½″ x 29″. As with many of the "primitive" painters, Chambers's reputation preceded the availability of facts about his life. Arriving from England in 1832, he was active in New York, Boston, and the Hudson River Valley. Here, Garrison's Point at West Point is introduced into a portion of the Hudson Valley that is more imaginary than real. Chambers frequently took his works from prints, imaginatively combining a variety of different views into a highly personal and visually exciting scene. (*Kennedy Galleries, Inc.*)

61

61. Thomas Doughty: *Desert Rock Lighthouse.* 1847. Oil on canvas, 27″ x 41″. The lighthouse (built 1830) on Mount Desert Rock, located twenty-five miles off the Maine coast, was visited by Doughty in 1836. Widely popularized by an engraving in Nathaniel Parker Willis's *American Scenery,* Doughty's view probably led Thomas Cole to visit the site. While Doughty's work was often technically comparable to Cole's, it lacked imagination and diversity. *Desert Rock Lighthouse* is unusually fresh in its animated brushwork and striking atmospheric effects, conveying all the qualities that we ordinarily associate with the rugged Maine coast. (*The Newark Museum; Gift of Mrs. Jennie E. Tompkins, 1939*)

62. Asher B. Durand: *Dover Plains, Dutchess County, New York.* 1848. Oil on canvas, 42½″ x 60½″. Although Durand occasionally painted imagined landscapes, he was best known for his views of specific places, such as *Dover Plains, Dutchess County, New York.* Exhibited at the National Academy of Design in 1848, a reviewer in the May 13 issue of *Literary World* wrote: "Durand seems to have been admitted by universal consent to be one of the high priests of the temple of Nature, and this distinction he has well earned. . . . 'The Scene in Dutchess County' is full of truth as well as beauty and so invested with the characteristics of the natural scenery of certain portions of our land that almost every visitor who looks upon it could localize the scene. Here is real atmosphere. . . ." This painting was subsequently engraved by James Smillie and distributed to members by the American Art Union in 1850. (*National Museum of American Art, Smithsonian Institution; Partial Gift from Thomas M. Evans and Partial Purchase*)

63. Asher B. Durand: *Kindred Spirits.* 1849. Oil on canvas, 44″ x 36″. Commissioned by the prominent collector Jonathan Sturgis, this painting was his expression of appreciation for Bryant's eloquent oration at the funeral of Thomas Cole. It shows Cole and William Cullen Bryant as kindred spirits contemplating the sublimity of nature. The location is one described by Cole in 1840 as being a "delicate morsel" several miles south of Kaaterskill Clove. Durand's painting betrays an engraver's passion for detail, while maintaining a poet's lyricism and spiritualism. (*The New York Public Library; Gift of Miss Julia S. Bryant*)

62

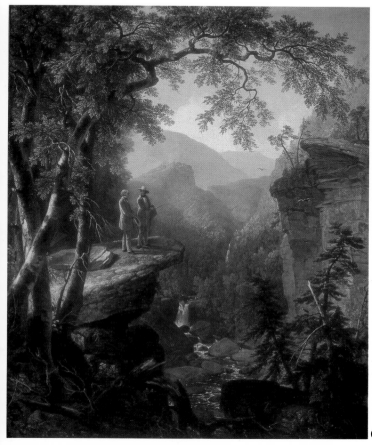

63

75

64. Asher B. Durand: *Landscape—Scene from "Thanatopsis."* 1850. Oil on canvas, 39½" x 61". This painting was inspired by William Cullen Bryant's moralizing poem "Thanatopsis," which states, "The venerable woods . . . /Are but the solemn decorations all/Of the great tomb of man." Panoramic and monumental in conception, it represents an ideal excursion into the then-fashionable gothic world of romance. Each pictorial element is carefully orchestrated to further our feeling of futility at the passage of time and human vulnerability. (*The Metropolitan Museum of Art; Gift of J. Pierpont Morgan, 1911*)

65. Asher B. Durand: *Study from Nature: Rocks and Trees.* c. 1850. Oil on canvas, 21½" x 17". In the 1850s Durand executed a series of landscape studies directly from nature. As a group, these plein-air studies are among the most distinguished in nineteenth-century American painting. In contrast to Thomas Cole who allowed a veil of memory to erase nature's details, Durand found in nature "a beautiful composition without need of change or adaptation." A sense of immediacy and luminosity are created by the variations in paint thickness, which are applied with a virtuosity matched only by the effect that Durand has achieved. Durand's efforts at plein-air painting parallel those of Courbet in France. As stated by Barbara Novak in *American Painting of the Nineteenth Century,* "The impetus is the same: the closest possible approximation on canvas of the artist's visual sensation, an objectivity that, finding its painterly equivalent, allows new laws of composition to grow from within the province of nature itself."[13] (*The New-York Historical Society*)

66. George H. Durrie (1820–1863): *Going to Church.* 1853. Oil on canvas, 27" x 35½". Durrie lived and worked for much of his career in New Haven, Connecticut, periodically traveling in New England and as far south as Virginia. Except for a brief period of study in 1839 with Nathaniel Jocelyn (1796–1881) he was self-taught. His earliest works were portraits, but in 1844 he exhibited his first "snowpiece," subsequently developing a format based on composite elements of picturesque landscapes. Durrie's reputation was largely restricted to the New Haven area; however, between 1861 and 1867 Currier and Ives issued ten lithographs after his works to a public that did not know his paintings. (*The White House Collection; Gift of George Frelinghuysen*)

65

66

67. Thomas Worthington Whittredge: *View of Hawk's Nest.* 1847. Oil on canvas, 26″ x 38½″. Exhibited at the American Art Union as *Kanawha Scenery* (in Western Virginia), this picture is among the best he painted before leaving in 1849 for Europe where he remained until 1859. His European experiences were varied, including three years' study in Düsseldorf, which between the late 1840s and early 1860s had attracted Albert Bierstadt, William Stanley Haseltine, and William Trost Richards; and about twice the number of years in Italy, where Sanford Gifford was painting and Nathaniel Hawthorne was writing *The Marble Faun.* (*Hirschl & Adler Galleries, Inc.*)

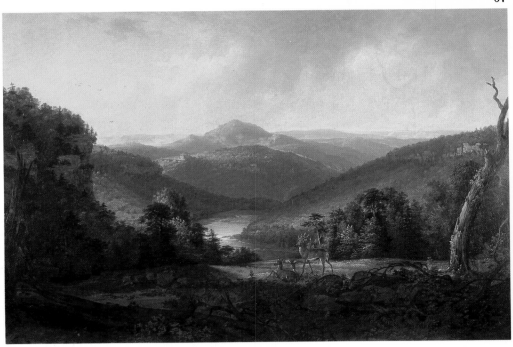

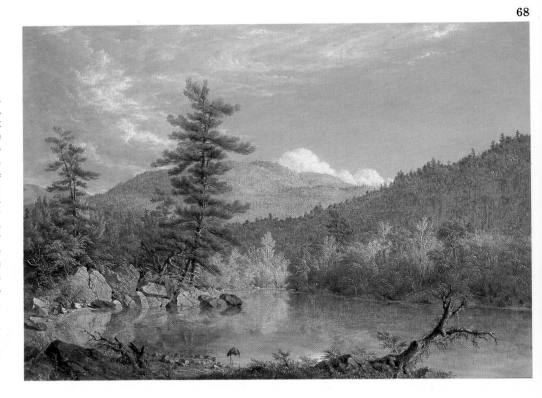

68

68. Sanford R. Gifford (1823–1880): *Solitude.* 1848. Oil on canvas, 22″ x 29¾″. Gifford was a native of Hudson, New York, located about twenty miles south of Albany on the river of the same name. Like John F. Kensett and Thomas Worthington Whittredge, he shaped his art according to the poetry of sunlight and air. Combining exquisitely precise outline with luminous color, Gifford's paintings display material unity, subtle tonal gradations, and a contemplative stillness. (*Private collection; photograph courtesy Vose Galleries of Boston, Inc.*)

70. Fitz Hugh Lane: *Lanesville.* 1849. Oil on canvas, 18″ x 26″. This was painted shortly after Lane's disengagement in 1848 from his partnership in the Boston lithographic firm of Lane and Scott. Back in Gloucester, where his family had lived since 1623, Lane in 1848 built a house overlooking the harbor and commenced his career as a painter. That summer he, like Thomas Cole and Thomas Doughty before him, visited Maine and was greatly impressed by the clarity of the atmosphere and its effect on color and form. Several factors recall his preoccupation with lithography: the precise delineation as well as the contrast between the shadowed foreground and the luminous distance where sky and sea merge. Observed intensely, the scene is characterized by the elusive stillness of a photograph. (*Kennedy Galleries, Inc.*)

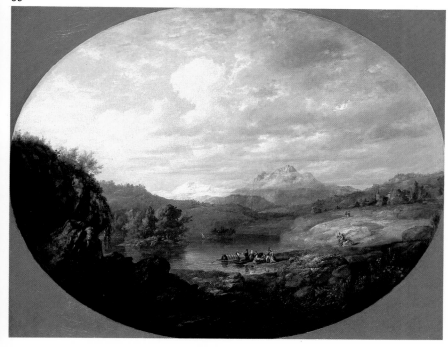

69. Daniel Huntington (1816–1906): *A Swiss Lake*. 1849. Oil on canvas, 27⅛" x 34⅛". A portrait, historical, and landscape painter, Huntington studied with Samuel F. B. Morse and Henry Inman. Greatly admired by his contemporaries, he served twice as president of the prestigious National Academy of Design (1862–1870 and 1877–1890). This landscape was done while he was living in New York and earning a living as a portrait painter. He had just returned from a second European trip, during which he spent almost three years in Rome. (*National Museum of American Art, Smithsonian Institution; Purchase*)

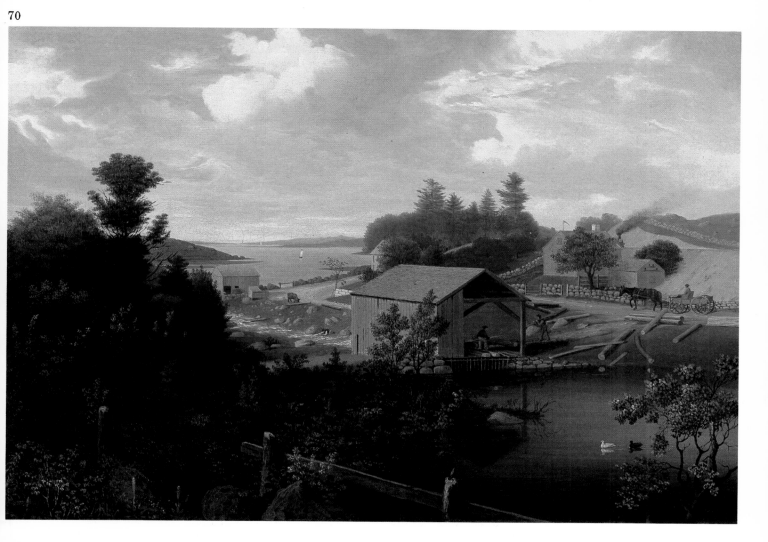

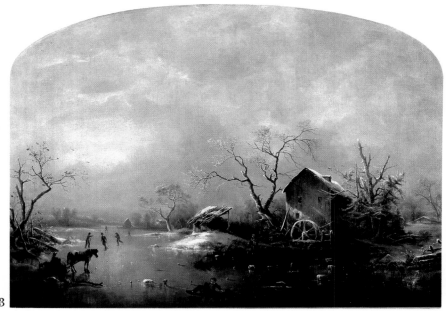

73

71

72

71. Frederic Edwin Church: *Evening After a Storm.* 1849–1852. Oil on canvas, 25″ x 36″. Through the intervention of the prominent Daniel Wadsworth, Church in 1844 became Cole's only pupil. In contrast to Cole's loose painting technique, Church's early views of New England scenery were tightly drawn and almost scientifically observed. Human drama no longer seems necessary to rationalize the environment; rather the young Church depends solely on nature's powerful revelation to convey meaning. In effect, Church had already managed to assimilate Cole's teachings and convincingly transform them to the needs of a society that looked at nature more as a source of national optimism and less as a repository of historical associations. (*Hirschl & Adler Galleries, Inc.*)

72. George F. Bottume (1828–1878): *Canal near Salem, Connecticut.* c. 1848–1855. Oil on canvas, 24″ x 36″. Born in Baltic, Connecticut, Bottume turned to painting around 1841, studying in New York with the portraitist Solomon Fanning (1807–1878?) during 1844 and 1845. He shortly returned to Connecticut where he worked in Norwich, primarily as a portrait painter traveling throughout the state and eventually settling in Springfield, Massachusetts. (*Kennedy Galleries, Inc.*)

73. Régis François Gignoux (1816–1882): *Winter Scene.* 1850. Oil on canvas, 36″ x 50¼″. A native of Lyons, France, Gignoux arrived in this country around 1840, and was almost immediately impressed by the bold beauty of the natural scenery. He specialized in landscapes, becoming best known for his winter scenes, which the critic Tuckerman described as "executed with great truth to nature and beauty of effect; it has been said that some are so truthful that they would almost allure a snow-bunting from the sky." Gignoux is also remembered for teaching a young landscapist from Newburgh, New York— George Inness. (*The Corcoran Gallery of Art; Gift of William Wilson Corcoran, 1869*)

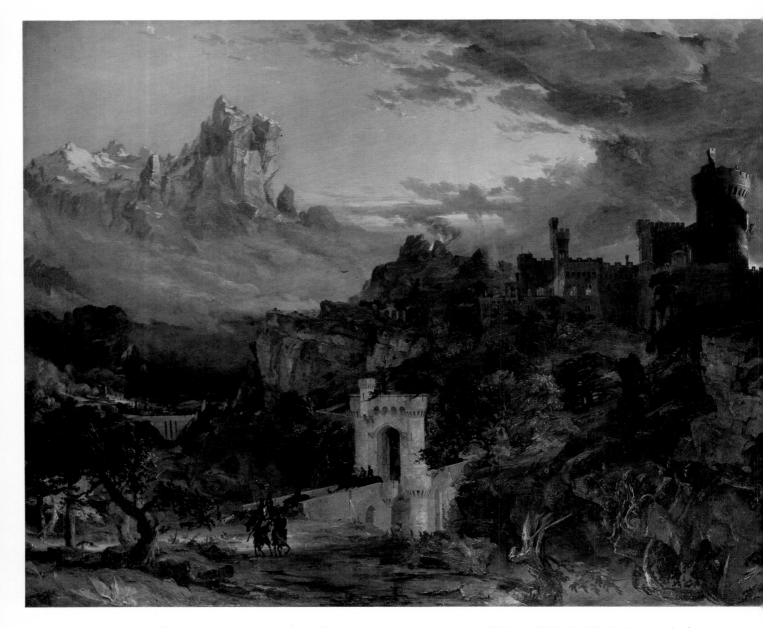

74. Jasper F. Cropsey: *The Spirit of War*. 1851. Oil on canvas, 44⅝″ x 67¼″. Exhibited extensively and regarded as one of Cropsey's greatest works, *The Spirit of War* is clearly indebted to the compositional formulas, coloration, and expressive brushwork of Thomas Cole's *Voyage of Life* series. While anticipating the emerging interest in luminist effect and serving as an ironic premonition of the coming war years, it also relates to the nostalgic fascination with the Middle Ages, the Gothic Revival in architecture, and the nature literature of Hawthorne, Cooper, and Irving. (*National Gallery of Art; Gift of the Avalon Foundation; photograph courtesy Vose Galleries of Boston, Inc.*)

75. James Hope (1818/19–1892): *A Marble Quarry*. 1851. Oil on canvas, 18″ x 24″. After painting portraits in Montreal (1844–1846), Hope returned to teach at the Castleton Seminary in Vermont. He subsequently abandoned portraiture for landscape painting, spending the winters in his New York studio. This scene shows a New England quarry that provided blocks for the Washington Monument. Designed in 1836 by Robert Mills (1781–1855), the Washington, D.C., "obelisk" was being erected between 1848 and 1884. Mills had also designed the Washington Monument (1815–1829) in Baltimore. (*Museum of Fine Arts, Boston; M. and M. Karolik Collection*)

76. William S. Jewett (1812–1873): *Hock Farm and a View of the Butte Mountains from Feather River*. 1851. Oil on canvas, 29″ x 40″. Unsuccessful in his 1849 search for gold, Jewett opened a portrait studio in San Francisco the next year, and proceeded to amass a fortune. Hock Farm was a 600-acre ranch that belonged to John Sutter at whose fort the gold rush began. Hock Farm represented a small remnant of Sutter's original grant of 250 square miles along portions of three navigable rivers. Jewett eventually retired to Europe where he bought a castle in the Pyrenees. (*Kennedy Galleries, Inc.*)

74

75

76

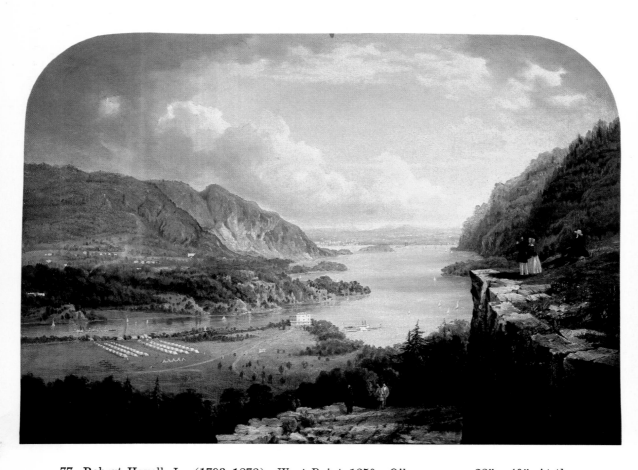

77. Robert Havell, Jr. (1793–1878): *West Point.* 1850s. Oil on canvas, 28″ x 40″. At the recommendation of the distinguished London publisher Colnaghi & Co., Havell was hired by John James Audubon to engrave his watercolor drawings for his memorable folio *The Birds of America.* Completing this project in 1838, he set out for New York where, beginning in 1841, he lived overlooking the Hudson River. He exhibited few paintings until shortly before his death; however, his style rivals the "silvery tone" pastorals of Thomas Doughty while maintaining the integrity of a precise location. (*Kennedy Galleries, Inc.*)

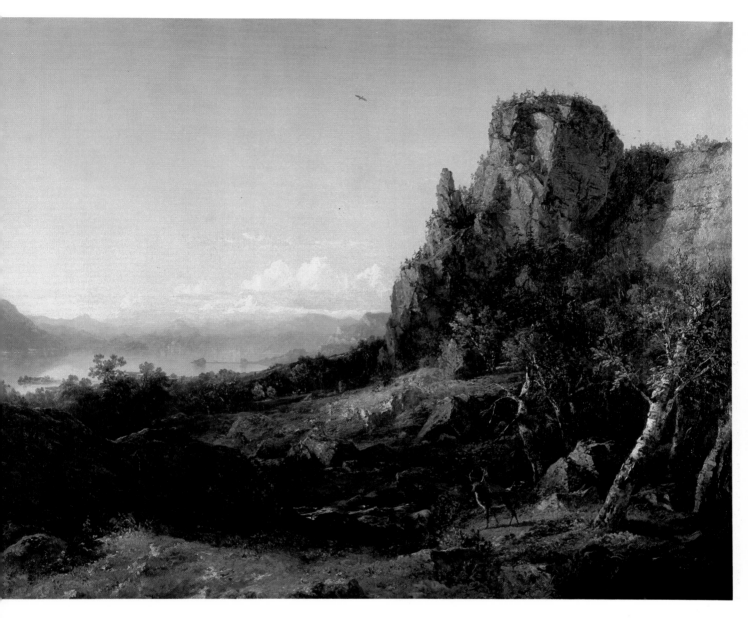

78. John F. Kensett: *Landscape with Deer*. 1853. Oil on canvas, 48″ x 72½″. For many years this painting was in the collection of Charles W. Gould as the companion to Asher B. Durand's *Progress* (see pl. 6). American society at mid-century was preoccupied with notions of progress and the march of civilization. Therefore, it was no coincidence that these artists—who had been close friends since 1840—would have so captured the tempo of their time in these complementary paintings. These two works appear together for the first time since their 1853 National Academy of Design exhibit and the subsequent 1932 sale of the Gould estate. Kensett began his career as an engraver of maps and bank notes in New York City. *Landscape with Deer* was completed shortly after Kensett's return to New York from seven years in Europe, several of which were spent traveling with Durand and John Casilear. Kensett's early works were painted within a limited range of browns, greens, and grays and tend to reflect the quiet pastoral aspects of intimate landscape views. Based on the meticulous observation of nature, Kensett's paintings are gems of American scenery. (*Hirschl & Adler Galleries, Inc.*)

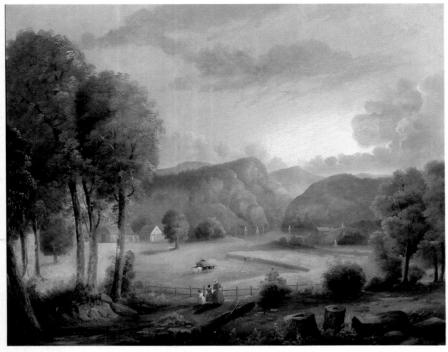

79

81

79. Unidentified artist: After *American Harvesting* by Jasper F. Cropsey. Second half of the nineteenth century. Oil on canvas, 28¾″ x 35½″. Painted after an engraving by James Smillie of Jasper F. Cropsey's *American Harvesting*. The engraving was published in 1851 by the American Art Union. The American Art Union circulated numerous engravings after works by its members, which served as sources of inspiration for the many folk artists who executed paintings of the same subject. (*Cary F. Baker, Jr.*)

80. William Sonntag (1822–1900): *Mountain Landscape*. 1854. Oil on canvas, 51¼″ x 41⅛″. Sonntag lived in Cincinnati and was a close friend of Robert Duncanson, having traveled with him to Europe in the mid-1850s. After returning to this country, Sonntag established a studio in New York City where he remained until his death. Today, he is best known for his Italian and American landscapes, which combine romantic sentiment and carefully rendered details. (*National Museum of American Art, Smithsonian Institution; Purchase*)

81. Unidentified artist: *Meditation by the Sea*. c. 1855. Oil on canvas, 13½″ x 19½″. Small in size yet enormously expressive, this painting maintains a striking fascination. Focused on the solitary figure in the foreground, the artist epitomizes a theme of contemplative solitude in nature. A disturbing stillness and an uncertain horizon prevail, eliminating all physical limits on the sea—the object of the spectator's attention. (*Museum of Fine Arts, Boston; M. and M. Karolik Collection*)

82. Asher B. Durand: *In the Woods*. 1855. Oil on canvas, 60¾″ x 48″. Considered by critics to rank among his finest works, *In the Woods* was possibly in mind when Henry T. Tuckerman wrote in *The Book of the Artists,* ". . . so characteristic is each tree, so natural the bark and foliage, so graphic the combination and foreground, that the senses and the mind are filled and satisfied with this purely sylvan landscape. . . . it is a fragment of the most peculiar garniture that decks the uncleared land of this continent."[14] In 1855 Durand stated in his "Letters on Landscape Painting," "Paint and repaint until you are *sure* the work *represents* the model—not that it merely resembles it." Two years after Jonathan Sturgis received this painting he wrote Durand, enclosing an additional payment, "I desire to add to the price of the wood picture. The trees have grown more than the worth of the sum since 1855." (*The Metropolitan Museum of Art; Gift in Memory of Jonathan Sturgis by his children, 1895*)

83. George Loring Brown (1814–1889): *Monte Pellegrino at Palermo, Sicily.* 1856. Oil on canvas, 19¼" x 32". In Boston after his first European trip, Brown won considerable praise from the venerable Washington Allston for his copies after Claude Lorrain. He returned to Italy around 1839 and remained there for twenty years, achieving considerable success among travelers for his nostalgic paintings of favorite tourist views. Nathaniel Hawthorne's *Italian Notebooks* contain the following account of an 1858 visit to the artist's studio: "He is a plain, homely Yankee . . . but wins one's confidence by his very lack of graces . . . His pictures were views . . . and were most beautiful and true . . . done with incredible care and minuteness of detail. . . ." Criticized for his painting technique, Brown nevertheless remained busy by satisfying the public demand for his stereotyped scenes. (*Museum of Fine Arts, Boston; M. and M. Karolik Collection*)

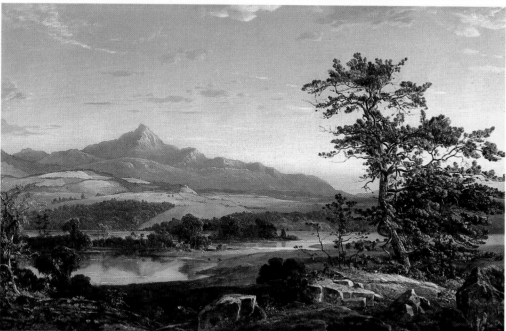

84. David Johnson (1827–1908): *Chocorua Peak, New Hampshire.* 1856. Oil on canvas, 19⅛" x 28¼". Active in the New York art scene during the 1850s and 1860s, Johnson was self-taught with the exception of several lessons from Jasper Cropsey in 1852. He was a studious imitator of Théodore Rousseau, yet his landscapes are sincere views of nature. Mount Chocorua is located near North Conway in the White Mountains of New Hampshire. The peak of Chocorua was a favorite location among artists, frequently described as a visual counterpart of contemporary transcendental literary passages. Durand often associated pantheism with the landscape movement: "On these [mountains] God has set his signet, and Art may not remove it when the picture professes to represent the scene."[15] (*Private collection*)

85

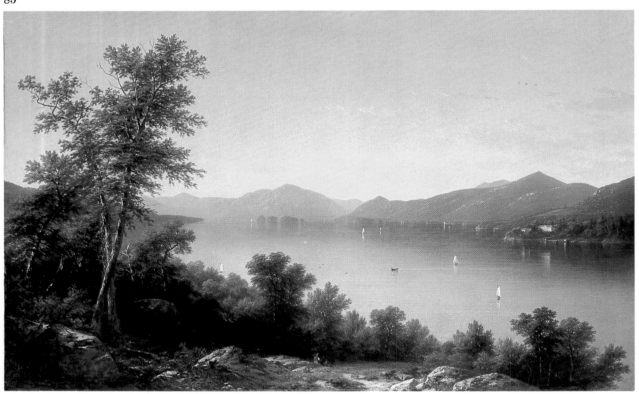

86

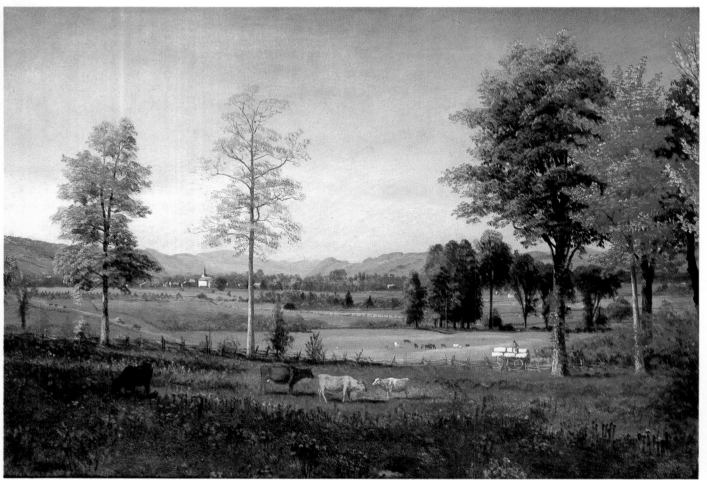

85. John W. Casilear (1811–1893): *Lake George.* 1857. Oil on canvas, 38″ x 60″. Apprenticed in 1826 to the New York engraver Peter Maverick, Casilear traveled in Europe between 1840 and 1843 with John F. Kensett, Thomas P. Rossiter, and Asher B. Durand. Under their influence he finally abandoned engraving for landscape painting in 1854. Casilear was highly regarded among collectors; one critic wrote: "Casilear excells in water scenes; his foregrounds are often beautifully elaborate; a pure light, a neat outline, and distinct grace and grandeur, mark the works of this faithful and accomplished artist." Lake George is viewed from the southern end, looking toward the Tongue Mountain Range, which forms the western entrance to the narrows. (*The Brooklyn Museum*)

86. Albert Bierstadt: *Eastern Landscape.* 1859. Oil on canvas, 20″ x 28″. Painted shortly after Bierstadt's tenure in Düsseldorf with Sanford Gifford and Thomas Worthington Whittredge, this canvas displays several qualities that distinguished this school: animated texture, striking color, and meticulous detail. Possibly a scene near Claremont, New Hampshire, this painting was among the last of his New England landscapes. In April of the same year he departed New Bedford and journeyed west, accompanying the Lander Expedition to the Wind River Mountains in the Nebraska-Wyoming Territory. This trip caused an abrupt transition to western landscapes in his paintings. Curiously, this change paralleled the shift in public taste away from Hudson River landscapes to those that were more dramatic and monumental, reflecting current attitudes concerning the manifest destiny of this country. (*Kennedy Galleries, Inc.*)

87. Fitz Hugh Lane: *View of Gloucester from Brookbank, The Sawyer Homestead.* 1850s. Oil on canvas, 17½″ x 29½″. Presented to the eye as a diorama behind glass, it is hard to accept the actuality of the scene. However, with the exception of the now-razed Sawyer Homestead, all the landmarks remain readily identifiable: Stage Fort, now a city park; Gloucester in the middle; Ten Pound Island and the lighthouse to the right; and the ledges of Dolliver's Neck on the extreme right. Samuel Elwell Sawyer was a patron of art and a distinguished Gloucester citizen. (*Hirschl & Adler Galleries, Inc.*)

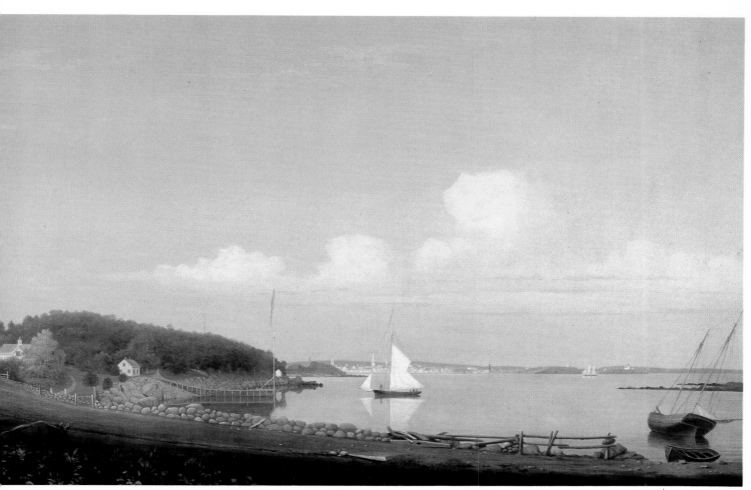

88. William Sidney Mount (1807–1868): *Long Island Farmhouses*. 1854–1859. Oil on canvas, 21⅞″ x 29⅞″. Like George Caleb Bingham, Mount was influenced by the mid-century mood of national pride. After studying portrait painting with Henry Inman in New York, he returned to rural Long Island, painting genre scenes in the area of Setauket and Stony Brook. A friend of Thomas Cole, whom he frequently accompanied on sketching trips, Mount preferred the golden tonalities of Dutch art. Unusual in that it is almost pure landscape, this painting shows the still-standing Brewster homestead near the village of Setauket. Setauket Harbor is seen in the right, beyond which is Long Island Sound and Strong's Neck. (*The Metropolitan Museum of Art; Gift of Lois F. Wickham, in memory of her father, William H. Wickham, 1928*)

89. Andrew W. Warren (1823–1873): *Long Island Homestead, Study from Nature*. 1859. Oil on wood, 12½″ x 23⅞″. This was painted during the late 1850s when the influence of John Ruskin and the Pre-Raphaelites was most strongly felt in this country. It followed by two years the first exhibit of this art style in New York. Expressing a reverential faith in nature, this movement was well received, as the groundwork had been laid by William Cullen Bryant's poetry and the romantic naturalism of the Hudson River painters. In his *Praeterita* John Ruskin stated, "A flower is to be watched as it grows in its associations with the earth, the air, and the dew; its leaves are to be seen as it expands in sunshine; its colors, as they embroider the field."[16] (*National Museum of American Art, Smithsonian Institution; Anonymous Gift, in memory of Mr. and Mrs. I. A. Lipsig*)

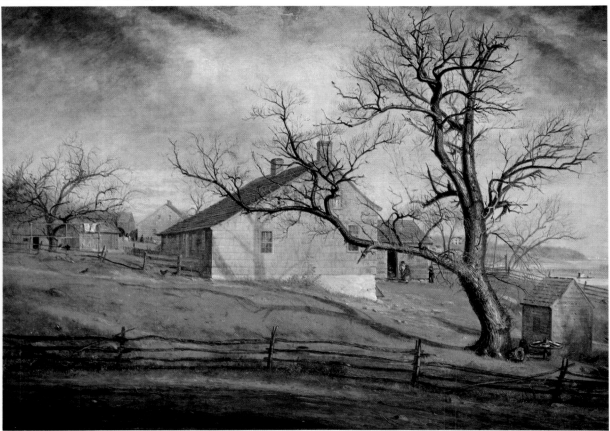

88

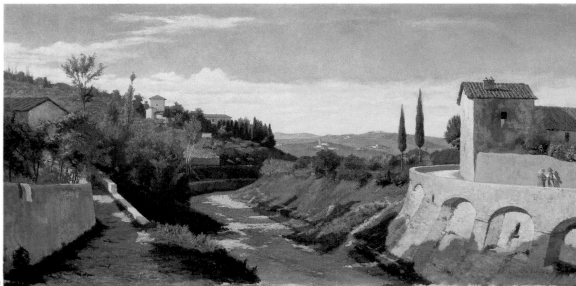

90

90. Elihu Vedder (1836–1923): *Fiesole.* 1859. Oil on canvas, 15″ x 29¼″. Encouraged by the influential J. J. Jarves in 1856, Vedder set out for Europe where he spent time in Paris and then settled in Florence. Befriended by a group of painters at the Caffé Michelangelo—the Macchiaioli or the "spot painters"—Vedder spent long hours in the countryside near Florence. Joining past and present associations in his Tuscan landscapes, Vedder summarized the essential characteristics of the scene into patterns of flat color tones and isolated detail. Many of Vedder's works reflect the quality of Blake's mystical poetry and are direct descendants of Samuel Palmer's symbolic landscapes. (*The Detroit Institute of Arts; Gift of Mr. and Mrs. James S. Whitcomb, 1956*)

91. Martin Johnson Heade: *Rhode Island Shore.* 1858. Oil on canvas, 20″ x 31¾″. After almost twenty years as a practicing artist, Heade turned to landscape painting in the mid-1850s. After spending two years in Providence, Rhode Island, he returned to New York City in 1859 where he rented studio space in the famous Tenth Street Building and immediately established a lasting friendship with the influential Frederic E. Church. Described by critics as Heade's first luminous picture, *Rhode Island Shore* explores light's pictorial possibilities, being characterized by a sharply defined foreground and a vaporous atmospheric background. While remaining topographically accurate in his meticulous detail, Heade, unlike Lane, developed with a definite romantic tendency. Captivated by the composition's seductive charm, we remain keenly aware of nature's duality: at times cultivated and civilized, at others mysterious and potentially destructive. (*Hirschl & Adler Galleries, Inc.*)

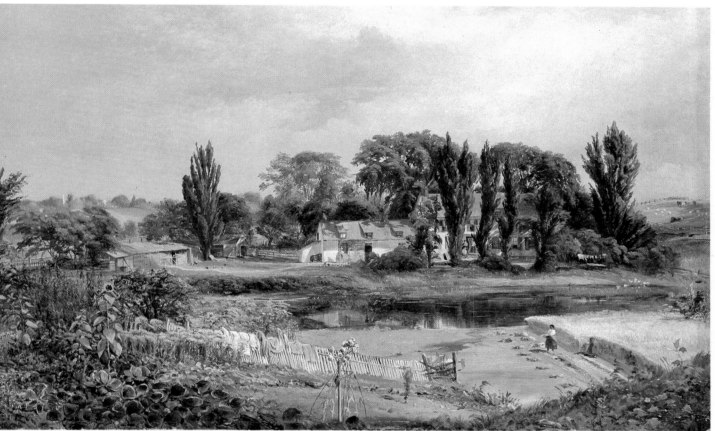

89

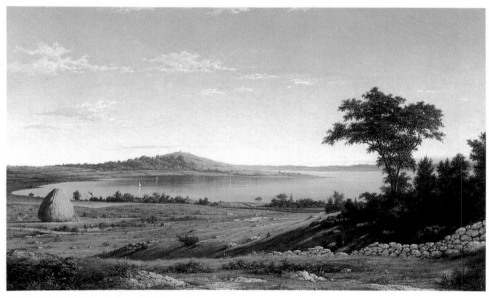

91

93

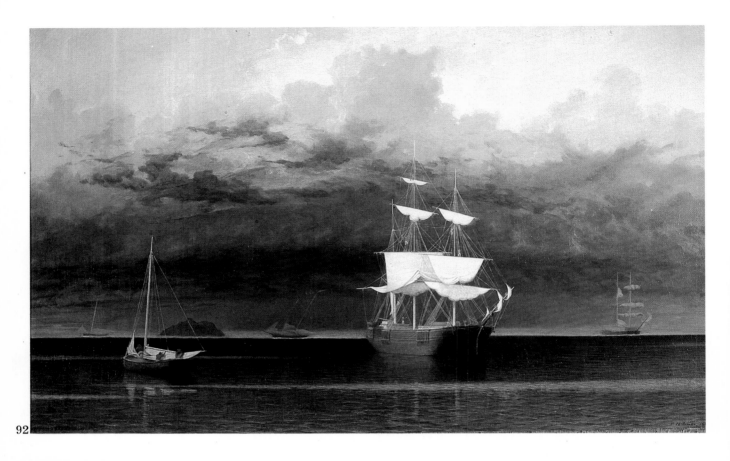

92

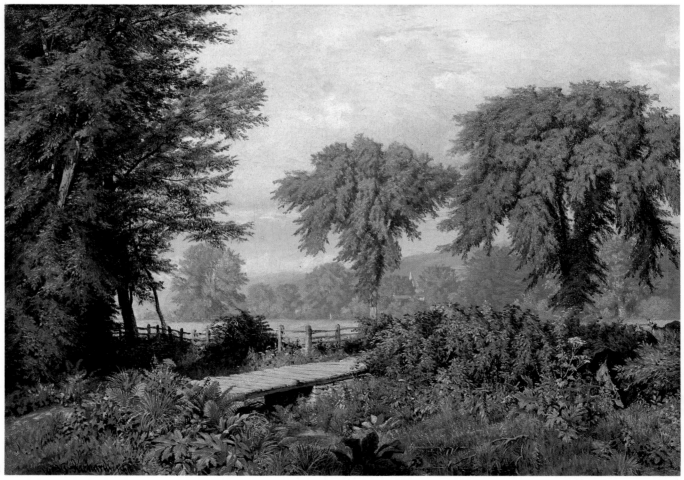

93

92. Fitz Hugh Lane: *Ships and an Approaching Storm off Camden, Maine.* 1860. Oil on canvas, 24″ x 39⅝″. A classic of the luminist mode of painting, this panorama does not really invite spectator participation but seeks instead to create a mood that is spiritual and universal. This mood is perhaps best described by Emerson: "Standing on the bare ground—my head bathed by the blithe air, and uplifted into infinite space—all mean egotism vanishes. I become a transparent eyeball; I am nothing; I see all; the currents of the Universal Being circulate through me; I am part and parcel of God."[17] (*Governor and Mrs. John D. Rockefeller IV*)

93. William Trost Richards (1833–1905): *Landscape.* 1860. Oil on canvas, 17″ x 23¼″. In his early work—similar to the Pre-Raphaelite painters William Holman Hunt, John Everett Millais, and William Dyce—we encounter an almost obsessive concern with detail. This painting, characterized by precise rendering of minutely observed facts, lacks a comparable interest in the effects of light and atmosphere, qualities that prevailed in his 1870s seascapes. Here, we are not tempted by a spacious landscape view; rather, Richards is content that we respond to the varied topography and vegetation: the facts of nature and the evidence of God's handiwork. Unpeopled, his landscape serves to contrast the passage of human time with the relative timelessness of nature. As if attempting to parallel the verse of Wordsworth, Richards leaves the spectator to discover nature's verdant beauty on a quiet day. (*Yale University Art Gallery; Gift of Mrs. Nigel Cholmeley-Jones*)

94. Charles H. Moore (1840–1930): *Down the Hudson to West Point.* c. 1860. Oil on canvas, 20¼″ x 30¼″. Moore was secretary of the Society for the Advancement of Truth in Art, an American voice echoing the beliefs of Ruskin and the Pre-Raphaelites. Formed in January 1863, this society believed that nature was the "perfected work of the Creator," but, unlike many others, felt that nature should include not only the mountains and wonderful land effects, but also the humblest aspects of the landscape. Moore continued his meticulous studies of nature throughout his life, transmitting his beliefs to his Harvard students between the early 1870s and 1909. (*Vassar College Art Gallery; Gift of Matthew Vassar*)

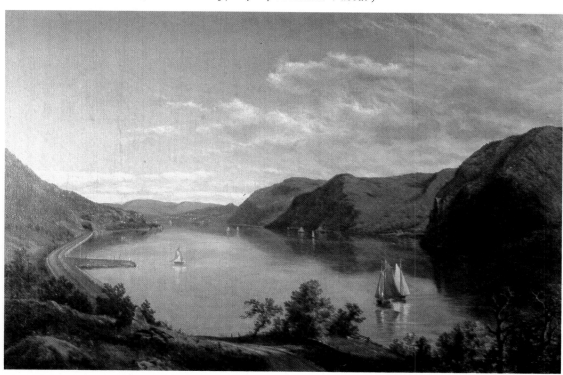

94

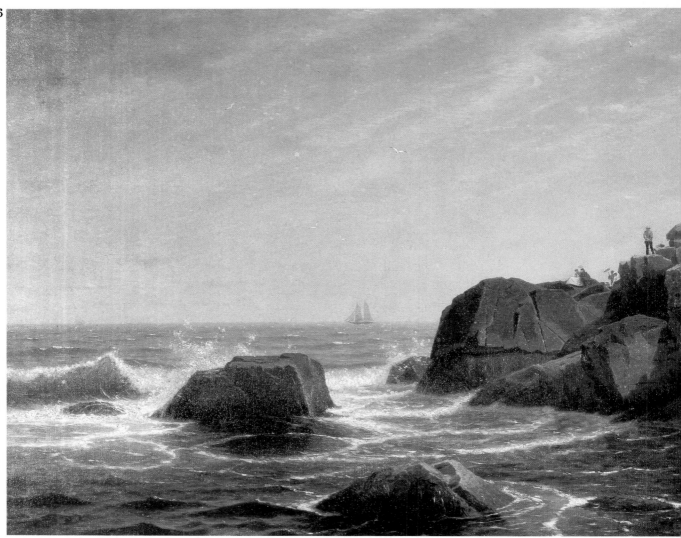

95. John Ferguson Weir (1841–1926): *View of the Highlands from West Point.* 1862. Oil on canvas, 19″ x 33″. Son of the painter Robert W. Weir (1803–1889) and elder brother of J. Alden Weir (1852–1919), John in 1869 became the first director of the newly organized Yale School of Fine Arts. In this painting of the bend in the Hudson River at West Point, Weir found an excellent opportunity for a panoramic scene. It approximates the effect produced by contemporary panoramic photographic strips, where the spectator digests the sequence of views by slowly turning from left to right. Weir subsequently painted scenes on industrial themes that are particularly significant because they capture important aspects of contemporary life. (*The New-York Historical Society*)

96. William Stanley Haseltine (1835–1900): *Castle Rock, Nahant.* 1865. Oil on canvas, 24″ x 38″. This landscape was painted within a few years of Haseltine's return to this country after two years' study at Düsseldorf, where he made friends with Emanuel Leutze, Thomas Worthington Whittredge, and Albert Bierstadt. In the same year he became a member of the prestigious National Academy of Design. The painting portrays the placid skies and spacious valleys that greeted the newly returned artist. The American landscape continued to attract Haseltine even after he became an expatriate, while living and working in Rome, in 1870. He made annual visits to this country and remained quite active in the art world, serving on the art committee for the 1893 Chicago World's Columbian Exposition and being one of the founders of the American Academy in Rome. (*The Corcoran Gallery of Art; Gift of Helen Haseltine Plowden, 1952*)

97. James A. Suydam (1819–1865): *Beverly Rocks.* c. 1860. Oil on canvas, 11″ x 9⅝″. Suydam turned to painting late in life, after being in business for numerous years with his brother. He traveled extensively in Greece and Asia Minor during the mid-1850s, then returned to New York and became a frequent exhibitor at the National Academy of Design, to which he left his funds and collection of paintings. (*National Academy of Design*)

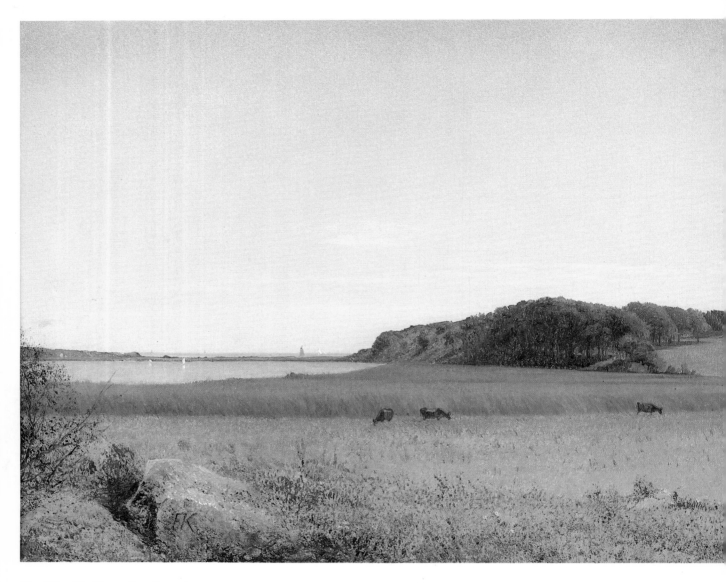

98. John F. Kensett: *An Inlet of Long Island Sound.* c. 1865. Oil on canvas, 14¼″ x 24″. "Kensett's art required for each picture a fresh observation of Nature. Each picture is based upon its own place, time, and point of view, carefully and exactly observed. Therefore, although making his home in New York City, he traveled widely in search of new impressions . . . yet all his pictures strike a very consistent and personal note. In drawing they are small and precise, in arrangement clear and well ordered, as one might expect from one trained as an engraver. . . . His painter's eye for light found its tools in delicate aerial tone and transparent depths of space, modulated in simple gradations, rather than in gaiety of hue. Whatever the subject, his works are filled with a sense of solitude and space. The mood is pensive, often tinged with melancholy, but clear and tranquil. His is a quiet art, narrow in range but sensitive and, to me, delightful."[18] (*Los Angeles County Museum of Art; Gift of Col. and Mrs. William Keighley*)

99. Thomas C. Farrer (1839–1891): *Mount Tom.* 1865. Oil on canvas, 16″ x 24½″. Although still too little known, Farrer arrived in this country in 1858 from England. By the 1860s he was closely allied with a group of artists sometimes called the American Pre-Raphaelites and in 1863 was instrumental in founding *The New Path,* a journal that extolled this type of realism. Farrer died in England. (*Private collection; photograph courtesy The Brooklyn Museum*)

100. Thomas C. Farrer: *View of Northampton from the Dome of the Hospital.* 1865. Oil on canvas, 28⅛″ x 36″. Executed with exacting detail, this panoramic view of Northampton was only recently attributed to Thomas C. Farrer. The painting was completed during the summer of 1865 while Farrer was working in Northampton. Contemporary newspaper accounts indicate that this painting and a related view of Mount Tom located near Northampton (pl. 99) were exhibited together at the end of that summer. Farrer returned to England in 1872; however, his reputation remained strong in this country. (*Smith College Museum of Art*)

98

99

100

101. Jasper F. Cropsey: *Starrucca Viaduct (In the Susquehanna Valley near Lanesboro, Pennsylvania)*. 1865. Oil on canvas, 22⅛" x 36⅜". *Starrucca Viaduct* was completed shortly after Cropsey's return from seven years in England. Accordingly, it is not surprising that it reflects his fascination with the Claudian landscape tradition and his association with Ruskin and the Pre-Raphaelite landscapists. Built near Lanesboro, Pennsylvania, in 1848 by the Erie Railroad, this viaduct was a heralded achievement of American engineering. A leading landscapist of the Hudson River tradition, Cropsey provided an implicit pictorial statement that "celebrated the progress of native ingenuity and reflected on the renewed peace after the divisive Civil War."[19] At the same time his strong admiration for Thomas Cole lends a historical perspective to this scene: the verdant foreground of industrial progress implies Cole's theme of human temporality and the inevitable natural reclamation of even the most impressive monuments of civilization. (*The Toledo Museum of Art; Gift of Florence Scott Libbey*)

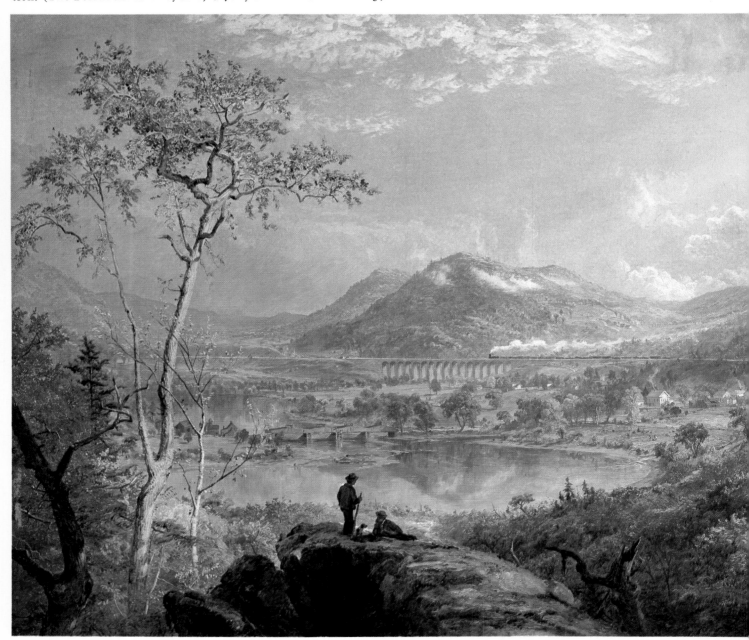

102. Samuel Colman (1832–1920): *Storm King on the Hudson.* 1866. Oil on linen, 32⅛" x 59⅞". Although only recently the subject of critical review, Samuel Colman was described in a 1920 *New York Times* obituary as a "foremost American landscape painter and a noted etcher." Related by marriage to the painter Aaron Draper Shattuck (1832–1928), Colman was well known in the New York art world; in 1862 he was elected a full academician of the prestigious National Academy of Design and was invited to participate in the Century Club's Jubilee Celebration honoring William Cullen Bryant. Colman went to Europe during the early 1860s and 1870s, and his visits included not only the expected stops in France and Italy but also Spain and Morocco. Painted after his first trip, *Storm King* already shows a departure from the meticulous delineation of nature that characterized the Hudson River style, emphasizing fluid brushwork and vaporous atmospheric color, as found later in the work of George Inness. Known for its dramatic storms, Storm King also provides the background for a poignant statement contrasting the billowing clouds created by nature and by the steamboat. (*National Museum of American Art, Smithsonian Institution; Gift of John Gellatly*)

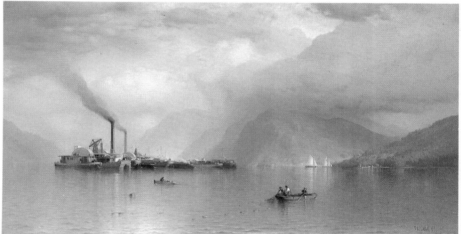

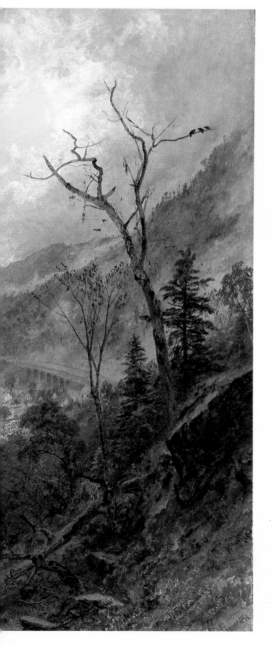

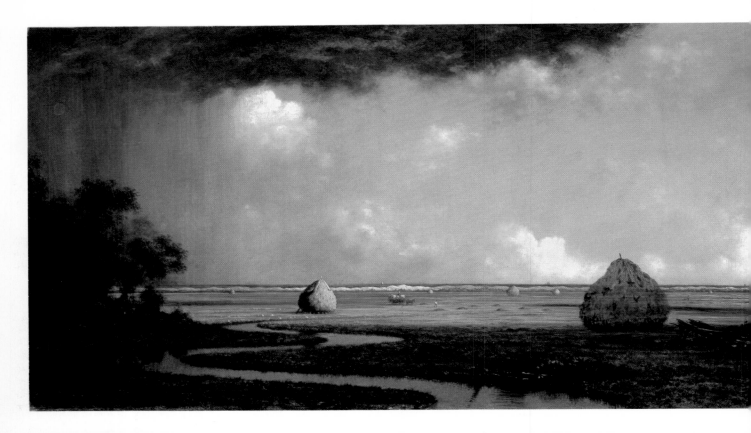

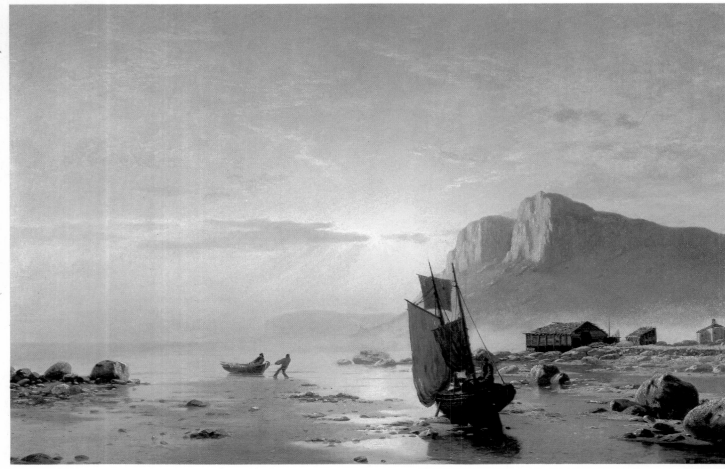

103. Martin Johnson Heade: *Marshfield Meadows, Massachusetts.* 1865–1875. Oil on canvas, 17⅛″ x 36⅛″. Like his close friend Church, Heade traveled extensively around the United States and abroad. A striking quality in his works was his skillful ability to establish dramatic pictorial contrasts, at one time creating exquisitely serene and contemplative landscapes, at another conveying such sublime qualities that our very person seems threatened. One critic called him the prototypical luminist and went on to comment: "Even his choice of marshlands is revealing. They were not only scenes of isolation in a nearly uninhabited landscape, with salt-water streams significantly meandering throughout, but also unstable environments, changing with the tides in a world between land and sea."[20] A spirituality seems to order the landscape components, clearly attempting to convey a sense of time that endures beyond an isolated moment. (*Amon Carter Museum*)

104. William Bradford (1823–1892): *Coast of Labrador.* 1866. Oil on canvas, 20″ x 30″. Beginning in 1859 Bradford visited the Arctic ten times, entirely captivated by the rugged beauty of the ice formations and the strange colors and lights that characterized the wilderness. Supported by the enthusiastic Frederic Church, Bradford's explorations resulted in the 1873 publication of *The Arctic Regions.* Illustrated with photographs, Bradford's text stated: "The wild rugged shapes, indescribable and everchanging, baffle all description. . . . Nor were the colors wanting to carry out the illusion, from dead white to glossy, glistening satin from the deepest green to the lightest shades; and even from faint blue to deepest lapis lazuli again as some lofty berg passed between us and the sun its crest would be bordered with an orange-colored halo in which sometimes prismatic shades appeared."[21] (*The High Museum of Art; Gift of Mr. and Mrs. Frank L. Burns*)

105. Alexander Helwig Wyant (1836–1892): *The Mohawk Valley.* 1866. Oil on canvas, 34¾″ x 53¾″. An ardent admirer of George Inness since the mid-1850s, Wyant adhered to his friend's dictum: "Whatever is painted truly according to any idea of unity possesses both the subjective sentiment—the poetry of nature—and the objective fact."[22] Personally enigmatic, Wyant was considered a great artist during his lifetime, representing along with Inness and Homer Dodge Martin the culmination of the Hudson River style. After 1866 Wyant moved toward a more painterly technique, favoring the tonal studies of Jean Baptiste Corot rather than the meticulous renderings of Asher B. Durand. Although painted with topographic accuracy, *The Mohawk Valley* also conveys a preference for mood and atmospheric suggestiveness. (*The Metropolitan Museum of Art; Gift of Mrs. George E. Schanck, in memory of Arthur Hoppock Hearn, 1913*)

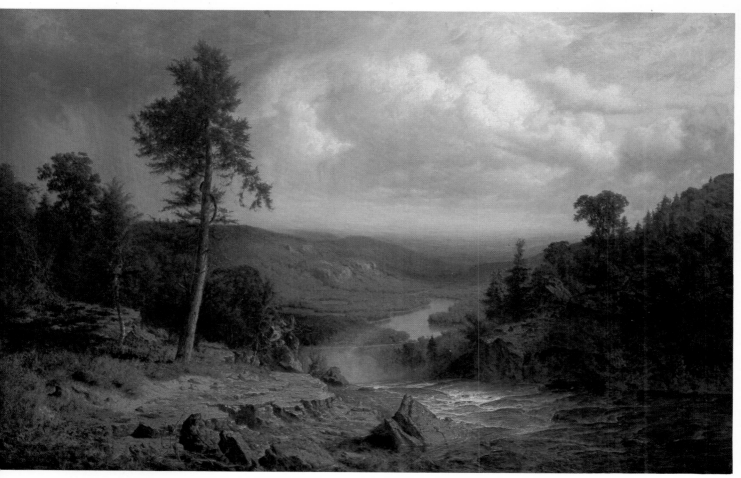

106. John G. Brown (1831–1913) : *View of the Palisades, Snead's Landing, Hudson River.* 1867. Oil on canvas, 38¼″ x 72½″. Brown was an immensely popular genre painter. Called "Newsboy" and the "Bootblack Raphael," he was an industrious purveyor of nostalgic city scenes that documented the plight of orphaned youngsters in the nineteenth century. However, as demonstrated by this view of the Palisades, Brown was also a gifted landscapist. Here, he captures the grand scale of the Palisades, the varied effects of the afternoon sun through the passing clouds, and the animated river traffic. (*The Fine Arts Museums of San Francisco; Gift of Mr. and Mrs. John D. Rockefeller III*)

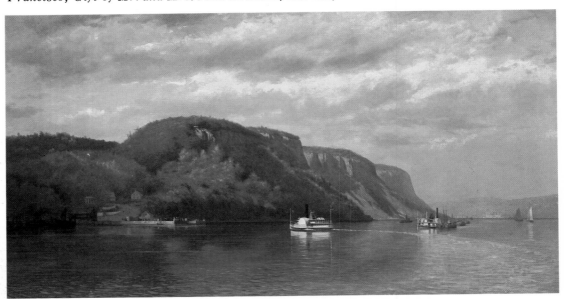

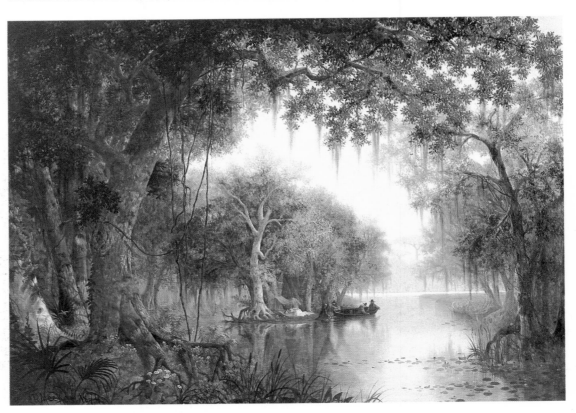

108. John Joseph Rusling Meeker (1827–1887) : *The Land of Evangeline.* 1874. Oil on canvas, 33″ x 46″. The New Jersey–born Meeker specialized in representations of the Louisiana bayous. His pursuit of an exotic landscape was characteristic of his age and, as did both Heade and Church, he recorded that landscape with documentary zeal. (*The St. Louis Art Museum; Purchase, Funds given by Mrs. W. P. Edgerton, by exchange*)

107. Winckworth Allan Gay (1821–1910): *A Farm House at Rye Beach, New Hampshire.* 1870. Oil on composition board, 9⅞" x 19". After early studies with Robert W. Weir at West Point, Gay went to Paris in 1847, becoming the first American to study with a Barbizon artist—Constant Troyon. His modest landscapes were not significantly influenced by the artists from Fontainebleau; however, his exhibition at the Boston Athenaeum during the 1850s did indicate current trends by French counterparts. Gay subsequently traveled to Egypt, Japan, China, and India, returning to Paris in the early 1880s. In 1894 he retired to his native Hingham, Massachusetts, where he remained until his death. (*Museum of Fine Arts, Boston; Bequest of Mrs. Edward Wheelwright*)

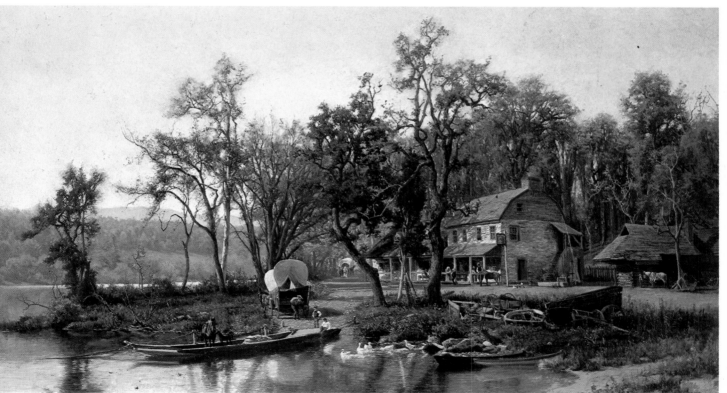

109. Hugh Bolton Jones (1848–1927): *Maryland Tavern.* 1876. Oil on canvas, 30" x 53½". Born in Baltimore, Jones began his art studies at the Maryland Institute, College of Art. *Maryland Tavern* was done a short time before his departure for four years in Europe, where he worked at the Pont Aven, France, artist's colony. A prolific artist represented in numerous collections, Jones is best remembered for his series of landscapes of the flat meadows of New Jersey and New England. (*Kennedy Galleries, Inc.*)

111. Alfred Thompson Bricher (1837–1908): *Morning at Grand Manan*. 1878. Oil on canvas, 25″ x 50″. During the 1870s Bricher made numerous and often repetitive paintings of the coasts of Maine, Massachusetts, and Rhode Island. Distinguished by a glowing tranquillity and luminous atmosphere, they transmit the exhilaration and spiritual pleasure that this generation found in nature, especially from areas that remained unsettled. Bricher maintained a New York studio, sketching extensively during the summer months at Nahant, Massachusetts, and on the islands off Maine. His experiences enabled him to render convincingly the sensation of the summer sun and light as it affects nature. One critic stated: ". . . [He] makes the water sparkle like diamonds in a silver setting."[23] (*Indianapolis Museum of Art; Martha Delzell Memorial Fund, 1970*)

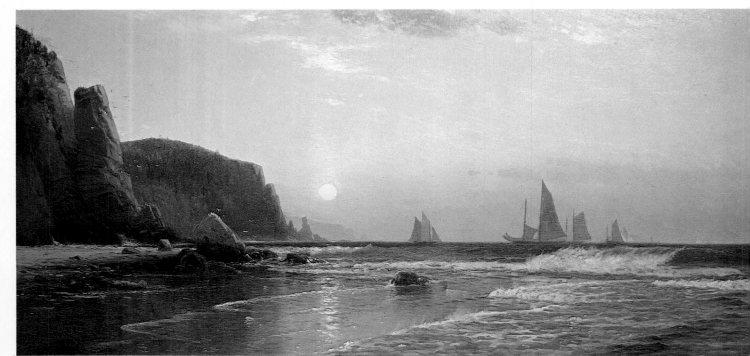

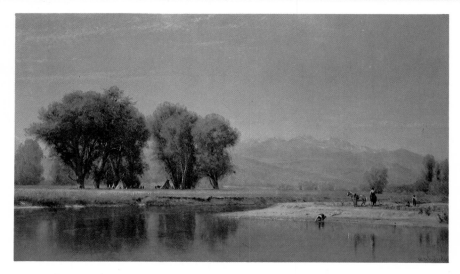

110. Thomas Worthington Whittredge: *On the Plains, Colorado*. 1877. Oil on canvas, 30″ x 50″. In his 1879 *Specimen Days* Walt Whitman noted, "While I know the standard claim is that Yosemite, Niagara Falls, the upper Yellowstone and the like afford the greatest natural shows, I am not so sure but the prairies and the plains, while less stunning at first sight, last longer, fill the aesthetic sense fuller, precede all the rest, and make North America's characteristic landscape. . . . Even their simplest statistics are sublime." Whittredge's vision of the American landscape was consolidated as a result of joining General John Pope's inspection tour through Colorado and New Mexico in the summer of 1866. His earlier "Hudson River" romantic visions of striking forest interiors or virgin wilderness were replaced by a landscape still relatively unravaged by the advances of civilization and characterized by a physical spaciousness that suited current attitudes of manifest destiny. (*Saint Johnsbury Athenaeum*)

112. Sanford R. Gifford: *A Sunset on the Hudson*. 1879. Oil on canvas, 18½" x 34⅛". A native of Hudson, New York (twenty miles below Albany on the Hudson River), Gifford maintained a studio in New York from 1846 until his death. He was, along with his friends, John F. Kensett and Thomas Worthington Whittredge—who accompanied the 1870 Ferdinand Vandeveer Hayden expedition to survey the Northwest Territories—a leading exponent of luminism, an articulate poet of nature dealing with themes of air and sunlight. Gifford's frequent trips on the Hudson River between his New York studio and upstate home not only made the river an integral part of his life but provided the chance to observe its subtle nuances at different seasons and times of day. The critic George W. Sheldon frequently spoke of Gifford's "air paintings" and on one occasion stated, "a veil is made between the canvas and the spectator's eye . . . a veil which corresponds to the natural veil of the atmosphere."[24] (*Private collection; photograph courtesy Hirschl & Adler Galleries, Inc.*)

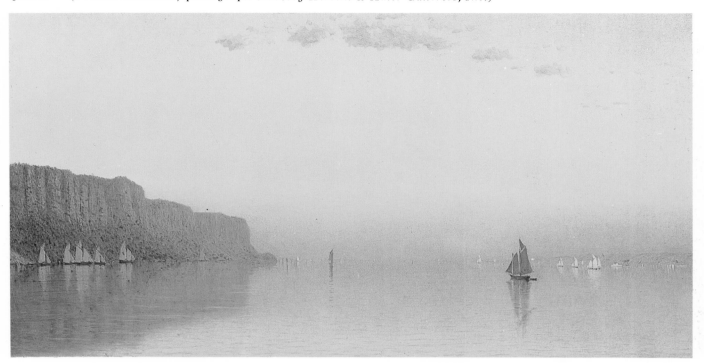

113. Thomas Worthington Whittredge: *A Breezy Day—Newport, Rhode Island*. 1880. Oil on canvas, 25¼" x 38½". After ten years in Europe Whittredge returned to the United States in 1859. In search of picturesque scenery, he traveled west for the first time in 1866. The trip consolidated a vision of the American landscape that emphasized geographical spaciousness or the grandeur of horizontal space. In his *Autobiography* Whittredge stated, "I had never seen any effect like it, and it was another proof of the vastness and impressiveness of the plains."[25] Although these comments were made in reference to the vast plains, they display sentiments shared by a series of landscapes done at Newport, Rhode Island. (*Amon Carter Museum; photograph courtesy Kennedy Galleries, Inc.*)

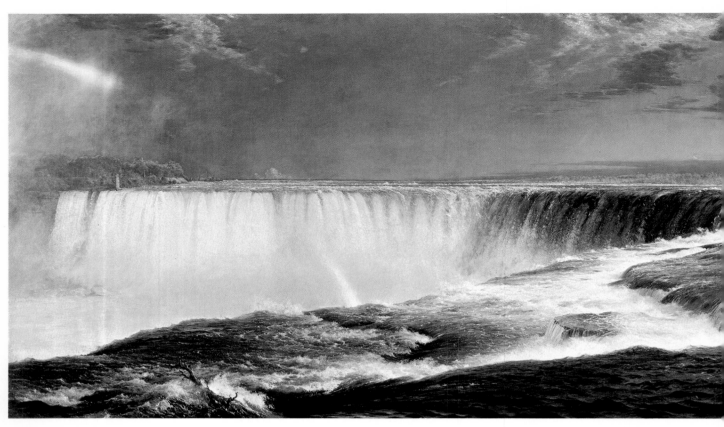
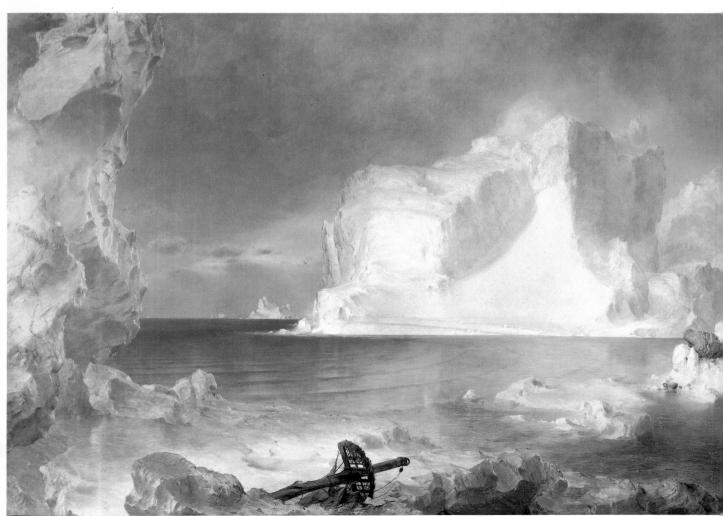

114. Frederic Edwin Church: *Niagara Falls*. 1857. Oil on canvas, 42½″ x 90½″. Church was greatly influenced during the winter of 1856 by his reading of *Modern Painters*, wherein Ruskin merged concepts of art, science, and poetry. It turned his attention to Niagara Falls, that most expressive, dramatic, and thoroughly American scene, which he proceeded to interpret in a Turneresque vocabulary. Considered by many to be the finest picture ever painted on this side of the Atlantic, *Niagara Falls* was painted by Church as viewed from the Canadian shore. Adapting Thomas Cole's teachings to a new age of national determination, Church was technically innovative in his use of an excessive horizontal, the unusual spectator's vantage point, and the animated brushwork. All hint of human drama is eliminated as Church depends on nature's powerful and transcendent revelation for meaning. In his 1835 "Essay on American Scenery" Cole wrote, "And Niagara! That wonder of the world!—Where the sublime and beautiful are found together in an indissoluble chain. . . . At our feet the floods of a thousand rivers are poured out—the contents of vast island seas. In its volume, we conceived immensity; in its course, everlasting duration; in its impetuosity, uncontrollable power."[26] (*The Corcoran Gallery of Art; Purchase, 1876*)

115. Frederic Edwin Church: *The Icebergs (The North)*. 1861. Oil on canvas, 112½″ x 164¼″. "With the exception of an occasional vein which is blue as sapphire, or stains from rock, an iceberg is purely white . . . ghastly and spiritless in a dull atmosphere; but in bright weather, especially late in the afternoon, kindling with a varied splendor. The picture aims to represent the berg at that brilliant hour" (Broadside, 1861). Frederic Church, accompanied by the Reverend Louis Noble, traveled to St. John's, Newfoundland, in June 1859 and chartered a ship for the purpose of making studies and sketches of icebergs in preparation for the first large and definitive painting of the arctic regions in the nineteenth century. After much anticipation on the part of the public and the press, the picture was first exhibited in April 1861 at Goupil's Gallery, New York, under the title *The North*. Eventually, the painting was reproduced as a chromolithograph by C. Risdon, after its exhibition in London in 1863.

The following is an excerpt from the review devoted to *The Icebergs* in the September 1, 1863, *Art Journal:* "You look across some transitory bay, whose dark waters, subsiding calmly, gleam strangely with the reflections of a huge, majestic berg not far away, to which the evening sun is imparting mild mysteries, sweet hintings of the loveliest prismatic colors. . . . It is to the heart of the *Icebergs* you have been brought now." *Icebergs* became a standard comparison for Church's subsequent paintings, and the reviews of his next major works, *Cotopaxi* (1862), *Chimborazo* (1864), and, particularly, *Aurora Borealis* (1865) refer to it, frequently. (*Dallas Museum of Fine Arts; Anonymous Gift*)

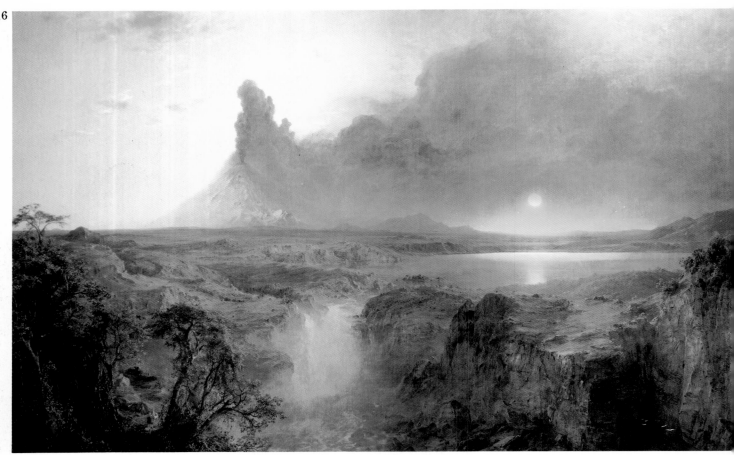

116. Frederic Edwin Church: *Cotopaxi*. 1862. Oil on canvas, 48″ x 85″. An important aspect of our landscape painting was the search for a native and heroic subject matter that possessed a timeless and cosmic meaning. As the nineteenth century progressed, this search began to focus on the vivid drama of nature found in South America and the Arctic. Encouraged by his earlier success, Church set off for South America in 1853, his first trip in search of an exotic landscape that might convey a fresh view of God-in-nature. Compelled by the thrill of undiscovered frontiers and the exhilarating writings of the German naturalist Alexander von Humboldt, Church visited South America again in 1857. He executed numerous pencil and oil sketches, which were later worked into finished paintings. The most persistent image from these trips was that of Cotopaxi, a still active volcano in north-central Ecuador. Placing the spectator almost over the foreground precipice, Church—with botanical exactitude—presents a vast panorama of a spectacular geography. In its curious mingling of atmospheric effects, both real and imagined, the painting provides the spectator with an escape from reality. When exhibited, these large paintings created a sensation: depiction of such an exotic landscape was new to American painting. So convincing was the imagery that spectators often spent hours examining each portion of it through opera glasses. (*The Detroit Institute of Arts; Purchase, Robert H. Tannahill Foundation, Gibbs-Williams, Dexter M. Ferry, Jr., Merrill and Beatrice W. Rogers and Richard A. Manoogian Funds*)

117. Albert Bierstadt: *The Domes of the Yosemite*. 1867. Oil on canvas, 116″ x 180″. Joined by F. H. Ludlow, Bierstadt in 1863 made his second trip west. Encountering Yosemite Valley for the first time, his companion described the view as seen from Inspiration Point: "That name had appeared pedantic, but we found it only the spontaneous expression of our own feelings on the spot. We did not so much seem to be seeing . . . a new scene on the old familiar globe as a new heaven and a new earth into which the creative spirit had just been breathed. I hesitate . . . to give my vision utterance. Never were words so beggared for an abridged translation of any Scripture of Nature."[27] Remaining at this camp for seven weeks, Bierstadt had finally found the "consummate emblem of national celebration, geology and metaphysics." (*Saint Johnsbury Athenaeum*)

118. Thomas Moran (1837–1926): *Cliffs of the Upper Colorado River, Wyoming Territory*. 1882. Oil on canvas, 16″ x 24″. Best known for his monumental canvases of Yellowstone, Moran spent much of his life exploring and depicting great geological formations. This painting was completed in the same year as a trip to Scotland's western isles and reveals the extent of Moran's debt to both the coloration and expressive movement of Joseph M. W. Turner's seascapes. Considering art to be in part an expression of emotions, Moran stated the following to the critic George W. Sheldon, "[Turner] sacrificed the literal truth of the parts to the higher truth of the whole. And he was right. Art is not Nature; an aggregation of ten thousand facts may add nothing to a picture, but be rather the destruction of it. . . . I place no value upon literal transcripts from Nature. My general scope is not realistic: all my tendencies are toward idealization."[28] (*National Museum of American Art, Smithsonian Institution; Bequest of Henry Ward Ranger through the National Academy of Design*)

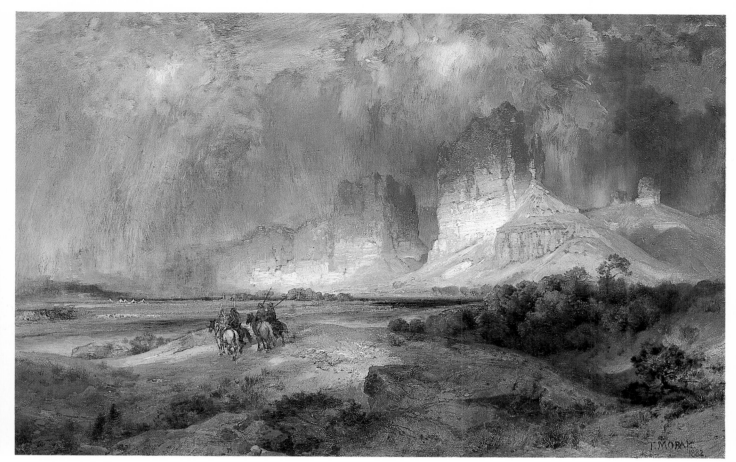

118

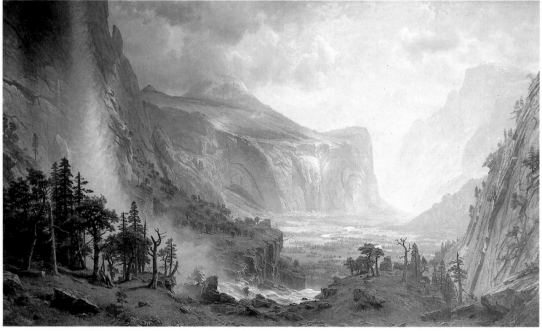

117

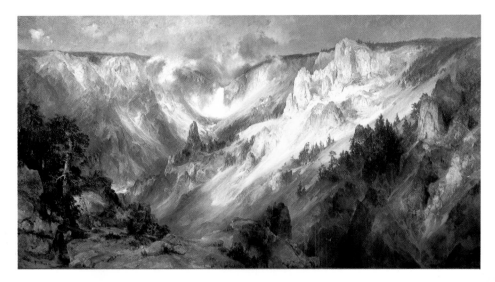

119. Thomas Moran: *The Grand Canyon of the Yellowstone.* 1893–1901. Oil on canvas, 96½″ x 168⅜″. Many artists made the arduous journey to record these breathtaking sights, but among them Thomas Moran is considered to have made the most important contribution to our awareness of this region. Inspired by both the technical possibilities found in the luminous works of Joseph M. W. Turner and the popular success of Albert Bierstadt, Moran—at the age of thirty-four—set out in 1871 with the geologist Ferdinand Vandeveer Hayden on a government surveying expedition to the Grand Canyon of the Yellowstone. The powerful impression created by his numerous on-the-spot watercolors was perhaps the most important factor in persuading Congress to preserve this national asset by establishing Yellowstone as a national park. (*National Museum of American Art, Smithsonian Institution; Gift of George G. Pratt*)

120. George Inness: *The Lackawanna Valley.* 1855. Oil on canvas, 33⅞″ x 50¼″. Commissioned by the first president of the Delaware, Lackawanna, and Western Railroad, this painting was intended to depict the new roundhouse complex at Scranton, Pennsylvania. As does Cropsey's *Starrucca Viaduct* (1865), Inness's painting presents nature in tenuous balance with impending industrialization. Exposure to Barbizon School painting during his 1854 travels in France strongly influenced his subsequent stylistic development. Within the context of American art this style was new and modern, and Inness was the purveyor or the ideological harbinger of a modern art. Gradually, he began the transition from a landscape based on subject matter—as emphasized by the Hudson River tradition—to one that explored the actual painterly process. (*National Gallery of Art; Gift of Mrs. Huttleston Rogers*)

121. George Inness: *Peace and Plenty*. 1865. Oil on canvas, 77⅝″ x 112⅜″. Painted to celebrate the conclusion of the Civil War, *Peace and Plenty* is among the artist's best-known works. It was executed in his Eagleswood, New Jersey, studio from various sketches made in Medfield, Massachusetts, and represents a composite impression of his response to the scene. In this painting Inness was clearly seeking to awaken an emotion and to convey a spiritual message unencumbered by topographical exactitude. This elimination of meticulous detail and the Barbizon-inspired painterly technique together emphasize the subjective mystery of nature. In contrast to Thomas Cole Inness's moral intent is not dependent on a sublime effect; rather he prefers a beautiful and peaceful landscape to convey his sense of national optimism. (*The Metropolitan Museum of Art; Gift of George A. Hearn, 1894*)

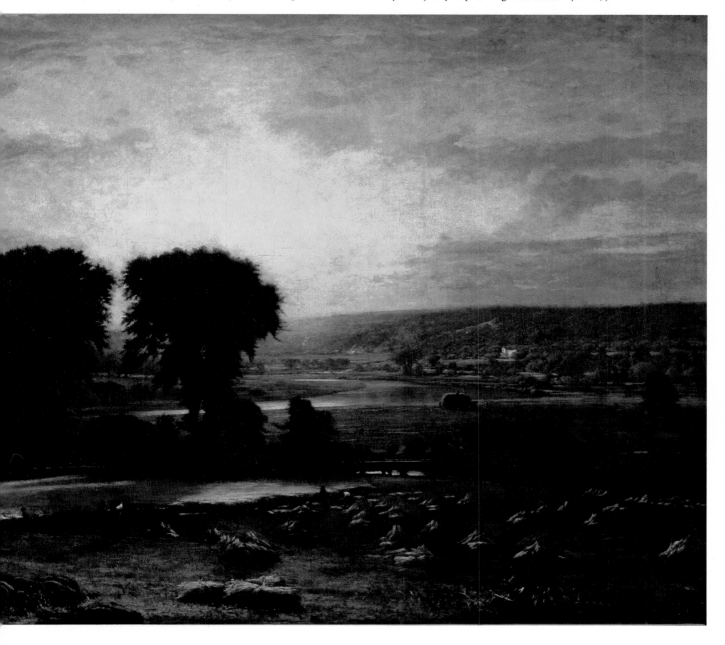

122. Eastman Johnson (1824–1906): *Sugaring Off*. 1860–1865. Oil on canvas, 17⅛″ x 32″. Distressed by the emotional and physical disruption of the Civil War, Johnson returned to the familiar and peaceful community of Fryeburg, Maine. There he became fascinated with the annual event of sugaring-off maple syrup. During the 1840s similar scenes of this celebration were popular symbols of national well-being. As conveyed by his French academic teacher Thomas Couture, Johnson's working method consisted of preparing quick expressive sketches that suggested the form and the colors. In this work very little of the overall scene is fully described, and yet we quickly respond to the striking atmospheric nuances. Composed in a documentary fashion, the sugaring-off event was transformed by Johnson into a monumental genre painting of contemporary American culture. (*The Fine Arts Museums of San Francisco; Gift of Mr. and Mrs. John D. Rockefeller III*)

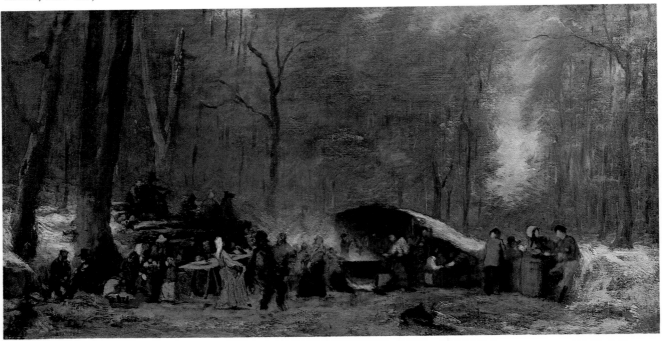

123. John La Farge (1835–1910): *Bishop Berkeley's Rock, Newport*. 1868. Oil on canvas, 30¼″ x 25¼″. This landscape was done during the time that La Farge joined William Morris Hunt's studio in Newport, Rhode Island. In 1864 the critic J. J. Jarves discussed the artist's work, noting that La Farge "evokes the essence of things, draws out their soul-life, endowing them with an almost superhuman consciousness. The solemn splendor and the interpenetrative power of his free, unconventional manner, with its spiritual suggestiveness of hues, seize upon the imagination and bind it firmly to his art, through sentiments that react more directly upon the heart than the head."[29] Simplified though richly painted, his muted landscapes anticipate La Farge's later work in stained glass. Discouraged by the public reception accorded his landscapes, La Farge in the 1870s began to experiment with new media, and during the late 1880s traveled to Tahiti, Samoa, and the South Seas. (*The Metropolitan Museum of Art*)

124. Thomas Eakins (1844–1916): *Max Schmitt in a Single Scull*. 1871. Oil on canvas, 32¼″ x 46¼″. Unlike the outdoor game scenes of Winslow Homer, Eakins was very concerned about representing the nuances of specific individuals and locations. Here, Eakins's boyhood friend Max Schmitt is seen in his shell, *Josie*, on the Schuylkill River, above the Girard Street Bridge. The picture represents the extent to which Eakins studied and applied intricate laws of perspective customarily reserved for representing architectural or illusionary stage designs. Curiously, Eakins did not paint out of doors, preferring to rely on small sketches, color notes, and an almost photographic recollection. Despite his scientific proclivities Eakins notes an elusive element when, on the process of artistic creation, he commented that one "combines and combines, never creates—but at the very first combination no man, and least of all himself, could ever disentangle the feelings that animated him just then, and refer each one to its right place."[30] (*The Metropolitan Museum of Art; Purchase, 1934, Alfred N. Punnett Fund and Gift of George D. Pratt*)

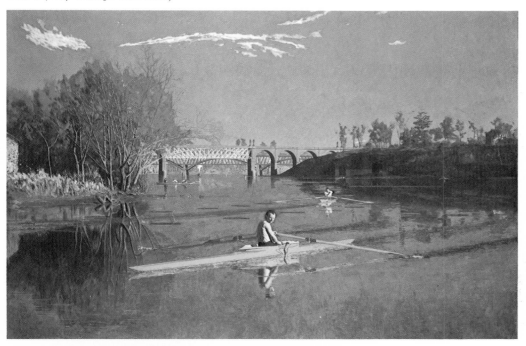

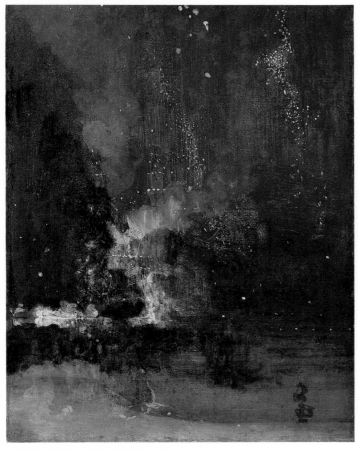

125. James Abbott McNeill Whistler (1834–1903): *Nocturne in Black and Gold: The Falling Rocket*. c. 1874. Oil on canvas, 24¾″ x 18⅜″. Greatly influenced by the Symbolist poet Stéphane Mallarmé, Whistler adhered to his advice, "Do not paint the object but the effect which it produces."[31] Inspired by a display of fireworks in London's Cremorne Gardens, *Nocturne in Black and Gold* is deliberately abstract, an adventure in subjective poetry that Whistler described as "an arrangement of line, form, and color." Infuriating the venerable English critic John Ruskin, this painting resulted in a famous trial wherein the revolutionary aesthetics of modernism were first voiced. It also represents the beginnings of a significant transition from traditional values, as the actual artistic process and personal expression were accepted as subjects rather than a scene distinguished by its realism or moral meaning. In 1878 the artist stated: "Art . . . should stand alone, and appeal to the artistic sense of eye or ear, without confounding this with emotions entirely foreign to it, as devotion, pity, love, patriotism or the like."[32] (*The Detroit Institute of Arts; Purchase, Dexter M. Ferry, Jr., Fund*)

126. George Inness: *Etretat.* 1875. Oil on canvas, 30" x 45". A favorite location during Inness's third European trip was Étretat, situated on the northern French coast where the Seine River meets the English Channel (sixteen miles from Le Havre). The stunning cliffs and captivating environment of this French resort had also attracted Gustave Courbet, Jean Baptiste Corot, and Claude Monet. Sensuously articulated, the scene creates a mood quite different from Hudson River landscapists, reflecting the artist's appreciation of the French painters. Inness presents a clear reaction against the wilderness worship of Thomas Cole and Frederic Church by advocating the significance of civilized landscape. In 1878 he stated, "I love it more and think it more worthy of reproduction than that which is savage and untamed. Every act of man, every thing of labor, effort, suffering, want, anxiety, necessity, love, marks itself wherever it has been."[33] Already evident in his 1875 painting of Étretat, this attitude represents an important shift in our landscape tradition. (*Wadsworth Atheneum; The Ella Gallup Sumner and Mary Catlin Sumner Collection*)

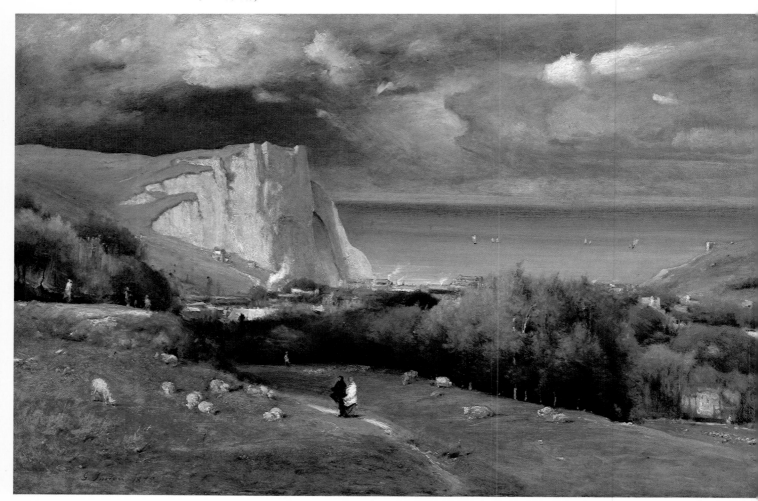

127. George Inness: *Clearing Up.* c. 1875. Oil on canvas, 27½″ x 41½″. Having returned from his third stay in Europe the previous winter, Inness began working near North Conway, New Hampshire, in the summer of 1875. In the heart of the beautiful White Mountains Inness applied the lessons of his recent experience to an active investigation of design, painterly brushwork, and color. The artist emphasized color, as he considered it to be the soul of a painting. A contemporary, the critic G. W. Sheldon, described Inness's principal pigments as white, very little black, Antwerp blue, Indian red, and lemon chrome. These pictorial experiments would attain fruition in Inness's paintings of the 1890s, wherein visual reality becomes secondary to the expression of a spirituality or inner emotion. Finally, in this work of around 1875 Inness proposes a clever analogy between the recent war and the subject of this landscape: the wake of the storm will witness the restoration of harmony or the natural order of an agrarian ideal. (*Kennedy Galleries, Inc.*)

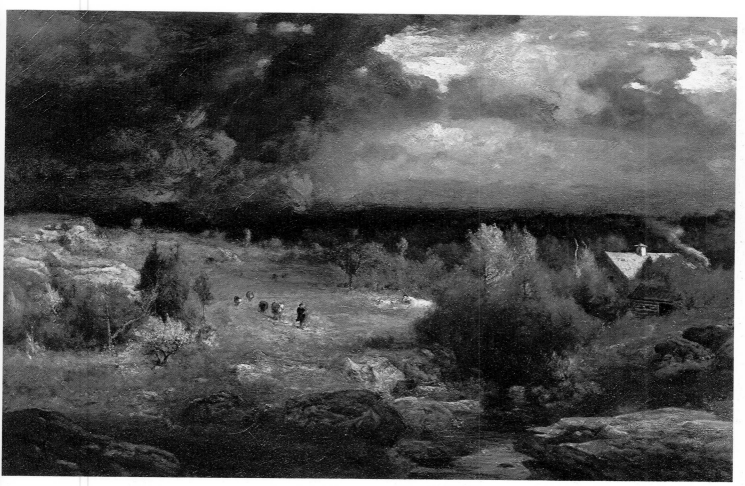

128. William Morris Hunt (1824–1879): *Gloucester Harbor.* 1877. Oil on canvas, 21″ x 31¼″. The son of a Vermont congressman, Hunt spent much of his time abroad studying or traveling. After six years with Thomas Couture in Paris and two years with J. F. Millet at Barbizon, Hunt returned to this country in 1854, moving to Newport, Rhode Island, two years later and eventually to Boston in 1862. While in Kettle Cove on Cape Ann, Hunt executed this painting in one summer afternoon, whereupon he exclaimed, "I believe that I have painted a picture with *light* in it!"[34] Hunt's remark was surprising because he frequently expressed his difficulty in depicting the transience of natural light. In contrast to works by the French Impressionists this painting reveals a persistent American tendency to maintain a semblance of solid form and detail. Among his contemporaries Hunt was recognized as one of New England's finest portraitists and a staunch Boston supporter of Barbizon art. (*Museum of Fine Arts, Boston; Gift of H. Nelson Slater, Mrs. Esther Slater Kerrigan, and Mrs. Ray Slater Murphy in memory of their mother, Mabel Hunt Slater*)

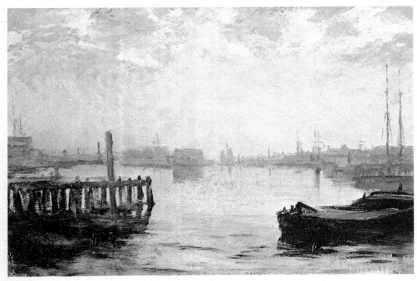

128

130. Winslow Homer: *Houses on a Hillside.* 1879. Oil on canvas, 15¾″ x 22½″. Compelled by a love of the outdoors, Homer carried Thomas Cole's vision of nature to new expressive heights, conveying the effects of light and atmosphere with a vigorous immediacy. In 1875 the critic Henry James (1843–1916) stated, "He is a genuine painter; that is, to see, and reproduce what he sees, . . . with its envelope of light and air."[35] *Houses on a Hillside* is an important transitional work, done after his 1866–1867 visit to France and preceding his equally influential 1881–1882 visit to Tynemouth, England. Distinguished by its bright coloring, animated brushwork, and bold forms, the painting not only is indicative of Americans engaged in postwar leisure activities but also anticipates the theme of individual and psychological solitude in nature, a subject that pervades much of Homer's later work. (*Hirschl & Adler Galleries, Inc.*)

130

129. Thomas P. Anshutz (1851–1912): *The Farmer and His Son at Harvesting.* 1879. Oil on canvas, 24¼″ x 17¼″. Born in Newport, Kentucky, Anshutz received his early training at the National Academy of Design before working in 1875 with Thomas Eakins at the Pennsylvania Academy of the Fine Arts. He became a member of the faculty in 1881, eventually serving as head of the faculty from 1888 for twenty-four years. Despite Eakins's departure from the academy his ideas continued in the teaching of his oldest follower. Anshutz enjoyed unprecedented success as a teacher, counting among his students Robert Henri, John Sloan, Maurice Prendergast, William Glackens, George Luks, John Marin, and Charles Demuth, and in so doing provided a powerful influence on the direction of early twentieth-century American art. Thus, the Eakins tradition was transferred through the teaching of Anshutz and Henri into this century, rivaling the earlier influence of Benjamin West and that which would be provided by Hans Hofmann. (*Sotheby Parke Bernet, Inc.*)

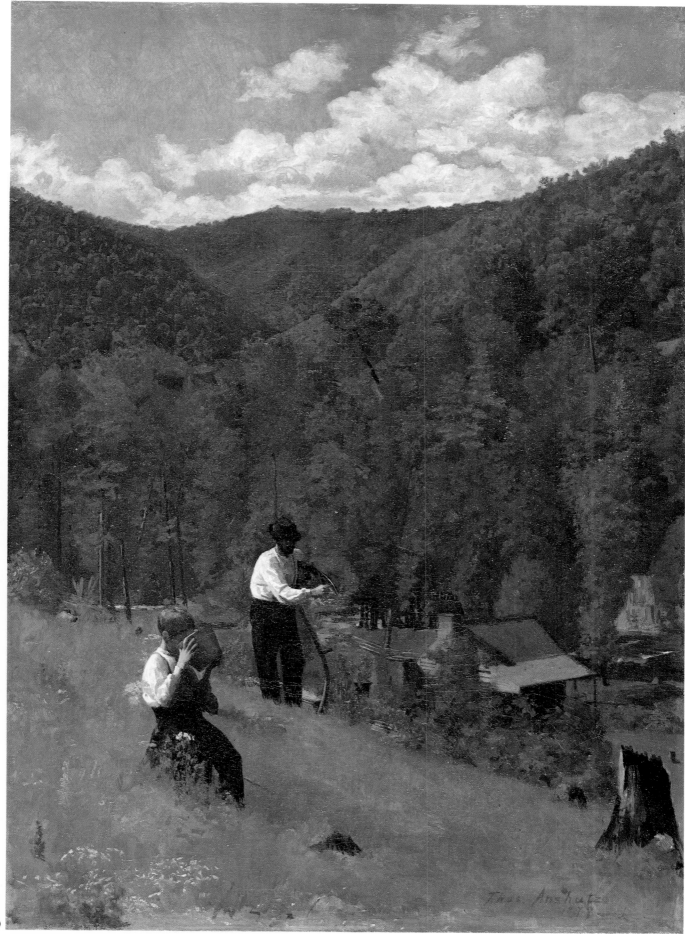

131

133

131. Eastman Johnson: *The Cranberry Harvest, Nantucket*. 1880. Oil on canvas, 27¼″ x 45¼″. During the 1870s, Johnson spent his summer months on Nantucket, an island off the Massachusetts coast, working on a series of plein-air studies of the cranberry harvest, another typically American event. The scene is modulated in a golden sunlight that seems to anticipate autumn. As reflected in the surrounding fields, dunes, and sky, the sun's warmth is conveyed in a limited color range, frequently highlighted in critical details yet avoiding precise outlines. Along with both the luminists and the Impressionists Johnson was experimenting with how light modifies our perception of our surroundings. Devoid of sentimentality the scene is an honest transcription of a contemporary rural activity. Within seven years after completing this painting, Johnson abandoned genre scenes for the more profitable field of portraiture. (*Timken Art Gallery, The Putnam Foundation; photograph courtesy Vose Galleries of Boston, Inc.*)

132. Henry A. Ferguson (1843/45–1911): *Glens Falls, New York*. 1882. Oil on canvas, 15″ x 26″. Ferguson was born and raised in Glens Falls, but after extensive travels throughout Mexico, South America, Europe, and Africa he settled in New York. His early experience in graphic techniques is clearly reflected in the meticulous detail that characterizes this painting. In many respects this painting anticipates Joel Cook's somewhat later observations in *America, Picturesque and Descriptive*: "Along the north side of the ravine, upon a beautiful plain, is the manufacturing settlement of around 10,000 people . . . Vast numbers of logs coming down the Hudson are gathered in a boom above the town, and sawmills cut them into lumber. Papermills cluster about the falls, and marble-saws work up the black rocks. In the center of the ravine, above the falls, a cavern is hewn where a rocky inlet makes a rude abutment for a bridge pier."[36] (*Courtesy Crandall Library*)

133. Childe Hassam (1859–1935): *Orchard in Bloom*. 1883–1886. Oil on canvas, 14¼″ x 18¼″. Beginning with an 1883 exhibition in Boston, Hassam's artistic distinction continued unabated for more than half a century. During that time his works were exhibited annually, reviewed favorably by the press, and purchased enthusiastically by collectors. Hassam traveled to Paris in 1885 and his *Orchard in Bloom* is an excellent example of his response to that experience. Representing the start of his concentration on fully orchestrated studies in subtle color harmonies, it is also one of his earliest experiments in the use of white as a separate pigment. Although the white does not dominate, Hassam selected the values of yellow, green, and brown in relation to it, thus creating an "envelope" of color. The use of a tilted picture plane continued in his later work. As did many other American landscape painters, Hassam received his early instruction in the graphic arts, producing more than 400 etchings and lithographs after the turn of the century. (*Private collection; photograph courtesy Wildenstein & Co. Inc.*)

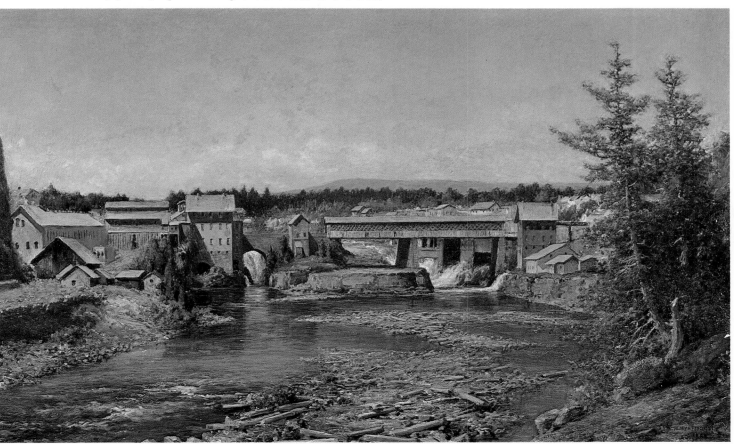

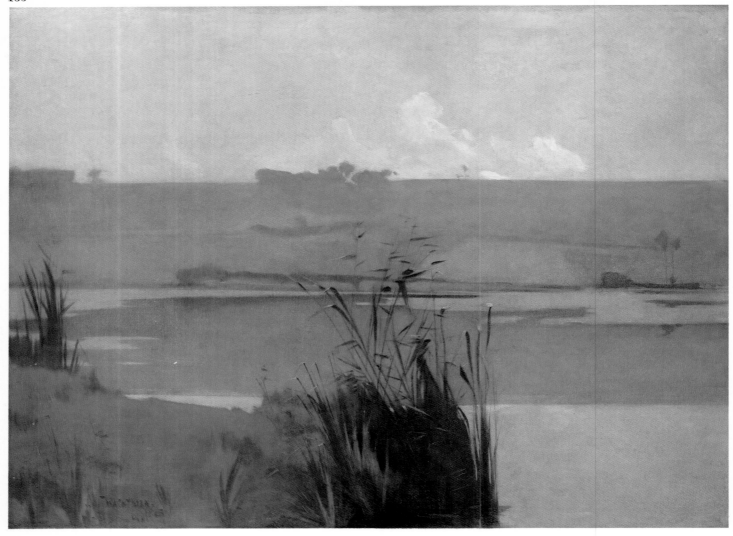

134. J(ohn) Francis Murphy (1853–1921): *Tints of a Vanished Past.* 1885. Oil on canvas, 33″ x 23½″. A regular exhibitor at the National Academy of Design, Murphy in 1887 built a studio at Arkville, New York, in the Catskills. Spending both the summer and autumn there, he returned to a studio in New York's Chelsea district during the winter. Curiously, Murphy was the first important artist since Thomas Cole who actually resided in the Catskills. In 1885 Murphy's work began to change from one based on direct observation of nature—recorded with realistic detail—to more poetic landscapes influenced by the Barbizon style of Wyant (an Arkville, New York, neighbor) and Inness. In contrast to this painting, which is also evocative of Corot, Murphy's contemporaries preferred his works from after the 1910s, especially his series of Indian summer landscapes where he combined a limited palette and a roughened surface texture. (*Mr. and Mrs. Herbert Baer Brill*)

135. John Henry Twachtman: *Arques-la-Bataille.* 1885. Oil on canvas, 60″ x 78⅞″. A native of Cincinnati, Twachtman was a close friend of Frank Duveneck. After extensive travels in Germany, Italy, and Holland he arrived in Paris in 1883, the same year that Claude Monet settled at Giverny. This painting shows a town located at the confluence of the Arques and Béthune rivers, about six miles southwest of the coastal city of Dieppe. Destined for the Paris Salon, it reflects the experience of his diversified travels; the vigorous brushwork and the almost monochromatic color recall the Munich Academy, while the decorative patterning, the lightened palette, and the elegant forms reflect the influence of Impressionism, James Abbott McNeill Whistler, and Japanese prints. His friend Childe Hassam once said of him, "The great beauty of design . . . is what impressed me always . . . strong, and at the same time delicate even to evasiveness."[37] (*The Metropolitan Museum of Art; Purchase, Morris K. Jesup Fund*)

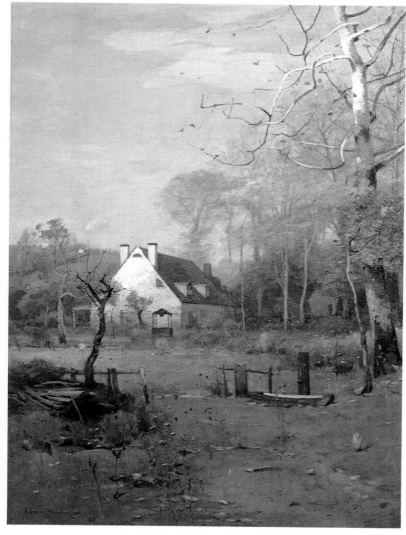

136. John Singer Sargent (1856–1925): *Home Fields*. 1885. Oil on canvas, 28¾" x 38". Sargent returned to landscape painting soon after his portrait of Madame Pierre Gautreau (*Madame X*, 1884, The Metropolitan Museum of Art) caused a controversy at the 1884 Paris Salon. Arriving in London during the summer of 1885, he subsequently made frequent trips—at the invitation of Edwin A. Abbey—to the Worcestershire countryside, twelve miles south of Stratford-upon-Avon. Reminiscent of Édouard Manet in his broken brushstrokes and use of flat colors with contrasting hues, Sargent sought to show the effect of light at specific times of day. In this painting the lengthening shadows indicate the approach of sunset. As in his provocative portraits, Sargent's primary purpose was to capture the true appearance of objects in nature, qualified only by his emphasis on the actual process of translating his impression into paint. On one occasion, the English poet Edmund Gosse observed Sargent working on a landscape, "He was accustomed to emerge from the house carrying a large easel, to advance a little way into the open and then suddenly plant himself down nowhere in particular, . . . his object was to acquire the habit of reproducing precisely whatever met his vision."[38] (*The Detroit Institute of Arts; Purchase, City Appropriation*)

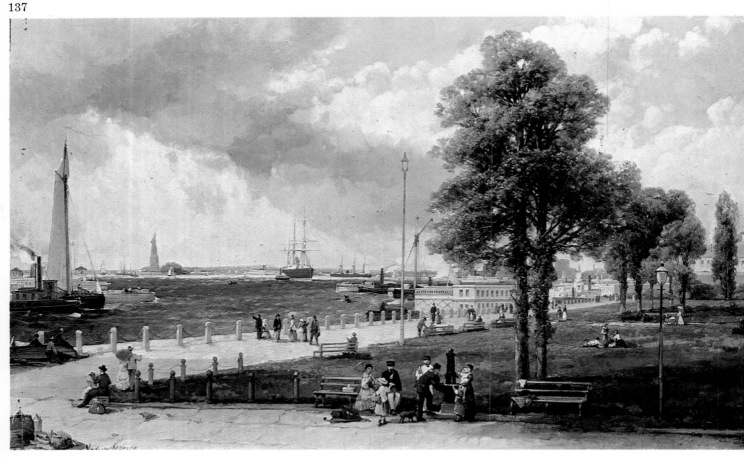

137. Andrew Melrose (1836–1901): *New York Harbor and the Battery.* c. 1887. Oil on canvas, 22″ x 36″. This painting was widely distributed as a chromolithograph in 1887. Displaying the recently unveiled Statue of Liberty, it perpetuates a tradition of bright and finely drawn view painting seen earlier in the work of Nicolino Calyo, Thomas Birch, Robert Salmon, and others. Although active along the entire eastern seaboard, Melrose was at his best in scenes of New York City and the Hudson River. (*The White House Collection*)

138. Albert Pinkham Ryder: *The Flying Dutchman.* c. 1887. Oil on canvas, 14¼″ x 17¼″. Although his imagery shared the romantic tradition introduced by Washington Allston, Ryder was intensely relevant for twentieth-century painters. Represented in the pivotal Armory Show of 1913 with ten paintings (none by Winslow Homer or Thomas Eakins), Ryder was described by his young friend Marsden Hartley in the following terms, "He had in him that finer kind of reverence for the element of beauty which finds all things somehow lovely. He understood best of all the meaning of the grandiose of everything that is powerful. . . . Ryder gave us first and last an incomparable sense of pattern and austerity of mood. Ryder was the last of the romantics, the last of that great school of impressive artistry, as he was the first of our real painters and the greatest in vision. . . . He knew the fine distinction between drama and tragedy, the tragedy which nature prevails upon the sensitive to accept. He was the painter-poet of the immanent in things."[39] (*National Museum of American Art, Smithsonian Institution; Gift of John Gellatly*)

139. Winslow Homer: *Winter Coast.* 1890. Oil on canvas, 36″ x 31½″. A radical change in style and subject matter emerged after Homer's second trip abroad (1881–1882) to a small fishing village near Tynemouth on the rugged North Sea coast. Returning to Prout's Neck, Maine—a place close in mood to Tynemouth and the artist's temperament—Homer's physical isolation during the long winter months challenged the artist to create his most successful compositions. The pervasive theme was solitude, both on an individual basis and as the focal point for a metaphoric exploration of humanity's relationship with nature. In this painting the sloping rocks of Prout's Neck and the distant surf completely overshadow the lone human figure. Technically, Homer's colors become more restrictive and somber and the atmospheric treatment more dramatic, qualities that substantially enhance the thematic impact. (*Philadelphia Museum of Art; John J. Johnson Collection*)

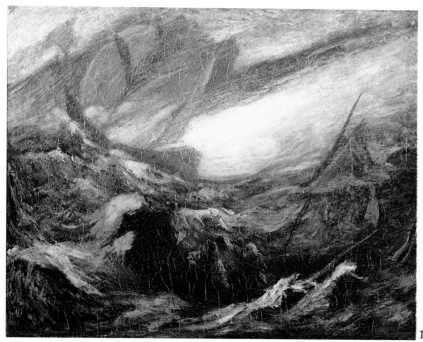

138

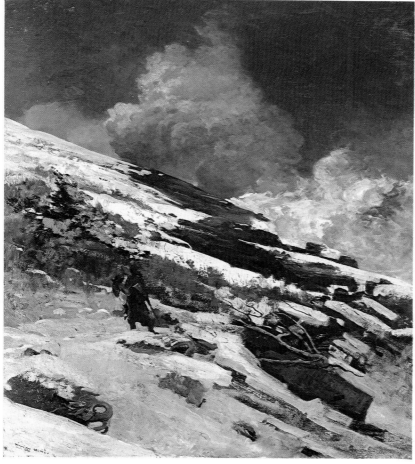

139

140. Ralph A. Blakelock (1847–1919):
Pawpack Falls, Hawley, Pennsylvania. c.
1891. Oil on canvas, 42½″ x 30½″.
Largely self-taught, Blakelock was best
known for his romantic and heavily im-
pastoed canvases of Indian encampments
and moonlit landscapes. Even though re-
petitive in subject matter, he was a
highly original colorist who built up suc-
cessive layers of paint, glaze, and var-
nish. In contrast to the haunting drama
found in Ryder, Blakelock preferred a
gently lyrical quality that differed
markedly from his troubled health and
precarious financial existence.

Writing in 1902, Frederick W. Mor-
ton stated, "Blakelock's compositions for
the most part are extremely simple. He
beheld a scene and received an impres-
sion. . . . He did not require composi-
tion with minute detail, and hence many
of his best works are little more than a
mere hint of a landscape—a broad
stretch of sky . . ., a stream or a pool
of water, . . . or perhaps a mountain in
the distance indistinct in the haze of a
summer afternoon. These simple ele-
ments sufficed for a framework, and his
sense of color and his ability to produce
tonal effects supplied the rest."[40] Here
Blakelock has chosen a simple landscape
view to explore the visual possibilities of
color, texture, and pattern, arriving at
a very personal vision of the scene.
(*Vose Galleries of Boston, Inc.*)

141. Theodore Robinson (1852–1896):
Port Ben, Delaware and Hudson Canal.
1893. Oil on canvas, 28¼″ x 32″. Among
the artist's most inspired works, *Port
Ben* has been described as a "jewel of
color and observation." Initially painting
in the manner of Winslow Homer and
Eastman Johnson, Robinson, after meet-
ing Claude Monet in 1887 at Giverny,
pursued a stylistic middle ground be-
tween French Impressionism and Ameri-
can realism. Although Robinson admired
Monet, he remained distrustful of the
French tendency to dissolve form in
color, preferring to maintain the integ-
rity of the objects in his paintings. De-
spite the color similarities to Monet, this
scene is not dissolved in a pervasive
light; rather Robinson uses the diagonal
canal to emphasize the pictorial depth.
After five years Robinson left Giverny in
1892 "disappointed with his recent work
and intensely aware of his continuing
inability to represent structural, three
dimensional forms using impressionist
techniques."[41] (*Pennsylvania Academy
of the Fine Arts; Gift of the Society of
American Artists*)

142. Winslow Homer: *The Artist's Studio in an Afternoon Fog.* 1894. Oil on canvas, 23⅞" x 30¼". After returning home from England in 1882, Homer moved for good to Prout's Neck, Maine, whose dramatic and isolated landscape provided him with subject matter for the rest of his career. Especially during the 1890s, he created a stunning series of major works that sought to examine profound and universal themes of humanity. Here, he has imbued a simple view of his studio with an epic quality—a quality charged by the brilliant glow of the sun through an afternoon fog that somehow transcends the transient moment and addresses an eternal situation. (*Memorial Art Gallery of the University of Rochester; R. T. Miller Fund*)

143. Julian Alden Weir (1852–1919): *The Red Bridge*. 1895. Oil on canvas, 24¼″ x 33¾″. A devoted friend of the poetic visionary Albert Pinkham Ryder, Weir also created decorative improvisations on nature that reflect an independent vision. *The Red Bridge* clearly reveals Weir's familiarity with and assimilation of Oriental mannerisms, especially Hiroshige's *Ohashi Bridge in Rain* (1857), copied by Van Gogh in 1886–1888. This influence is evident in his fascination with intersecting horizontals and verticals and the arbitrary truncating of the bridge. Quite possibly, this Oriental influence was transmitted through James Abbott McNeill Whistler, a close friend of Weir's father. In *American Art* John Wilmerding noted, "An equally strong decorative structure holds together J. Alden Weir's *Red Bridge* of 1895, which contains as well complex balances of reds and greens, water and sky, nature and industry. As a romantic image of technology, this bridge marks an interesting point of transition between the images of Cropsey thirty years earlier and Joseph Stella thirty years later."[42] (*The Metropolitan Museum of Art; Gift of Mrs. John A. Rutherfurd, 1914*)

144. Homer Dodge Martin (1836–1897): *Harp of the Winds: A View on the Seine.* 1895. Oil on canvas, 28¾″ x 40¾″. An early practitioner of the Hudson River landscape style, Martin gradually came under the influence of George Inness's painterly emphasis on the awakening of an emotion. Restricted throughout his life by a vision impairment, Martin relied extensively on his memory, which deprived his works of the vigorous qualities of on-the-spot observation. By 1890, and living in Minnesota, he was nearly blind and yet exclaimed, "I have learned to paint at last. If I were completely blind now and knew where the colors were on my palette, I could express myself."[43] *Harp of the Winds* was painted from memory and as such, represents his emotional involvement with nature's subjective moods. (*The Metropolitan Museum of Art; Gift of Several Gentlemen, 1897*)

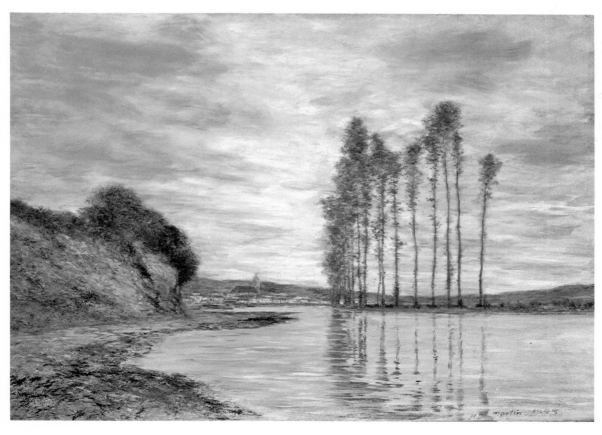

145. Henry Ward Ranger (1858–1916): *Connecticut Woods.* 1899. Oil on canvas, 28¼″ x 36¼″. An assiduous student of Barbizon and nineteenth-century Dutch art during his formative years, Ranger was strongly influenced by Impressionism; his palette became brighter and his brushwork more spontaneous. Beginning in 1899 he started spending his summers in the vicinity of Old Lyme, Connecticut, establishing an artist's colony in the next year. One critic noted: "His specialty was forest interiors in which one is led in quiet stages back into the woods or down a winding stream. He lavished great attention on the bark of large, partially lit trees, their autumn leaves rendered in thick dabs of paint over damp varnish."[44] Today, Ranger is best known as a proponent of an American art based on Barbizon precedents. (*National Museum of American Art, Smithsonian Institution; Gift of William T. Evans*)

146. Childe Hassam: *Bridge at Old Lyme*. 1908. Oil on canvas, 24″ x 27″. Increasingly during the 1890s Hassam's painting surface became considerably brighter and more vibrant. Displaying a vigorous surface tension reminiscent of Claude Monet, *Bridge at Old Lyme* maintains the quintessentially "native" flavor that ensured Hassam's popularity. His works did not serve a storytelling capacity; rather his attention remained directed toward the creation of spatially effective and aesthetically pleasing arrangements of colors and forms. As did countless others, Hassam developed a personal view that represented the synthesis of several styles. His affinity to the Impressionism of Monet and Alfred Sisley progressively increased from the mid-1890s; however, in spite of the color modifications caused by the flickering sunlight, the forms in works such as *Bridge at Old Lyme* maintain an individual identity. His works arrested times and places, poignant moments in Hassam's life, rendering his surroundings timeless. (*Georgia Museum of Art, The University of Georgia; Gift of Alfred H. Holbrook, 1945*)

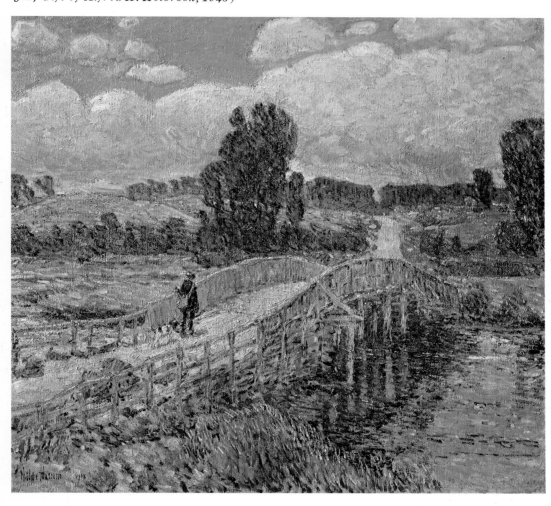

147. Maurice B. Prendergast (1859–1924): *The Stony Beach, Ogunquit*. 1900–1901. Watercolor, 20⅞″ x 13¹⁵⁄₁₆″. Prendergast's formal art training was received late in life, during the 1890s two European trips provided a significant influence. Between 1891 and 1895 Prendergast was introduced by the Canadian Charles W. Morrice to a group of artists called the Nabis. Centered on Paul Gauguin, the group included Maurice Denis, Pierre Bonnard, and Édouard Vuillard. Also, during 1898 and 1899 Prendergast discovered the Venetian masters of festive pageants, especially the Bellinis, and Carpaccio's *St. Ursula* series. In contrast to George Bellows or John Sloan, Prendergast delighted in decorative patterns of colorful rhythmic forms that appeared as a mosaic. One critic noted, "Prendergast's world was largely a peaceful world . . . of summer outings, excursion crowds, of Sunday afternoons in the park. It is paradoxical that this beguiling spectacle . . . should have been the spearhead in America of a radical artistic development."[45] That development was modern abstraction. (*Collection of Mr. and Mrs. Arthur G. Altschul*)

148. Robert Henri (1865–1929): *Rainstorm— Wyoming Valley*. 1902. Oil on canvas, 26″ x 32″. Probably completed in several hours, this painting was done during the summer of 1902 while Henri was staying at the home of his wife's parents in Black Walnut, a small town in the hills of northeastern Pennsylvania. In this painting, characterized by a captivating spontaneity, Henri's years of experience are displayed in the consummate skill with which he renders the transitory effects of wind and rain in masses of color and tone. Henri was a major force in American art, an influential teacher and a passionate spokesman for artistic freedom from the jury system. For a time he operated his own art school (1909–1912), attracting George Bellows, Edward Hopper, Rockwell Kent, Yasuo Kuniyoshi, and Stuart Davis. In 1923 the popular handbook *Art Spirit* was published, and during his last years, he spent considerable time working out Hardesty Maratta's system of color harmonies. (*Private collection*)

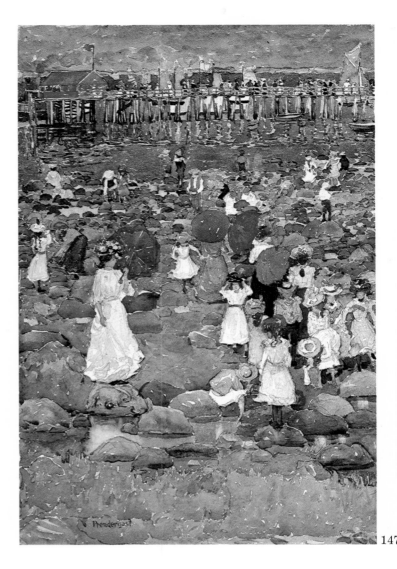

147

149. Arthur Bowen Davies (1862–1928): *Unicorns*. 1906. Oil on canvas, 18¼″ x 40¼″. Remembered today as the principal organizer of the 1913 Armory Show, Davies was a perplexing and a highly influential personality during the first three decades of this century. As a painter of his time he was fiercely independent, perhaps anachronistic, preferring a Symbolist or visionary imagery of classical themes, decorative grace, and aesthetic pleasure. *Unicorns* represents a departure in style and format, a quiet pastoral probably set in the Mohawk Valley painted in a nineteenth-century panoramic tradition with convincing detail and a haunting romanticism. The canvas is carefully arranged in methodical bands of sky, land, and water, emphasizing throughout the play of light. In Davies's work objective narrative meaning is secondary to aesthetic, decorative, and symbolic considerations, all of which are crucial to an understanding of his intentions. Davies's ethereal landscapes provided a poetic, nostalgic retreat in a realist-oriented environment. (*The Metropolitan Museum of Art; Bequest of Lillie P. Bliss, 1931*)

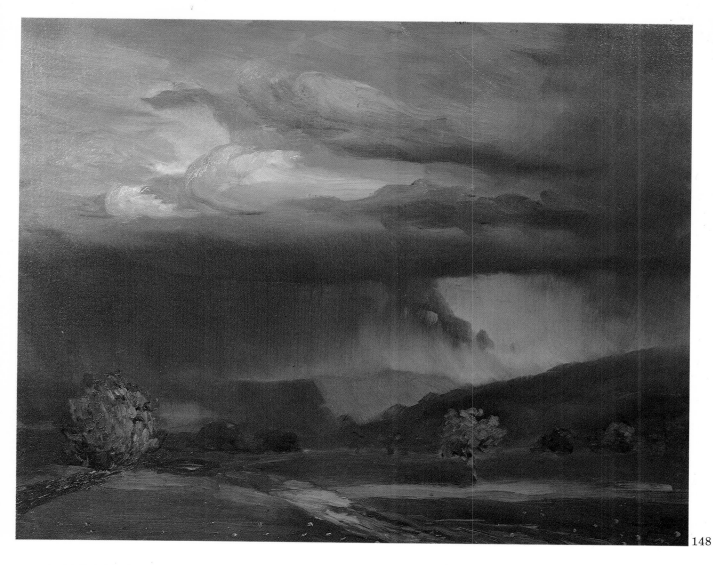

148

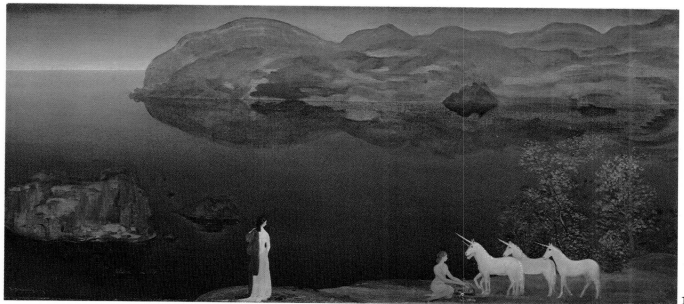

149

150. Dwight William Tryon (1849–1925): *The Sea, Evening*. 1907. Oil on canvas, 30″ x 48″. Upon his return from the Orient in 1907, Freer was welcomed by Tryon's *The Sea, Evening*. In a letter to the artist dated August 3, he described it with considerable enthusiasm, demonstrating his astute knowledge of Oriental art and the ideas of both Ernest Fenollosa and Arthur W. Dow, "It is a wonder! Marvellously convincing, tremendously powerful and extremely dignified. Nothing could be more truthful, and at the same time, so subtle. . . . Certainly, I have seen nothing more suggestive of that particular mood of the Sea. The coloring is very beautiful, and its directness recalls the work of the great masters of the early Kano school—Sesshu, Sesson, and Masunobu [*sic*]. In one of the great Kyoto Temples, there is an ink painting of a huge waterfall by a Sung painter called Okamatsu [*sic*] . . . I believe it to be one of the greatest pictures in existence. You, I am sure, would be fascinated by it. Its great qualities are simplicity, line, and notan (light and dark). Color, if added, might have given it additional charm, but it certainly could not have increased its subtlety of suggestion."[46] (*Freer Gallery of Art*)

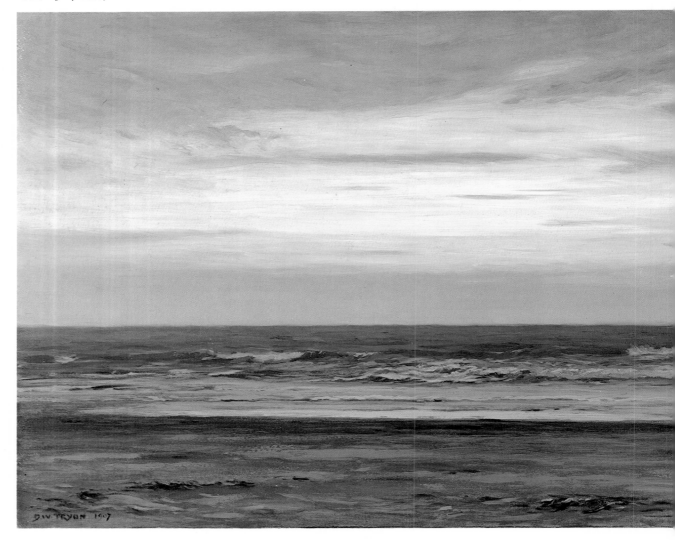

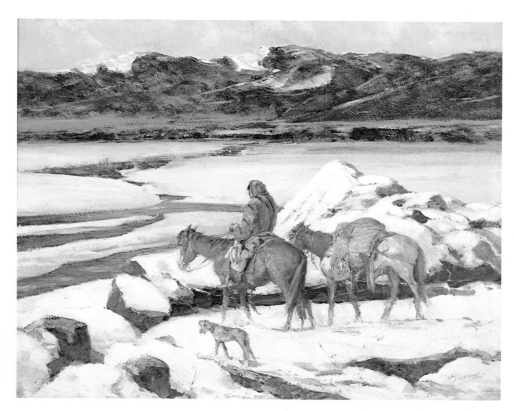

151. Oscar Berninghaus (1874–1952): *On the Trail.* 1908. Oil on canvas, 20″ x 16″. Returning from his studies in Paris, Berninghaus discovered the beauty of the Taos pueblo in New Mexico. Attracting such artists as Victor Higgins (1884–1949), Irving Couse (1866–1936), Ernest Blumenschein (1874–1960), and others, Berninghaus and the Taos Colony discovered the unique character of this aspect of the American landscape. Of particular importance was the fact that for the first time active artists' colonies were arising in Woodstock, New York (Birge Harrison); Provincetown, Massachusetts (Charles W. Hawthorne); and New Hope, Pennsylvania (Daniel Garber, Robert Spencer, Edward Redfield). These colonies not only challenged the artistic dominance of New York City but also explored new aspects of the American scene. (*The Warner Collection of the Gulf States Paper Corporation*)

152

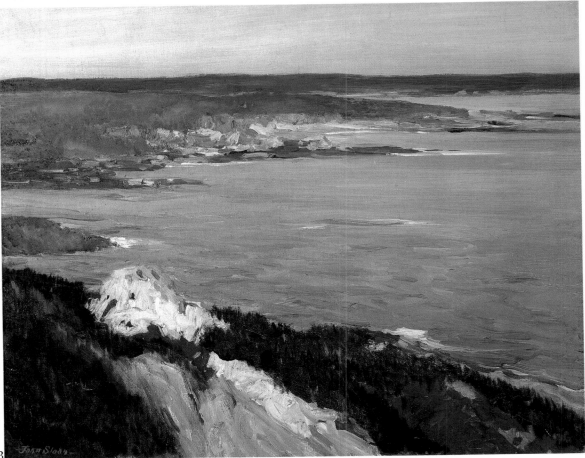

153

152. Joseph Pickett (1848–1918?): *Manchester Valley.* 1914–1918. Oil with sand on canvas, 45½″ x 60⅝″. Very little is known of Pickett; he turned to serious painting late in life, possibly after 1913, while he was tending a grocery store in New Hope, Pennsylvania. Pickett was a skilled artisan who combined in his work an individual vision and an unerring understanding of his medium. (*Collection, The Museum of Modern Art, New York; Gift of Abby Aldrich Rockefeller*)

153. John Sloan (1871–1951): *Lookout, Green and Orange Cliffs—Gloucester.* 1917. Oil on canvas, 22″ x 27″. A mentor of Robert Henri, Sloan shared his belief that art should participate in and reflect the observed realities of daily life. A member of The Eight, Sloan created a stunning social and cultural commentary on his times. He was set above his contemporaries by a special gift, a rare combination of humanism and technical abilities. After 1913 Sloan increasingly became involved in experiments in form and color, seeking greater structural clarity or "a focus on the edge of forms." At first he painted in Gloucester, Massachusetts, between 1914 and 1918, subsequently going to Taos in 1919. In spite of the beauty of this landscape, it lacks the expressiveness found in Sloan's city views, in which he clearly felt a strong sympathy with the subject matter. (*Chapellier Galleries, Inc.*)

154. Ernest Lawson (1873–1939): *Boathouse, Winter, Harlem River.* 1916. Oil on canvas, 40½″ x 50⅛″. A student in the early 1890s of both J. Alden Weir and John H. Twachtman at Cos Cob, Connecticut, Lawson was the least understood member of The Eight. Its spokesman, Robert Henri, viewed Lawson as a sensitive and daring colorist, qualities that he highly regarded. As did other American Impressionists, Lawson painted with a harsh surface texture and frequently studied the same subject under varying conditions of light and atmosphere. In this case he was fascinated by High Bridge in New York's Washington Heights district. Projected into national recognition by the Armory Show, Lawson was renowned for his exquisite use of glowing colors and decorative surface effects, causing F. Newlin Price to refer to his work as a "palette of crushed jewels."[47] (*The Corcoran Gallery of Art; Gallery Fund, 1916*)

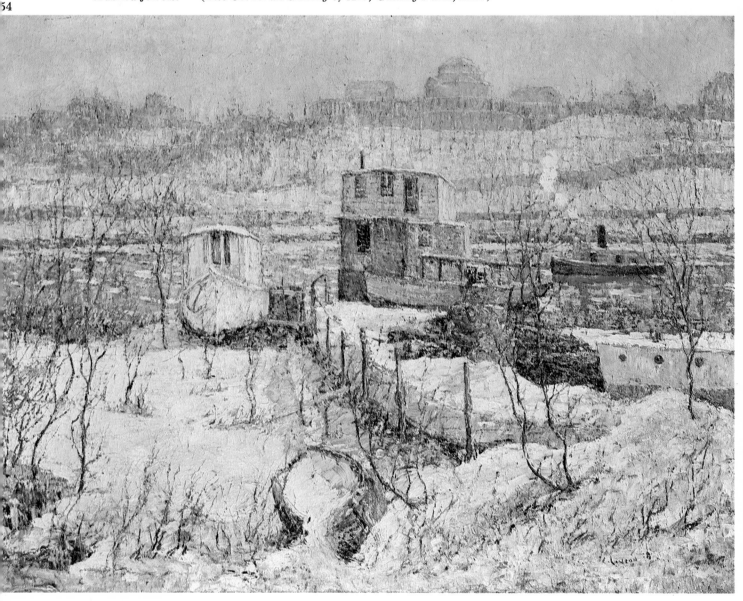

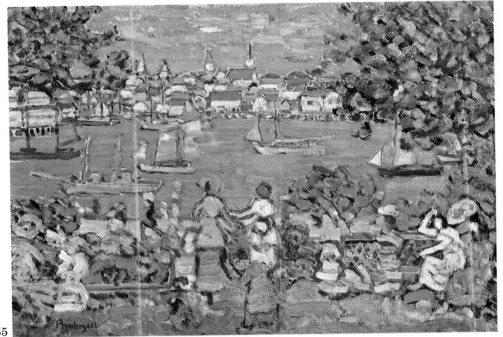

155

156

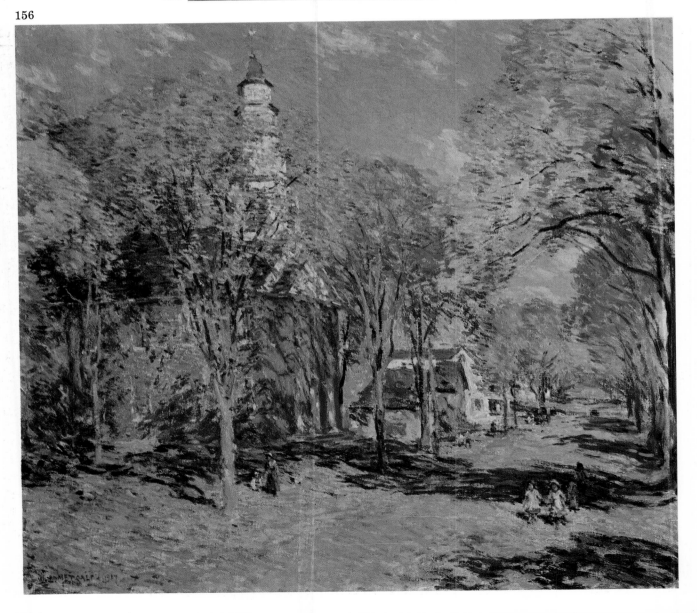

155. Maurice B. Prendergast: *Gloucester*. 1916. Oil on canvas, 20″ x 28½″. In his comments accompanying the exhibition catalogue *Maurice Prendergast—Art of Impulse and Color,* Jeffrey R. Hayes states, "By 1914, the year of his permanent relocation to New York, Prendergast's coloristic and compositional approach to pictures intended for public exhibition had been generally established. . . . Many of these paintings employ cove and seashore settings which, through their meandering headlands and finger-like inlets, invite a feeling of sturdy informality based upon an underlying structure of compressed, widely swung arcs, intersecting elements, or vortical undulations. Illusionistic spatial conventions are largely negated by the arbitrary distribution of colors, which fluctuate in value between cool and warm or are stacked vertically in the precious manner of layered sand patterning."[48] (*Private collection; photograph courtesy Hirschl & Adler Galleries, Inc.*)

156. Willard L. Metcalf (1858–1925): *October Morning—Deerfield, Massachusetts.* 1917. Oil on canvas, 26″ x 29″. A sensitive and talented artist, Metcalf began his career as an illustrator; achieving considerable success by 1899, he turned to painting. A founding member of The Ten, Metcalf maintained a New York studio, but spent most of his time painting in New England, especially in Maine and Old Lyme, Connecticut. Metcalf was quite popular in his day; however, in comparison with many contemporaries his works lack a sense of poetry or profundity, as they are characterized by an illustrative quality. Despite the appearance of an impressionist technique he retains a meticulous definition of form, and his painting surface lacks the energetic pigment application found in Childe Hassam, which is so characteristic of plein-air sketches. (*Freer Gallery of Art*)

157. Daniel Garber (1880–1958): *Fields in Jersey.* c. 1920. Oil on canvas, 36¼″ x 44″. Academic Impressionism maintained a stronghold on the art scene through Garber, who after studying at the Pennsylvania Academy of the Fine Arts with Thomas Anshutz and J. Alden Weir (between 1899–1905) joined the faculty in 1909 and remained an active teacher until 1951. Although strongly decorative, his best paintings were done from the area around his summer house at Cuttaloosa Glen in the Delaware Valley (in Lumberville, Bucks County, near New Hope, Pennsylvania)—especially the area across the river from New Hope. Despite this decorative quality the landscapes maintain a gentle lyricism and poetry of color that make Garber's works among the best of the late Impressionists. (*Sotheby Parke Bernet, Inc.*)

157

158. Augustus Vincent Tack (1870–1949): *Storm*. c. 1920–1923. Oil on canvas, 37″ x 48″. On February 5, 1934, Duncan Phillips wrote to Robert B. Harshe, the director of The Art Institute of Chicago, urging that paintings by both Tack and Dove be included in the second "Century of Progress" exhibition. Of Tack's *Storm*, which was then on view in Baltimore, Phillips wrote, "The design is majestic and the colors so fused and the effect so easily recognizable that it is not out of place with the other pictures. It is merely superior in style as well as in spirit to nine tenths of them." Phillips also expressed his hope that the Chicago exhibition would "not leave out important artists who by habit and inclination stand apart from groups and societies, who make their own way without dealers and who are not invited to the big exhibitions in the museums." (*The Phillips Collection*)

159. John Marin: *Maine Islands*. 1922. Watercolor, 16¾″ x 20″. Marin was greatly inspired by his association with Alfred Stieglitz. Like Charles Burchfield, Marin evolved a highly personal imagery, in which natural or industrial forms became the focal point for the conveyance of pure emotional expression. His watercolors, especially those from 1922, while staying in Stonington on Deer Isle, Maine, were unparalleled in their expressiveness, a fact that resulted in few imitators. (*The Phillips Collection*)

160. George Bellows (1882–1925): *The Picnic*. 1924. Oil on canvas, 23″ x 29½″. Bellows is considered to be not only Robert Henri's best student but also the best painter of the Ashcan group. He received popular success as a painter and printmaker, becoming in 1909 (as a result of the sensation created by *Stag at Sharkey's*) the youngest member of the National Academy of Design. Bellows possessed an exquisite technical ability that was both vigorous and carefully controlled. Until 1916 his works were realistic approximations of nature; however, after his studies with Jay Hambidge the geometric organization or dynamic symmetry of his pictures becomes more pronounced. *The Picnic* was done shortly after Bellows had completed about sixty lithographs, and Hambidge's influence is clearly seen in the careful placement of masses against one another. Bellows's works are distinguished by a simplification of forms and a dramatic contrast of light against dark, qualities that place him as an important transitional figure between his teacher and another Henri product, Edward Hopper. (*The Peabody Institute, Irwin Fund; photograph courtesy The Baltimore Museum of Art*)

159

160

161. Niles Spencer (1893–1952): *Back of the Town (Provincetown)*. 1926. Oil on canvas, 30¼″ x 36¼″. Influenced by both George Bellows and Robert Henri, Spencer's style struck a compromise between realism and abstraction. In the early 1920s he simultaneously with Charles Sheeler arrived at a movement termed *precisionism*. Spencer's preference for industrial subject matter was also shared by George Ault and Louis Lozowick, who in contrast to Sheeler collectively maintained an aura of mystery in their works. In 1941, Spencer stated: "There is realism in the work of abstract artists. . . . The deeper meanings of nature can only be captured in painting through disciplined form and design. The visual recognizability is actually irrelevant. It may be there or not."[49] (*Sotheby Parke Bernet, Inc.*)

162. Georgia O'Keeffe: *Wave, Night*. 1928. Oil on canvas, 30″ x 36″. Although it is an unusual landscape for O'Keeffe, *Wave, Night* wonderfully captures the solitude and rhythm of the ocean landscape of the Maine coast, a region that inspired many nineteenth-century landscapists. In her recent book (1976) O'Keeffe stated, "In the spring of 1920 I went to York Beach, Maine, with an old friend of Stieglitz. The house had a board walk across a cranberry bog out to the long, clean beach of the ocean. The house was a large, very plain, almost empty place with a few good old Indian rugs kicked about in rather disorderly fashion over the otherwise bare floors. My room was large—faced out on the ocean and the rising sun. The first thing you noticed was a large double bed and the fireplace, birch wood logs for the fire. . . .

"I spent much time walking on the long, clean sandy beach—often picking up extraordinary things that I kept in large platters of water to paint. When walking I seldom met anyone as it was very early springtime and cold. I loved running down the board walk to the ocean—watching the waves come in, spreading over the hard wet beach—the lighthouse steadily bright far over the waves in the evening when it was almost dark. This was one of the great events of the day."[50] (*Addison Gallery of American Art, Phillips Academy; Gift of Charles L. Stillman*)

163. Marvin Cone (1891–1965): *Prelude*. 1931. Oil on canvas, 30¼″ x 36″. A close colleague of Grant Wood, Marvin Cone remained in Cedar Rapids after his training at The Art Institute of Chicago and a subsequent trip to Europe. A guiding force behind the Stone City art colony (1932–1933), he concentrated on panoramic landscapes of the Iowa countryside, similar to Wood's works but avoiding his emphasis on pure design. On one occasion, Wood described Cone's work as follows: "Marvin's work has a directness and honesty. . . . There is no compromising with problems of representation. . . . It is the full bodied art of a man who loves the simple qualities that meet the eye and depicts them with clarity and sound craftsmanship."[51] (*Cedar Rapids Museum of Art; Community School District Collection*)

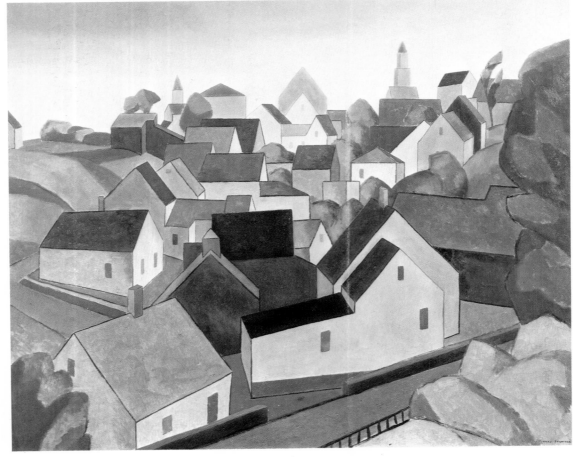

162

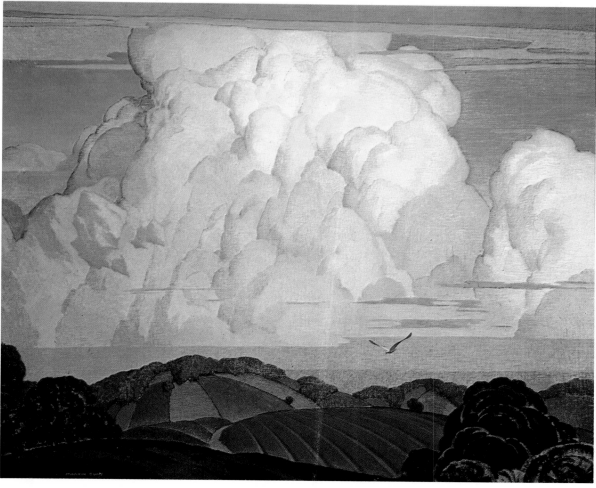

163

164. John Kane (1860–1934): *St. Paul's Church*. 1933. Oil on canvas, 19½" x 22". Kane was among the first of America's modern primitives to gain approval. In a fashion shared by many other untrained artists, Kane developed an individual perspective system that emphasized spatial relationships. Kane was a skilled workman in many trades: he laid cobblestones in Pittsburgh streets, painted freight cars and houses, assisted in the construction of bridges, and worked in an ammunition plant. Enthralled by Pittsburgh, he once stated, "Why shouldn't I want to set them down when they are to some extent children of my labors and when I see them always in the light of beauty."[52] (*Kennedy Galleries, Inc.*)

165. Grant Wood: *Spring Turning*. 1936. Oil on masonite panel, 18⅛" x 40". Throughout his life Wood remained strongly captivated by the primal character of the rural American landscape. On one occasion he stated, "The naked earth in its massive contours, asserts itself through anything that is laid upon it."[53] Wood's landscape views are disturbingly well organized; his technical design emphasizes the order and harmony of the rural community. Pleased with the result, Wood continued in this direction until his death in 1942. Although technically distinguished and clever, his works conveyed an idealized impression of a society at a time when the public increasingly preferred a direct image. Thus, his position was extremely vulnerable within the realistically oriented American Scene. This fact, as well as the backlash from Thomas Hart Benton's abrasive attacks against the art establishment, probably caused the indifferent public response accorded to a retrospective of his work at The Art Institute of Chicago in 1942. (*Private collection; photograph courtesy James Maroney, Incorporated, New York*)

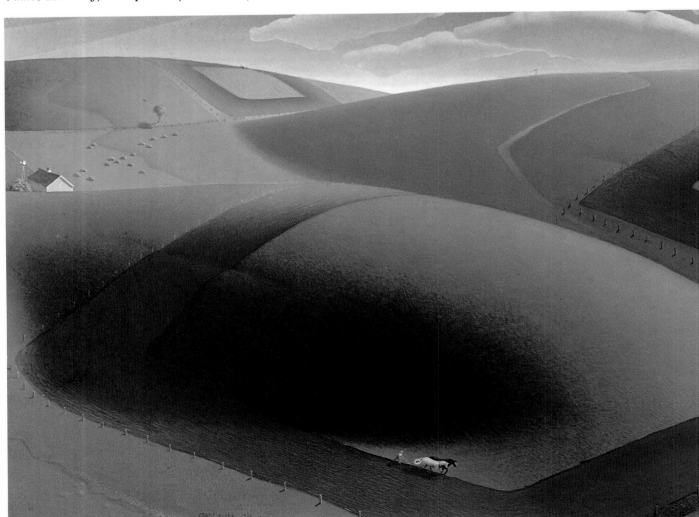

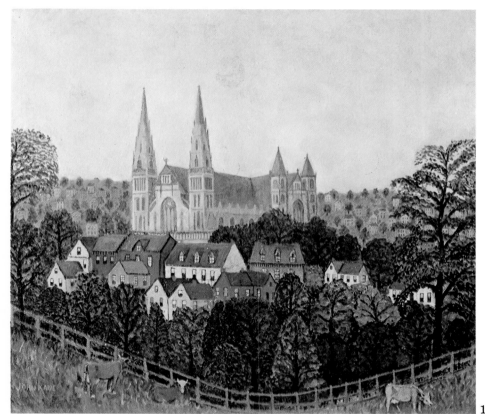

164

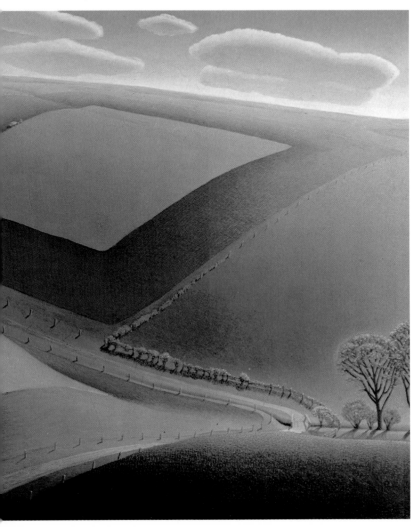

165

145

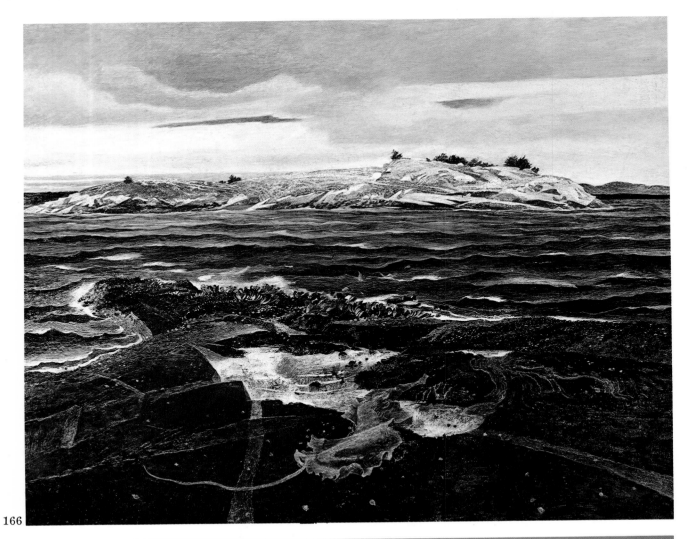

166

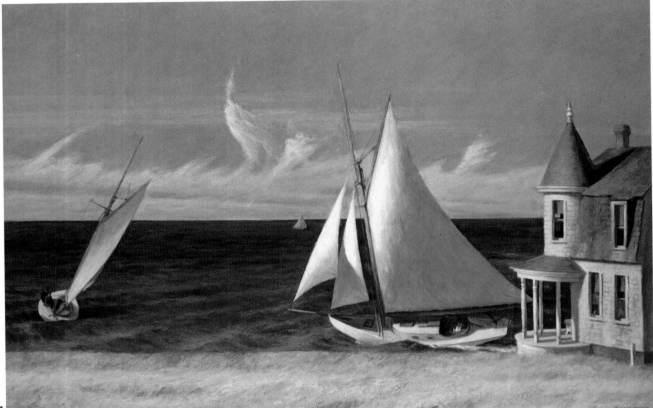

167

166. Andrew Wyeth (b. 1917) : *Off Caldwell Island*. 1940. Tempera on panel, 32″ x 40″. Working predominantly in tempera, Wyeth is a supreme craftsman who seeks a direct encounter between spectator and subject, attempting in his paintings to crystallize what the photographer Cartier-Bresson calls "the decisive moment." In 1961 Wyeth commented, "If what I'm trying to do has any value at all, it's because I've managed to express the quality of the country which I live in. Not the historical quality . . . what is important . . . is a sort of organic thing of the country . . . being able to find something which expresses it symbolically, not just a scene of a beautiful countryside with a rainbow effect or a storm coming up."[54] (*Kennedy Galleries, Inc.*)

167. Edward Hopper (1882–1967) : *The Lee Shore (Cape Cod)*. 1941. Oil on canvas, 28¼″ x 43″. Although he was a Robert Henri pupil, Hopper emphasized design considerations over subject matter. Closely related to Winslow Homer's objective vision of nature, Hopper's style emphasized solid forms, few details, and clear colors. In addition to his poignant city scenes we find beginning in 1930 equally sensitive paintings of Gloucester and South Truro, Cape Cod. These scenes possess timeless and essential American qualities: a mood of contemplative solitude and alienation found through our art history. Hopper commented in 1939, "My aim in painting is always, using nature as the medium, to try to project upon canvas my most intimate reaction to the subject as it appears when I like it most; when the facts are given unity by my interest and prejudices. Why I select certain subjects rather than others, I do not exactly know, unless it is that I believe them to be the best medium for a synthesis of my inner experience."[55] (*Private collection; photograph courtesy Kennedy Galleries, Inc.*)

168. Marsden Hartley (1877–1943) : *Evening Storm, Schoodic Point, Maine*. 1942. Oil on composition board, 30″ x 40″. A pioneer of modernism, Hartley was influenced by several sources, including the French, the Blaue Reiter group, and the Italian Futurists. After almost twenty years of searching in Europe, Mexico, and the American Southwest, Hartley found, in the late 1930s, his strongest inspiration in the countryside of his native Maine. There he was attracted by the rugged individuality of the landscape and the potential for a romantic imagery. An ardent admirer of Albert Pinkham Ryder, Hartley pursued an imagery with a similar mysticism and haunting coloration. Published a year after his death, the following comments are from "Notes on Painting by the Artist," ". . . whatever is one's nativeness, one holds and never loses no matter how far afield the traveling may be. . . . This quality of nativeness is colored by heritage, birth and environment, and it is therefore for this reason that I wish to declare myself the painter from Maine. We are subjects of our nativeness, and are at all times happily subject to it, only the mollusk, the chameleon, or the sponge being able to affect dissolution of this aspect."[56] (*Collection, The Museum of Modern Art, New York; Acquired through the Lillie P. Bliss Bequest*)

169

171

169. Arthur G. Dove (1880–1946): *High Noon*, 1944. Oil on canvas, 18″ x 27″. As did many of his contemporaries, Dove considered nature a viable source of imagery. Unlike his nineteenth-century predecessors, he selected a few environmental elements, reducing them to a series of two-dimensional patterns and carefully balancing their interaction and rhythmic repetition. After 1930 he was able to devote all his time to painting. Nature remained his inspiration, but his imagery was more lyrical as his forms became more abstract and primordial. (*Wichita Art Museum*)

170. Charles E. Burchfield: *Midsummer Afternoon*. 1952. Watercolor, 40″ x 30″. Throughout the 1950s Burchfield's dual interest in solitude and elemental nature became more prevalent. His stylistic calligraphy became more conventionalized and rhapsodic; however, his moods grew to be more generalized—displaying a singular preference for the enduring values in nature. (*Kennedy Galleries, Inc.*)

171. Maxfield Parrish (1870–1966): *Early Evening Snow*. 1953. Oil on canvas, 13½″ x 15½″. The son of the well-known etcher Stephen Parrish, Maxfield almost exclusively painted landscapes during the last thirty years of his life. Beginning in 1910, Parrish was one of the most widely recognized artists because of his numerous illustrations for books, greeting cards, calendars, magazines, and advertisements. Unfortunately, Parrish's critical reputation suffered as his popular acclaim increased. In an April 5, 1935, letter Parrish described many of the qualities that distinguish this painting. "I feel that the broad effect, the truth of nature's mood attempted, is the most important, has more appeal than the kind of subject. 'Broad effect' is a rather vague term, but what is meant is that those qualities which delight us in nature—the sense of freedom, pure air and light, the magic of distance, and the saturated beauty of color, must be convincingly stated. . . . If these abstract qualities are not in a painting it is a flat failure. . . ."[57] (*Private collection; photograph courtesy Vose Galleries of Boston, Inc.*)

170

172. Clyfford Still (b. 1904): *1951 Yellow.* 1951. Oil on canvas, 109½″ x 92¼″. Still, along with Mark Rothko and Barnett Newman, was an innovator of color-field painting; they were determined as a group to arrive at an aesthetic statement independent of Western painting traditions. In 1970 Irving Sandler stated that the group's intentions were "visionary; they aimed to create an abstract art suggestive of the sublime, of transcendence, of revelation."[58] Similar correlations between romanticism and Abstract Expressionism have been made by other critics. (*Collection of Mr. and Mrs. Frederick R. Weisman*)

172

173. Mark Rothko (1903–1970): *Orange and Yellow.* 1956. Oil on canvas, 91″ x 71″. In his 1961 article "The Abstract Sublime" Robert Rosenblum compared works by Rothko to Turner's paintings of sea and sky in the following terms: "The floating, horizontal tiers of veiled light in the Rothko seem to conceal a total, remote presence that we can only intuit and never fully grasp. These infinite, glowing voids carry us beyond reason to the Sublime; we can only submit to them in an act of faith and let ourselves be absorbed in their radiant depths."[59] Years earlier, in 1949, Rothko stated, "The progression of a painter's work, as it travels in time from point to point will be toward clarity: toward the elimination of all obstacles between the painter and the idea, and between the idea and the observer. As examples of such obstacles, I give (among others) memory, history, or geometry, which are swaps of generalizations from which one might pull out parodies of ideas (which are ghosts) but never an idea itself. To achieve this clarity is, inevitably, to be understood."[60] (*Albright-Knox Art Gallery; Gift of Seymour H. Knox*)

174. Milton Avery (1893–1965): *Sea Grasses and Blue Sea.* 1958. Oil on canvas, 60⅛″ x 72⅜″. Avery is perhaps at his best in his many seascapes. Frequently compared to Matisse, he shared similar views about evocative color, decorative surface patterns, and the poetry of nature. In 1965 Mark Rothko eulogized his fellow artist: "Avery is first a great poet. His is the poetry of sheer loveliness, of sheer beauty. Thanks to him this kind of poetry has been able to survive in our time. This—alone—took great courage in a generation which felt that it could be heard only through clamor. . . . But Avery had that inner power in which gentleness and silence proved more audible and poignant. . . . There have been several others in our generation who have celebrated the world around them, but none with that inevitability where the poetry penetrated every pore of the canvas to the very last touch of the brush."[61] (*Collection, The Museum of Modern Art, New York; Gift of Friends of the Artist*)

175. Charles E. Burchfield: *Dandelion Seed Heads and the Moon.* 1961–1965. Watercolor, 54¼″ x 38½″. "Since 1956 my work has tended more and more toward the abstract—a term not to be confused with the school which has that title. The abstractness of my recent work is arrived at through the distillation of natural formations, or moods, into symbols, an idea aimed at in 1915 and arrived at through a large period of conscious experimental attempts at conventionalization. It is as if there is a veil between me and the ultimate in painting and only bit by bit am I allowed to penetrate the mystery beyond that veil. . . . 1965 finds me going back more and more to that rhapsodic visionary year of 1915 for inspiration and subject matter, which in turn, becomes absorbed into a further probing into the secrets of life, nature, and the world of the spirit."[62] (*Kennedy Galleries, Inc.*)

174

Notes

Text Notes

1. As stated by James Jackson Jarves in *The Art-Idea,* "the artistic love which animates modern landscapes is based upon the feeling that it is not, as the ancients in general fancied, the material expression or disguise of many gods, but the creation of the one God—his sensuous image and revelation, through the investigation of which by science or its representation by art men's hearts are lifted toward him" (Boston, Mass.: Hurd & Houghton, 1864; reprint ed., Benjamin Rowland, Jr., ed. [Cambridge, Mass.: The Belknap Press of Harvard University Press, 1960], p. 86).

2. Barbara Novak, *Nature and Culture* (New York: Oxford University Press, 1980), pp. 157–200.

3. E. P. Richardson, *Painting in America* (New York: Thomas Y. Crowell, 1965), pp. 128, 215.

4. Copley-Pelham Letters, letter of c. 1767, Massachusetts Historical Society Collection, 1914, vol. 71, pp. 65–66.

5. Nina Fletcher Little, *American Decorative Wall Painting, 1790–1850* (Sturbridge, Mass.: Old Sturbridge Village, 1952). See also bibliography.

6. William Burgis, engraved by I. Harris, *A South East View of ye Great Town of Boston in New England in America,* 1743. 23½″ x 52″. The Henry Francis du Pont Winterthur Museum, Winterthur, Delaware.

7. Stephen T. Riley, "John Smibert," in Ian M. G. Quimby, ed., *American Painting to 1776, A Reappraisal* (Winterthur Conference Report, Charlottesville, Va.: University Press of Virginia, 1971), p. 177.

8. The Burgis work consisted of twenty-eight views in line engravings, while Barres's work consisted of views and maps of the Atlantic seaboard prepared for the British Admiralty. For more information see John D. Morse, ed., *Prints in and of America to 1850* (Winterthur Conference Report 1970, Charlottesville, Va.: University Press of Virginia, 1970).

9. John Wilmerding *et al., American Light—The Luminist Movement 1850–1875* (Washington, D.C.: National Gallery of Art, 1980), p. 69.

10. Hugh Blair, *Lectures on Rhetoric and Belles Lettres* (London, 1783), I, pp. 55–56.

11. John Wilmerding, *American Art* (New York: Penguin Books, 1976), p. 38. See also Novak, *Nature and Culture,* pp. 239, 299.

12. Novak, *Nature and Culture,* p. 145.

13. Arthur M. Schlesinger, *The Birth of the Nation* (New York: Alfred A. Knopf, 1968), p. 250.

14. For an excellent discussion, see Hugh Honour, *Romanticism* (New York: Harper & Row, 1979).

15. Quoted in *M. and M. Karolik Collection of American Paintings* (Cambridge, Mass.: Harvard University Press for the Museum of Fine Arts, 1949), p. 478. William James Bennett (1787–1844) also arrived in 1816 and subsequently completed nineteen colored aquatints of American cities between 1831 and 1838.

16. William Gilpin, *Two Essays—One on the Author's Mode of Executing Rough Sketches; the Other, on the Principles on Which They Are Composed* (London, 1804),

p. 19. Also of interest is the following passage by Gilpin, originally published in 1791: "These splendid remnants of decaying grandeur speak to the imagination . . . they record the history of some . . . great event, which transfers its grand ideas to the landscape, and, in the representation of elevated subjects, assists the sublime" (*Forest Scenery*, Francis G. Heath, ed. [London, 1879], p. 18).

17. Wilmerding, *American Light*, p. 295 states, "The young Republic proclaimed itself nature's nation, a society created in and of a wilderness unparalleled in beauty and sublimity—particularly the daunting challenge of the sublime. Not even the Alps could compare with a massive continent of untamed mountains and streams and plains." See also Washington Allston, *Lectures on Art and Poems*, Richard Henry Dana, Jr., ed. (New York: Baker & Scribner, 1850), p. 94.

18. Richardson, *Painting in America*, p. 143. See also E. P. Richardson, *Washington Allston: A Study of the Romantic Artist in America* (Chicago: University of Chicago Press, 1948), p. 92.

19. Jared B. Flagg, *The Life and Letters of Washington Allston* (New York: Scribner's, 1892), p. 186. See also, Richardson, *Allston*, pp. 59–60.

20. Richardson, *Allston*, p. 138; Flagg, *Allston*, p. 57.

21. John McCoubrey, ed., *American Art, 1700–1960* (Englewood Cliffs, N.J.: Prentice-Hall, 1965), p. 58.

22. John K. Howat, *The Hudson River and Its Painters* (New York: The Viking Press, 1972), pp. 34–35.

23. John Wilmerding, *A History of American Marine Painting* (Boston and Salem, Mass.: Little, Brown, 1968), p. 59.

24. Wilmerding, *American Art*, pp. 76–77; Novak, *Nature and Culture*, p. 20.

25. Wilmerding, *American Light*, p. 75 states, "his art was transitional . . . he was the first landscape painter of great ambition and commensurate talent to attempt to unite the sublime with the mythology of America. In so doing he virtually created a new art form by elevating landscape to the level of history painting." Originally delivered as a lecture in 1835, Cole's "Essay on American Scenery" was published in *The American Monthly Magazine*, n.s. 1 (January 1836), pp. 1–12. Text reproduced in McCoubrey, *American Art*, pp. 98–109. Cole's essay articulated a spirit that dominated American landscape painting for thirty years.

26. MS. Cole papers, The New York State Library, December 13, 1826. Quoted in Barbara Novak, *American Painting of the Nineteenth Century* (New York: Praeger Publishers, 1969), p. 66.

27. *Ibid.*, December 25, 1826, pp. 67, 71.

28. Novak, *Nature and Culture*, p. 20.

29. Richardson, *Painting*, p. 167.

30. Wolfgang Born, *American Landscape Painting: An Interpretation* (New Haven, Conn.: Yale University Press, 1948), p. 78. See the following for additional references about panoramas: John Francis McDermott, *The Lost Panorama of the Mississippi* (Chicago: University of Chicago Press, 1958) and Lee Parry, "Landscape Theatre in America," *Art in America* (November–December 1971), pp. 52–61.

31. Cole, "Essay," 1836, p. 11–12, quoted in McCoubrey, *American Art*, p. 108. Cole's concern for the wilderness destruction was shared by other mid-century conservationists. In 1847, a critic writing in the *Literary World* (May 15, p. 348) urged artists to pursue a sacred mission of preserving in paint nature's wilderness. This was quite a change from Jackson's Second Annual Message (December 6, 1830), wherein he urged the nation to clear the land and subjugate the wilderness. For the extent of destruction in 1850 see the maps in Richard G. Lillard, *The Great Forest* (New York: Alfred A. Knopf, 1947). See also George P. Marsh, *Man and Nature* (New York: Scribners, 1864), and Roderick Nash, *Wilderness and the American Mind* (New Haven, Conn.: Yale University Press, 1967).

32. In 1843 Thomas Cole painted *View of the Falls of Munda near Portage on the Genesee Falls*, oil on canvas, 51″ x 39½″; Rhode Island School of Design. It was distinguished by the extent to which Cole reflected the actualities of the site not only on canvas but also in the very descriptive title.

33. David B. Lawall, *Asher B. Durand* (Montclair, N.J.: Montclair Art Museum, 1971), p. 57. Durand's election as the president of the leading national art academy also signaled official recognition of landscape painting.

34. Novak, *American Painting*, p. 70; McCoubrey, *American Art*, p. 110.

35. Letter III, *The Crayon* 1, no. 5 (January 31, 1855), p. 66.

36. Letter V, *The Crayon* 1, no. 10 (March 7, 1855), pp. 145–146. Durand advised, "When you shall have acquired some proficiency in foreground material, your next step should be the study of atmosphere—the power which defines and measures space" (quoted in John I. H. Baur, "Early Studies in Light and Air by American Painters," *Brooklyn Museum Bulletin* 9, no. 2 [Winter

1948], p. 6). At about the same time during the mid-1850s Durand executed a series of spontaneous studies from nature that rivaled Courbet. For more information see Novak, *Nature and Culture*, p. 239, and Novak, *American Painting*, pp. 87–90.

37. Wilmerding, *American Light*, p. 105, "presence of light as a metaphor of plenitude and well-being" and p. 106, "This notion that landscape might be charged with symbolic content was an important foundation for the evolution of luminism." Novak, *Nature and Culture*, p. 273, states, "The truths of light and atmosphere that absorbed American artists quickly served a concept of nature as God, turning landscape paintings into proto-icons."

38. "Representative Art," *Atlantic Monthly* 5 (June 1860), pp. 687–693.

39. Alexis de Tocqueville, *Journey to America* (1831; reprint, Garden City, N.Y.: Doubleday Anchor Books, 1971), p. 399.

40. Worthington Whittredge, *The Autobiography of Worthington Whittredge, 1820–1910*, John I. H. Baur, ed. (*Brooklyn Museum Journal*, 1942), p. 40.

41. Henry T. Tuckerman, *The Book of the Artists: American Artist Life* (1867; reprint ed., New York: James F. Carr, 1966), p. 511. See also, Novak, *Nature and Culture*, p. 299, n. 55.

42. *Ibid.*, pp. 536–537.

43. Wilmerding, *American Art*, p. 85.

44. Novak, *American Painting*, pp. 160–161.

45. Wilmerding, *American Light*, p. 85.

46. James Jackson Jarves, *The Art-Idea*, pp. 192–193.

47. Novak, *Nature and Culture*, pp. 255, 299, n.62. Wilmerding, *American Art*, p. 88. As indicated in Novak, *Nature and Culture* (p. 255), the Düsseldorf experience reinforced an American aesthetic rather than giving rise to it.

48. Whittredge. *Autobiography*, pp. 45–46. For further information see Nancy D. W. Moure, "Five Eastern Artists Out West," *American Art Journal* 5, no. 2 (November 1973), pp. 15–31, and John D. Unruh, Jr., *The Plains Across—The Overland Emigrants and the Trans-Mississippi West, 1840–60* (Urbana: University of Illinois Press, 1978).

49. Walt Whitman, *Specimen Days* (1882; reprint ed., Boston: David R. Godine, 1971), p. 94.

50. Novak, *Nature and Culture*, p. 231.

51. Wilmerding, *American Light*, pp. 215–216; Novak, *American Painting*, p. 102. See also Kynaston McShine, ed., *The Natural Paradise, Painting in America 1800–1950* (New York: The Museum of Modern Art, 1976), p. 44.

52. John I. H. Baur, "American Luminism," *Perspectives USA*, no. 9 (Autumn 1954), p. 91.

53. Richardson, *Painting*, p. 211.

54. Wilmerding, *American Light*, pp. 11–12.

55. *Ibid.*, pp. 98, 123.

56. *The Complete Essays and Other Writings of Ralph Waldo Emerson* (New York: Modern Library, 1950), p. 6. See also Wilmerding, *American Light*, p. 78.

57. Donald B. Kuspit, "Nineteenth-Century Landscape: Poetry and Property," *Art in America* 64, no. 1 (January–February 1976), p. 69.

58. Wilmerding, *American Light*, p. 227.

59. Wilmerding, *American Art*, p. 96. The theme of solitude, serenity, and frozen time pervade the luminist aesthetic and much of our landscape tradition. Writing in 1831, Alexis de Tocqueville spoke of "a silence so deep, a stillness so complete, that the soul is invaded by a kind of religious terror. . . . One would say that for a moment the Creator has turned his face away and all the forces of nature are paralyzed" (Tocqueville, *Journey*, p. 383).

60. Wilmerding, *American Light*, p. 84.

61. George W. Sheldon, *American Painters, with Eighty-three Examples of Their Work Engraved in Wood* (New York: Appleton, 1879), p. 20.

62. Louis L. Noble, *After Icebergs with a Painter, A Summer Voyage to Labrador and Around Newfoundland* (New York: Appleton, 1861), p. 223.

63. Alexander von Humboldt, *Cosmos*, trans. E. C. Otté, 2 vols. (New York: Harper & Bros., 1850–1859). See also Douglas Botting, *Humboldt and the Cosmos* (New York and London: Harper & Row, 1973). Novak, *Nature and Culture*, pp. 138–139, states: "Sensationalism, exalted rhetoric, and reportage played their parts. But, the artists' deepest intentions were, as Humboldt required, to reveal the forces that regulate the universe, and to make everyone who saw their pictures a witness to its laws."

64. Wilmerding, *Marine Painting*, p. 80.

65. Novak, *Nature and Culture*, pp. 72–73.

66. Wilmerding, *American Art*, p. 98.

67. Wilmerding, *American Light*, p. 90.

68. Petrarch, *De vita solitaria*.

69. Quoted in John Howat *et al.*, *19th-Century America, Paintings and Sculpture* (exhibition catalogue) (New York: The Metropolitan Museum of Art, 1970), no. 107. See also David C. Huntington, *The Landscapes of Frederic Edwin Church* (New York: George Braziller, 1966), pp. 12–13.

70. Quoted in Samuel Eliot Morison,

The Oxford History of the American People (New York: Oxford University Press, 1965), I, p. 413.

71. Novak, *Nature and Culture*, p. 67.

72. Fitz Hugh Ludlow, *The Heart of the Continent: A Record of Travel Across the Plains and in Oregon, with an Examination of the American Principle* (New York: Hurd & Houghton, 1870), p. 412.

73. The establishment of Yellowstone as the first national park and the institution of Arbor Day were in themselves tangible responses to the wilderness destruction that occurred during the first half of the twentieth century. See also W. H. Truettner, *National Parks and the American Landscape* (Washington, D.C.: National Collection of Fine Arts, 1972).

74. Wilmerding, *American Light*, p. 93.

75. Nicolai Cikovsky, Jr., "George Inness and the Hudson River School: The Lackawanna Valley," *American Art Journal* 2, no. 2 (Fall 1970), p. 52.

76. George Inness, "A Painter on Painting," *Harpers New Monthly Magazine* 56 (December 1877–May 1878), p. 461.

77. *Ibid.*, p. 458.

78. Quoted in Samuel Isham, *The History of American Painting* (New York: The Macmillan Company, 1936), p. 256.

79. Joshua Taylor, *America as Art* (Washington, D.C.: Smithsonian Institution Press, 1976), p. 128.

80. Novak, *American Painting*, pp. 191–210. See also Van Deren Coke, *The Painter and the Photograph* (Albuquerque, N.M.: University of New Mexico Press, 1964).

81. Wilmerding, *Marine Painting*, p. 226.

82. Quoted in L. Goodrich, *Winslow Homer* (New York: George Braziller, 1959), p. 19: "The basic fact is that Homer, before he went abroad, had developed an independent brand of Impressionism based on firsthand observation of nature, and with affinities to Japanese art, and that the French experience merely confirmed and strengthened those tendencies."

83. Richardson, *American Painting*, p. 317.

84. As the younger generation returned from European studies in the 1870s and 1880s, a sharp break from luminism toward Impressionism occurred. Also a key influence was the April 1886 exhibition at the American Art Association Galleries of "300 Works in Oil and Pastels by the Impressionists of Paris." Organized by Durand-Ruel (1831–1922) the exhibit was subsequently moved to the National Academy of Design. The overall public response was quite good, providing greater public acceptance of this new style.

85. James Abbott McNeill Whistler, "The Red Rag," *The* [London] *World*, May 22, 1878. Quoted in Robert Goldwater and Marco Treves, comp. and ed., *Artists on Art from the Fourteenth to the Twentieth Century* (New York: Pantheon Books, 1945), pp. 349–351. See also Novak, *American Painting*, p. 249, for a comparison between Whistler's nocturnes and Thomas Cole's landscapes. Quoted in John Rewald, *Post-Impressionism from Van Gogh to Gauguin* (New York: The Museum of Modern Art, 1956), p. 148, Gustave Kahn and Jules Laforgue quoted the Symbolist goal: "The essential aim of our art is to objectify the subjective (the externalization of the Idea) instead of subjectifying the objective (nature seen through the eyes of a temperament)."

86. George Santayana, *The Sense of Beauty: Being an Outline of Aesthetic Theory* (New York: Scribners, 1896; reprint ed., New York: Dover Publications, 1955), p. 22.

87. Richard Boyle, *In This Academy, 1805–1976* (Philadelphia: The Pennsylvania Academy of the Fine Arts, 1976), p. 138.

88. Novak, *Nature and Culture*, p. 239, states, "This pragmatic emphasis on the density and weight of the object in reality is a quality that has distinguished the American tradition since Copley. Along with philosophical determinants, it impeded the development of a 'pure' impressionism that would fracture both the object and the picture's surface."

89. Harrison S. Morris, *Confessions in Art* (New York: Sears Publishing Co., 1930), p. 131.

90. Marsden Hartley was especially influenced by Ryder. Throughout his life Ryder maintained close contact with a small circle of friends, including the artist J. Alden Weir and the collector John Gellatly. Also, he frequently visited New York exhibitions and traveled to Europe several times.

91. A. P. Ryder, "Paragraphs from the Studio of a Recluse," *Broadway Magazine* 14 (September 1905) in McCoubrey, *American Art*, pp. 186–187. Recently, Barbara Novak stated, "Ryder's indeterminable process of painting and repainting . . . was an attempt to realize his *idea*, just as Cézanne's repeated attempts were to realize his sensations" (quoted in *American Painting*, p. 220).

92. Patricia Hills, *Turn-of-the-Century America* (New York: Whitney Museum of American Art, 1977), pp. 145–161.

93. Quoted in Giles Edgerton, "The Younger American Painters: Are They Creating a National Art?," *The Craftsman* 13 (February 1908), p. 525.

94. William Innes Homer *et al., Avant-Garde Painting and Sculpture in America 1910–25* (Wilmington: Delaware Art Museum, 1975), p. 14.

95. Theodore Stebbins, *American Master Drawings and Watercolors* (New York: Harper & Row, 1976), p. 306.

96. Lloyd Goodrich and Doris Bry, *Georgia O'Keeffe* (New York: Whitney Museum of American Art, 1970), p. 19.

97. Leo Marx, *The Machine in the Garden: Technology and the Pastoral Ideal in America* (New York: Oxford University Press, 1964), p. 356.

98. Wilmerding, *American Art*, p. 181.

99. Joseph S. Czestochowski, *John Steuart Curry and Grant Wood—A Portrait of Rural America* (Columbia, Mo., and London: University of Missouri Press, 1981).

100. Quoted in Matthew Baigell, *The American Scene: American Painting of the 1930s* (New York: Praeger Publishers, 1974), p. 111.

101. Quoted in *A Mirror of Creation* (New York: Friends of American Art in Religion, 1980, unpaged), John I. H. Baur states, "Often, however, abstract-expressionist paintings were untitled or simply numbered in order to avoid associations which the artists felt extraneous to their meaning. . . . Perhaps Kyle Morris came closest to describing one way in which this kind of art functions when he wrote: 'I have recently come to recognize more clearly the influence of . . . external nature upon my work although I arrived at this by an inverted approach. I must put it this way. I was not exploring "nature" in my work, but was exploring rather the surface of a canvas and the ways paint works on that surface; I was not responding to the images of nature, but to the painted surface. However, I did respond, and the images did have a way of leading me. . . . Those images and suggestions are elusive, but they are also very powerful. Maybe they didn't suggest leaves, but they may have suggested a fluttering movement. There was not the specific silhouette of things seen, but a suggestion of the forces that shape such things—a sense of the mutability and constant change which is the force and life in nature.' Morris's statement does not reflect the thinking of all abstract expressionists but his attitude was common enough to serve as an indication of how persistent nature has been in American art, even in a kind of urban painting more concerned with introspection than with the outer world."

102. Joshua Taylor, *The Fine Arts in America* (Chicago: University of Chicago Press, 1979), pp. 209–210.

103. Mark Rothko, quoted in *The Tiger's Eye* 1, no. 9 (October 15, 1949), p. 114.

104. McShine, *Natural Paradise*, p. 47.

105. Baur, *A Mirror of Creation* (unpaged) states: "All of these artists [abstract expressionists] were deeply moved by nature, as their art shows, but Burchfield was perhaps the most responsive and certainly the closest to Emerson in using its spiritual content."

106. Born, *American Landscape*, p. 215. See also *A Mirror of Creation* (unpaged), where Baur concludes that "This is a current in American art that has varied in breadth and strength from the beginning of the Hudson River school down to the present moment. . . . All one can say surely is that it has proved one of the most durable elements in American thought and culture through the last 150 years."

107. Lloyd Goodrich, "What Is American in American Art" (New York: M. Knoedler & Co., 1971), p. 21.

Caption Notes

1. Quoted in John Wilmerding, *American Art* (New York: Penguin Books, 1976), p. 87.

2. James Jackson Jarves, *The Art-Idea* (1864; reprint ed., Cambridge, Mass.: Harvard University Press, 1960), p. 235.

3. *Ibid.,* p. 190.

4. *Ibid.,* p. 254.

5. Quoted in Donald B. Kuspit, "Nineteenth-Century Landscape: Poetry and Property," *Art in America* 64, no. 1 (January–February 1976), p. 70.

6. Quoted in *International Studio* 60 (February 1917), p. 105.

7. A. P. Ryder, "Paragraphs from the Studio of a Recluse," *Broadway Magazine* 14 (September 1905); quoted in John W. McCoubrey, *American Art 1700–1960* (Englewood Cliffs, N.J.: Prentice-Hall, 1965), pp. 186–187.

8. Catalogue of one-man show, Photo-Secession Gallery, "291," New York, 1913; reprinted in MacKinley Helm, *John Marin* (Boston: Pellegrini & Cudahy in association with Institute of Contemporary Art, 1948), pp. 28–29.

9. Quoted in Henry Geldzahler, *American Painting in the Twentieth Century* (New York: The Metropolitan Museum of Art, 1965), pp. 131–132.

10. Quoted in Francis V. O'Connor, *Jackson Pollock* (New York: The Museum of Modern Art, 1968), pp. 39–40.

11. Thomas Cole, "Essay on American

Scenery," January 1835; quoted in John Mc-Coubrey, *American Art, 1700–1960*, p. 105.

12. John I. H. Baur, *A Mirror of Creation—150 Years of American Nature Painting* (New York: Friends of American Art in Religion, 1980), unpaged.

13. Barbara Novak, *American Painting of the Nineteenth Century* (New York: Praeger Publishers, 1969), p. 87.

14. Henry Tuckerman, *The Book of the Artists* (New York: James F. Carr, 1966), p. 189f.

15. Asher B. Durand, "Letters on Landscape Painting," *The Crayon* 2 (July–December 1855), p. 16.

16. John Ruskin, *Praeterita* (London, 1899), II, p. 300.

17. *The Complete Essays and Other Writings of Ralph Waldo Emerson* (New York: Modern Library, 1950), p. 6.

18. Edgar P. Richardson, *Painting in America, From 1502 to the Present* (New York: Thomas Y. Crowell, 1965), p. 222.

19. Quoted in Wilmerding, *American Art*, p. 86.

20. John Wilmerding quoted in Kynaston McShine, *The Natural Paradise* (New York: The Museum of Modern Art, 1976), p. 44.

21. William Bradford, *The Arctic Regions* (London, 1873).

22. George Inness, "A Painter on Painting," *Harper's New Monthly Magazine* 56 (December 1877–May 1878), pp. 456–461.

23. Obituary in *The Staten Islander*, October 7, 1908.

24. George W. Sheldon, *American Painters, with Eighty-three Examples of Their Work Engraved on Wood* (New York: Appleton, 1879), pp. 17–20.

25. John I. H. Baur, ed., *The Autobiography of Worthington Whittredge* (1942; reprint ed., New York: Arno Press, 1969), p. 46.

26. Cole, "Essay on American Scenery," in McCoubrey, *American Art,* p. 105.

27. Fitz Hugh Ludlow, *The Heart of the Continent* (New York: Hurd & Houghton, 1870), p. 426.

28. Sheldon, *American Painters*, pp. 22–28.

29. Jarves, *The Art-Idea*, p. 225.

30. Lloyd Goodrich, *Thomas Eakins: His Life and Work* (New York: Whitney Museum of American Art, 1933), p. 18.

31. Quoted in Frederic A. Sweet, *James A. McNeill Whistler* (Chicago: The Art Institute of Chicago, 1968), p. 28.

32. "The Red Rag," *The* [London] *World,* May 22, 1878.

33. Inness, "A Painter on Painting," pp. 456–461.

34. Quoted in Helen M. Knowlton, *The Art and Life of William Morris Hunt* (Boston: Houghton Mifflin, 1900), p. 119.

35. "On Some Pictures Lately Exhibited," *The Galaxy* 20 (July 1875), pp. 89–97; quoted in McCoubrey, *American Art*, p. 165.

36. Joel Cook, *America, Picturesque and Descriptive* (Philadelphia: John C. Winston, 1900).

37. Quoted in Donelson F. Hoopes, *The American Impressionists* (New York: Watson-Guptill, 1972), p. 94.

38. *Ibid.,* p. 58.

39. Quoted in Marsden Hartley, ed., *Adventures in the Arts* (New York: Boni & Liveright, 1921), pp. 40–41.

40. Frederick W. Morton, *Brush & Pencil* (February 1902), p. 269.

41. John K. Howat and Diane H. Pilgrim, *American Impressionist and Realist Paintings and Drawings from the Collection of Mr. and Mrs. Raymond I. Horowitz* (New York: The Metropolitan Museum of Art, 1973), p. 62.

42. Wilmerding, *American Art*, pp. 57–58.

43. Hoopes, *The American Impressionists*, p. 28.

44. Peter Bermingham, *American Art in the Barbizon Mood* (Washington, D.C.: Smithsonian Institution Press, 1975), p. 165.

45. Perry T. Rathbone, Preface to *Maurice Prendergast, 1859–1924* (Boston: Museum of Fine Arts, 1960), p. 12.

46. Charles Lang Freer to Dwight William Tryon, August 3, 1907. Charles Lang Freer Papers, Freer Gallery of Art, Washington, D.C., vol. 22, pp. 265–268.

47. F. Newlin Price, *Ernest Lawson, Canadian-American* (New York: Ferargil Galleries, 1930), unpaged.

48. Jeffrey R. Hayes, *Maurice Prendergast—Art of Impulse and Color* (College Park, Md.: University of Maryland Art Gallery, 1976), p. 150.

49. From the exhibition catalogue *A New Realism: Crawford, Demuth, Sheeler, Spencer* (Cincinnati, Ohio: Modern Art Society, 1941).

50. *Georgia O'Keeffe* (New York: The Viking Press, 1976), plate 46.

51. Grant Wood, *Paintings by Marvin Cone* (Cedar Rapids, Iowa: Cedar Rapids Art Association, 1939), unpaged.

52. *Sky Hooks: The Autobiography of John Kane* (as told to Marie McSwigan), foreword Frank Crowninshield (Philadelphia: J.B. Lippincott, 1938).

53. Quoted in Matthew Baigell, *The American Scene: American Painting of the 1930s* (New York: Praeger Publishers, 1974), p. 111.

54. Interview conducted by George Plimpton and Donald Stewart, *Horizon* [New York] 4, no. 1 (September 1961), pp. 88–101.

55. Edward Hopper to Charles Sawyer, October 29, 1939; quoted in Lloyd Goodrich, *Edward Hopper* (New York: Harry N. Abrams, 1971), p. 163.

56. Quoted in D. Miller, *Lyonel Feininger and Marsden Hartley* (New York: The Museum of Modern Art, 1944), p. 65.

57. Quoted in Coy Ludwig, *Maxfield Parrish* (New York: Watson-Guptill, 1973), p. 174.

58. Irving Sandler, *The Triumph of American Painting: A History of Abstract Expressionism* (New York and Washington, D.C.: Praeger Publishers, 1970), p. 150.

59. Robert Rosenblum, "The Abstract Sublime," *ARTnews* 59 (February 1961), p. 56.

60. Mark Rothko, "A Statement on His Attitude of Painting," *The Tiger's Eye* 1, no. 9 (October 15, 1949).

61. Adelyn Breeskin, *Milton Avery* (Washington, D.C.: National Collection of Fine Arts, 1969).

62. *Charles Burchfield—His Golden Year—A Retrospective Exhibition of Watercolors, Oils and Graphics* (Tucson: University of Arizona Press, 1965), p. 82.

Chronology

This chronology covers major artistic and historical events that relate to the contents of this book. Although by no means complete, it should provide the reader with a point of departure for further consideration. An excellent resource is *The Encyclopedia of American Facts and Dates,* Gorton Carruth and Associates, ed. (New York: Thomas Y. Crowell, 1979).

c. 1564
> First Professional painter of the New World, Jacques Le Moyne de Morgues working in Florida.

1587
> Roanoke Colony sponsored by Sir Walter Raleigh, established by John White.

1607
> Jamestown is founded as the first permanent English Colony in North America.

1620
> Plymouth Colony is established.

1626
> Peter Minuit purchases Manhattan Island.

1630
> John Winthrop founds Boston. Colonial population is estimated at 5,700.

1636
> Harvard College is founded.

1660s
> Colonial population is estimated at 84,800.

1670
> John Foster executes first engraved portrait in Colonial America; a woodcut of Massachusetts theological writer Richard Mather. Turner House (House of the Seven Gables) begun in Salem. In 1671

the first of the great Hudson Valley manors established at Fordham.

1680s
> John Bunyan's *Pilgrim's Progress* is published in 1681 to popular acclaim. The Parson Capen House in Topsfield, Massachusetts, is completed in 1683. Francis Bacon's *Essays* are published in 1688. William Penn receives a charter from Charles II for Pennsylvania in 1681, and in the next year Philadelphia is laid out.

1710
> Colonial population is estimated at 357,500.

1725
> Queen Anne style of furniture attains popularity in the Colonies.

1729
> John Smibert settles in Boston, becoming the first professional painter to arrive in the Colonies.

1720s and 1730s
> Monumental architecture begins throughout New England, including Christ Church ("Old North Church") in Boston in 1723 and Old State House (Independence Hall) in Philadelphia in 1732.

1737–1738
> John S. Copley born in Boston and Benjamin West born near Springfield, Pennsylvania.

1740s
> Faneuil Hall in Boston opened to the public in 1742. Alexander Pope's "Essay on Man" reprinted throughout the Colonies in 1747. English artists William Williams and John Wollaston arrive in

the Colonies in c. 1747 and 1749, respectively.

1750

Colonial population is estimated at 1,207,000. Parlange Plantation built in Louisiana.

1754

King's College chartered in New York by a grant of King George II.

1759

Benjamin West departs for Europe.

1760s

Colonial population is estimated at 1,610,000. Painter John S. Copley develops a considerable following in Boston. The Conestoga wagon is developed in Philadelphia, providing a significant contribution to Colonial transportation.

1763

Benjamin West settles in England, becoming instrumental in establishing the Royal Academy in 1768 and becoming its president in 1792.

1766

St. Paul's Chapel, a subsidiary to Trinity Church, built in Manhattan. Copley's portrait *The Boy with a Squirrel* is exhibited in London and receives critical acclaim.

1777

James Thomson's *Seasons* first published in this country.

1781

Surrender of Cornwallis at Yorktown, Virginia. The distinguished American furniture maker Duncan Phyfe arrives in New York. Articles of Confederation go into effect on March 1.

1782

C. W. Peale's gallery opens in Philadelphia. First Great Seal of the United States is adopted. Hector St. John de Crevecoeur's *Letters from an American Farmer* quite popular.

1783

Revolutionary War concluded with the Peace of Paris in February.

1787

Federal Convention meets in Philadelphia to draft new constitution.

1788

After the 1787 adoption of the Northwest Ordinance, the first settlements in this territory occur in Marietta, Ohio.

1789

George Washington is inaugurated in New York as the first president of the United States. After designs by Jefferson, the capitol at Richmond, Virginia, is built. The French Revolution begins.

1790

First congressionally authorized U.S. census is completed in August, with results of approximately 4 million. First patent law, copyright act, and federal naturalization act passed. During this decade the first wave of European artists arrive in this country—George Beck, Michele Cornè, William Birch, William Winstanley, Francis Guy, and William Groombridge.

1791

Massachusetts Historical Society founded in Boston, first Bank of the United States opened in Philadelphia and L'Enfant draws up plan for District of Columbia.

1793

First national coinage issued at the Philadelphia Mint. Eli Whitney of Georgia invents the cotton gin.

1794

First part of deistic *The Age of Reason* written by Thomas Paine (Part II in 1795). Charles W. Peale organizes the Columbianum in Philadelphia. First turnpike in America completed between Philadelphia and Lancaster, Pennsylvania.

1798

Samuel T. Coleridge and William Wordsworth publish the *Lyrical Ballads*.

1800

Second congressionally authorized U.S. census is completed, with results of approximately 5½ million. Washington, D.C., becomes the national capital.

1801

Washington Allston studies at the Royal Academy with West. Founded by Joseph Dennie of Philadelphia, *Port Folio* begins publication, becoming the decade's leading magazine.

1802

American Academy of Fine Arts is established in New York.

1803

First territorial expansion as a result of the Louisiana Purchase from France.

1804

Expedition of Meriwether Lewis and William Clark departs from St. Louis to explore the Louisiana Territory. After the successful showing of *Rising of a Thunderstorm at Sea* at the 1803 Paris Salon, Allston departs for Rome, where he befriends Samuel T. Coleridge (1805).

1805

Pennsylvania Academy of the Fine Arts is established by Charles W. Peale.

1807

The Athenaeum is founded in Boston. Robert Fulton's steamboat, *Clermont*, travels between Albany and New York.

1809

Washington Irving publishes *A History of New York* under the pseudonym Dietrich Knickerbocker.

1810

Third congressionally authorized census is completed, with results in excess of 7 million. Organization of the Society of Artists of the United States in Philadelphia.

1811

Allston and his pupil Samuel F. B. Morse move to London from Boston.

1812

War with Great Britain.

1814

British capture Washington and set fire to the White House. Peace accord signed at Ghent, Belgium, in December.

1815

North American Review founded in Boston. Cornerstone for Washington Monument is laid in Baltimore.

1817

John Trumbull receives Capitol rotunda commission for the *Signing of the Declaration of Independence*. William Cullen Bryant publishes "Thanatopsis" in the *North American Review*.

1818

Allston returns to Boston from London.

1819

Washington Irving's *Sketchbook of Geoffrey Crayon, Gent* is published and becomes an immediate best seller. Landscape lithographs drawn on stone by Bass Otis are printed in *Analectic Magazine*, Philadelphia. Thomas Cole emigrates to this country from England.

1820

Thomas Doughty abandons his profitable trade as a leather merchant to begin landscape painting.

1820–1821

Picturesque Views of American Scenery is published in Philadelphia. Drawings by Joshua Shaw were engraved by John Hill.

1821

John Hill publishes *Drawing Book of Landscape Scenery*, James Fenimore Cooper's great American novel *The Spy* is published.

1822

Thomas Doughty begins exhibiting landscapes at the Pennsylvania Academy of the Fine Arts. William Becknell of Missouri pioneers the Santa Fe Trail.

1823

Asher B. Durand establishes his reputation as an engraver after his copy of Trumbull's *Declaration of Independence* is accorded popular success. James Fenimore Cooper completes *The Pioneers*.

1825

Several guidebooks for American travel by stagecoach become available. Erie Canal officially opens. The route from Buffalo to Albany then down the Hudson River to New York City establishes that city's prominence as a trade center. The New York Drawing Association is organized, becomes the National Academy of Design in 1826. Samuel F. B. Morse was an active founder. Thomas Cole makes his first sketching trip up the Hudson River.

1826

James Fenimore Cooper publishes *The Last of the Mohicans*. First overland expedition made to California by Jedediah Strong Smith.

1827

Hudson River Portfolio is published in New York, with aquatints by Hill based on drawings by W. G. Wall. The first volume of John James Audubon's *Birds of America* is published in London.

1828

Robert Salmon emigrates to America, settles in Boston. Noah Webster's monumental *American Dictionary of the English Language* is published in New York. Andrew Jackson is elected president.

1829

Thomas Cole departs for Europe, remaining until 1832. Delaware and Chesapeake Canal formally opened.

1830

Population is estimated at approximately 13 million. First covered wagons make the trek from the Missouri River to the Rocky Mountains. Canal mileage in America amounts to 1,277 with only 73 miles of railroad. By 1850 there would be almost 4,000 miles of canal and more than 9,000 miles of railroad.

1831

Mechanical reaper invented by Cyrus McCormick. Gramercy Park established in New York. Thomas Cole in Italy, painting in Tuscany and the Roman Campagna.

1835

Samuel F. B. Morse invents the tele-

graph. Nathaniel Currier sets up a lithographic shop in New York with J. H. Bufford. Currier is joined in 1850 by J. Merritt Ives, changing the company name in 1857 to Currier and Ives. *Democracy in America* is published by Alexis de Tocqueville. Washington Irving publishes *Tour on the Plains.*

1836

Ralph Waldo Emerson publishes *Nature.*

1837

Financial panic in New York. Alfred Jacob Miller painting in the West with Scotsman Captain Stewart. Ralph Waldo Emerson delivers his address "The American Scholar," urging reliance on American not European artistic and literary modes.

1839

Apollo Association is established in New York, becomes American Art-Union in 1844 and closes in 1852. Daguerre-Niepce mode of photography announced in France. The present Trinity Church in New York is erected, becoming a prominent example of the Gothic Revival in America.

1840

Population is estimated in excess of 17 million. George Loring Brown arrives in Italy, remaining for almost twenty years devoting himself to painting landscapes in the manner of Claude Lorrain. Asher B. Durand departs for Europe with Kensett, Casilear, and Rossiter. Whittredge working in Cincinnati as a portrait painter. Panorama style of painting popularized by many, including John Banvard (canvases rolled on drums unfolded gradually before the spectators, often taking one hour). Nathaniel Parker Willis publishes a collection of stories, *The Romance of Travel.* Founding of *The Dial,* edited by Transcendentalist Margaret Fuller.

1841

First appearance of Emerson's *Essays.* Andrew J. Dowling, a landscape gardener from Newbury-on-the-Hudson, publishes his *Treatise on the Theory and Practice of Landscape Gardening.*

1842

First expedition of John Frémont to explore the route to Oregon.

1843

John Ruskin publishes *Modern Painters.*

1844

Emerson publishes *Essays,* Second Series. Telegraph line opened between Baltimore and Washington, D.C. Church begins studies with Cole in the Catskills,

remaining until 1848. Thomas Moran emigrates from England to Maryland.

1845

Durand succeeds Morse as President of the National Academy of Design, remains in that position until 1861. George Caleb Bingham begins his paintings of Missouri. Fitz Hugh Lane establishes a lithography partnership with John Scott in Boston.

1846

War with Mexico. Oregon boundary established with Great Britain at the 49th parallel. Gifford makes a sketching tour of the Catskills and the Berkshires. Inness studying painting with Régis F. Gignoux in Brooklyn. Smithsonian Institution established.

1847

Brigham Young with a group of Mormons settle at Great Salt Lake, Utah. Inness and Cropsey separately travel to Europe.

1848

Gold is discovered at Sutter's Mill, near Sacramento, California. A cast-iron building is constructed in New York. War with Mexico ended, with this country receiving territory that now consists of almost seven western states. Robert Duncanson receives a commission from Nicholas Longworth for a series of landscape murals for his Cincinnati home.

1849

Lane returns to Gloucester, where he remains, painting until his death in 1865. Whittredge departs for studies in Düsseldorf and Rome.

1850

Harper's Magazine is founded in New York. Seventh congressionally approved census, with results in population of over 23 million. First proposal for the creation of a park in New York City available to all citizens; a "central park."

1851

The New York Times and *Illustrated American News* begin publication. Eastman Johnson working in the Düsseldorf studio of Emanuel Leutze. Ruskin publishes *The Stones of Venice.*

1852

Harriet Beecher Stowe's *Uncle Tom's Cabin* published in Boston.

1853

Crystal Palace built in New York for the Exhibition of the Industry of All Nations. The Bryan Gallery of Christian Art opened in New York. After reading the writings of Alexander von Humboldt, Church together with Cyrus W. Field

travels for the first time to Ecuador. Commodore Perry sails to Japan, and subsequent 1854 treaty opens this country to world trade. Bierstadt travels to Düsseldorf to study art, while Duncanson and Sonntag travel to France, Italy, and England.

1854

Henry Thoreau after two years away from civilization finally publishes *Walden, or Life in the Woods.* Kansas-Nebraska Act passed. Inness in Paris then Barbizon to study art. Haseltine studies in Düsseldorf, where he meets Bierstadt and Whittredge.

1855

Walt Whitman publishes *Leaves of Grass.* Edited by W. J. Stillman and John Durand, *The Crayon* begins publication in New York, promoting Ruskin's views on Pre-Raphaelite painting. William Morris Hunt returns to Boston from France and actively begins to cultivate an appreciation for Barbizon painting. Whistler departs for studies in Europe, settling in Paris. Frank Leslie's *Illustrated Newspaper* begins publication.

1856

Frederic E. Church visits Niagara Falls. Haseltine, Leutze, Whittredge, and Bierstadt make a sketching trip down the Rhine River. The center of artistic interest begins to shift from Rome to Paris.

1857

Atlantic Monthly is established in Boston. Central Park is laid out in Manhattan by Frederick Law Olmsted and Calvert Vaux. *Harpers Weekly* is founded in New York. Tenth Street Studio Building is built by William Morris Hunt in New York for artists' studios. Exhibition of Pre-Raphaelite paintings in New York. Cropsey travels to Europe, remaining in London until 1863. Church successfully exhibits *Niagara Falls.*

1858

Precipitated by the financial panic of 1857, a spirit of religious revivalism sweeps this country. First transatlantic cable message is sent. Bierstadt visits the Rocky Mountains with the General Frederick W. Lander expedition.

1859

John Brown seizes the arsenal at Harpers Ferry, West Virginia. Oil is discovered in Pennsylvania. Charles Darwin publishes *On the Origins of the Species.* Church completes the monumental *Heart of the Andes* (The Metropolitan Museum of Art), subsequently purchased for $10,000, the highest price paid for a work by a living artist. Church first travels to Labrador to study icebergs. The Corcoran Gallery of Art is established.

1860

Population now exceeds 31 million people. The Confederation of Southern States is formed, and South Carolina secedes from the Union. Nathaniel Hawthorne publishes *The Marble Faun.* Thomas Farrer, an English follower of Ruskin, settles in New York. Richards spends the summer painting open-air landscapes near Bethlehem, Pennsylvania.

1861

Outbreak of the Civil War. Bradford makes his first trip to Labrador, after which he is recognized both here and abroad for his Arctic scenes.

1862

Emancipation Proclamation just submitted by Lincoln. Whistler meets the English artists Rossetti, Millais, and Moore. Moran travels to England to study Turner's works.

1863

Society for the Advancement of Truth in Art founded in New York, and its journal, *New Path,* begins publication. Heade visits Brazil and Bierstadt visits California's Yosemite Valley with Fitz Hugh Ludlow. Salon des Refuses is held in Paris.

1864

James Jackson Jarves publishes *The Art-Idea.* Inness emphasizes the expressive potential of landscape painting.

1865

Civil War ends. Whittredge, Gifford, and Kensett travel on a painting trip to the Rocky Mountains, returning the next year. James Renwick designs main buildings at Vassar College.

1866–1867

Homer and Eakins depart for studies in France.

1867

American Society of Painters in Water-Color is founded by Samuel Colman and James D. Smillie. Vedder settles in Italy, remaining for the duration of his life. Paris International Exposition is held, awarding Church a medal for his *Niagara Falls.* Alaska is acquired from Russia.

1869

First transcontinental railroad is completed, joining east and west coasts. Financial scandal known as "Black Friday"

on Wall Street because of gold speculation.

1870

Population is estimated in excess of 39 million. The Metropolitan Museum of Art and Boston Museum of Fine Arts are founded. *Scribner's Monthly* is established. Gifford, Whittredge, and Kensett accompany Hayden survey expedition to the Rocky Mountains. Eakins returns from Europe and settles in Philadelphia. Mecca for American painters is clearly Paris.

1871

Great Chicago Fire. Bierstadt sketches among the California redwood trees.

1872

As a result of government expeditions in 1859 and 1870, Yellowstone Park is established by Congress as a national park. Thomas Moran paints the monumental *Grand Canyon of the Yellowstone.* Trinity Church in Boston is begun by H. H. Richardson.

1873

Financial panic precipitated by the failure of a major New York banking house. J. Alden Weir studies in Paris. Moran accompanies a geographical survey to Grand Canyon in northern Arizona.

1874

Beginning around this time, there is greater emphasis on establishing art schools throughout the country. Charles Eliot Norton lectures on the history of art at Harvard.

1875

Art Students League is formed in New York.

1876

Centennial Exposition held in Philadelphia. Alexander Graham Bell invents the telephone. Henry James publishes his novel *Roderick Hudson.* Philadelphia Museum of Art is founded. Eakins becomes an instructor at the Pennsylvania Academy of the Fine Arts.

1877

Reconstruction formally ends. Society of American Artists is formed in opposition to the National Academy of Design, exhibiting in 1878.

1879

Thomas Edison invents the incandescent light bulb. The Art Institute of Chicago is founded.

1880s

Population is estimated in excess of 50 million. Art associations are formed in many cities, giving rise to museums in Cincinnati (1881), Indianapolis (1883), and Detroit (1888).

1881

The *Century Magazine* is founded. Homer visits Tynemouth, England.

1882

Homer settles in Prout's Neck, Maine remaining for the rest of his life.

1886

Major exhibition of French Barbizon and Impressionist paintings in New York. Whistler is elected president of the Society of British Artists in London. Statue of Liberty is completed and the American Federation of Labor is founded.

1888

George Eastman introduces the Kodak camera.

1890

Alfred Stieglitz returns to New York and becomes active in a photoengraving company.

1891

William M. Chase establishes an outdoor summer school at his home at Shinnecock, Long Island.

1893

World's Columbian Exposition is held in Chicago. The painting section is clearly dominated by the French Impressionists. Financial panic.

1897

Stieglitz becomes the editor of *Camera Notes.*

1898

"Ten American Painters" (Impressionists) organize and exhibit as a group. U.S.S. *Maine* is blown up in Havana harbor.

1900

Hopper studies with Henri, and Hartley summers for the first time in Maine. The automobile gains in public acceptance.

1902

Stieglitz founds the Photo-Secession, begins publication of *Camera Work* the next year.

1903

Panama Canal Treaty is approved; commercial travel does not begin until 1914.

1905

Alfred Stieglitz and Edward Steichen establish their avant-garde gallery at 291 Fifth Avenue. Albert Einstein publishes special theory of relativity.

1908

Exhibition of "The Eight" at New York's Macbeth Gallery. Dove and other Americans begin to travel to Paris. Ford

Motor Company introduces the Model T.
1909

Exhibits at "291" include works by Marin, Maurer, and Hartley.
1910

Exhibition of "Young American Painters" at "291" includes Marin, Dove, Hartley, Steichen, and Weber.
1912

Taos Society of Artists is founded. Exhibitions of modern art continue in this country.
1913

International Exhibition of Modern Art (Armory Show) opens in New York, introducing avant-garde art to the American public. American Synchromists exhibit in Paris and Munich. Federal Reserve System established.
1914

World War I begins in Europe. First poems by Edgar Lee Masters are published; eventually they become the collection called *Spoon River Anthology.*
1916

Forum Exhibition of "Modern American Painters" at New York's Anderson Galleries includes Dove, Hartley, and Marin.
1917

U.S. declares war on Germany.
1918

Whitney Studio Club and Phillips Collection are founded. Population is estimated in excess of 103 million.
1920

The Société Anonyme is founded in New York, holds exhibitions until 1939. Frederick Jackson Turner publishes *The Frontier in American History,* and Sinclair Lewis publishes *Main Street.*
1925

Mrs. John D. Rockefeller, Jr., begins planning Colonial Williamsburg, while amassing a folk art collection.
1927

Charles A. Lindbergh flies *The Spirit of St. Louis* nonstop from New York to Paris.
1928

New School for Social Research (New York) murals being completed by Benton.
1929

The Museum of Modern Art founded. The stock market crash signals the beginning of the Great Depression.
1930

Whitney Museum of American Art is founded. Regionalist Grant Wood receives acclaim for *American Gothic,* exhibited in Chicago.

1932–1933

Stone City (Iowa) Art Colony held during the summers of these two years, under the direction of Grant Wood, Marvin D. Cone, and John S. Curry.
1933

Public Works of Art Project is organized under the Treasury Department. The Bauhaus is closed in Germany. Hans Hofmann opens his art school in New York.
1934

The December 24 issue of *Time* magazine hails regional painting.
1935

Federal Art Project is organized under the Works Progress Administration, continues until 1943. Whitney Museum organizes the exhibit "Abstract Painting in America," while The Museum of Modern Art exhibits paintings by George Caleb Bingham.
1936

American Abstract Artists organize in New York. The Museum of Modern Art holds two important exhibits: "Cubism and Abstract Art" and "Fantastic Art, Dada and Surrealism."
1937

National Gallery of Art is founded in Washington, D.C.
1939

New York World's Fair. Major Picasso exhibit held at The Museum of Modern Art. World War II begins in Europe.
1941

National Gallery of Art opens in Washington, D.C.
1943

The Museum of Modern Art opens "Romantic Painting in America" exhibit. Pollock exhibits at Peggy Guggenheim's Art of This Century gallery, New York. He and others associated with Abstract Expressionism gain recognition.
1945

World War II ends.
1950

Painters of the New York School exhibit at the Venice Biennale.
1958

The Museum of Modern Art circulates "The New American Painting" exhibit in eight European countries. Artists include Baziotes, Gorky, Francis, Gottlieb, de Kooning, Pollock, Rothko, Stamos, Still, and others.
1960

The term *pop art* becomes common.
1964

U.S. involvement in Vietnam escalates.

Op art becomes a common term. Painting based on photography becomes accepted.

1965

National Foundation on the Arts and the Humanities established by Congress.

1975

Major exhibitions begin anticipating the Bicentennial, which results in widespread appreciation and popular interest in aspects of the American past.

Selected Bibliography

This bibliography is not intended to be comprehensive. Many of the publications cited herein provide extensive bibliographies that can guide the reader to additional valuable material.

Primary-source material exists in the collections of the Archives of American Art, The New-York Historical Society, and the Henry Francis du Pont Winterthur Museum, among others. See also Bernard Karpel, ed., *Arts in America—A Bibliography* (Washington, D.C.: Smithsonian Institution Press, 1979–1980).

The bibliography is divided into three sections, the first consists of general dictionaries and encyclopedias; the second contains histories, surveys, critical writings, and exhibition catalogues of American art; and the third contains specific references for the artists illustrated here.

Dictionaries and Encyclopedias

BENJAMIN, SAMUEL GREENE WHEELER. *Our American Artists*. Boston, 1879.

————. *Art in America, a Critical and Historical Sketch*. New York: Harper & Bros., 1880.

CLEMENT, CLARA ERSKINE, and HUTTON, LAURENCE, eds. *Artists of the Nineteenth Century and Their Works*. Boston, 1879. Rev. ed. Boston and New York: Houghton Mifflin, 1884.

COWDREY, MARY BARTLETT, ed. *American Academy of Fine Arts and American Art-Union, 1816–1852*. 2 vols. New York: The New-York Historical Society, 1853.

————. *National Academy of Design Exhibition Record, 1826–1860*. 2 vols. New York: The New-York Historical Society, 1943.

DUNLAP, WILLIAM. *A History of the Rise and Progress of the Arts of Design in the United States*. 2 vols. New York, 1834. rev. ed. Edited by Rita Weiss. Introduction by J. T. Flexner, 3 vols. New York: Dover Publications, 1969.

FIELDING, MANTLE. *Dictionary of American Painters, Sculptors, and Engravers*. Philadelphia: Lancaster Press, 1926.

GROCE, GEORGE C., and WALLACE, DAVID H. *The New-York Historical Society's Dictionary of Artists in America, 1564–1860*. New Haven, Conn.: Yale University Press, 1957.

JOHNSON, ALLEN, and MALONE, DUMAS. *Dictionary of American Biography*. 20 vols. New York: Scribner's, 1928–1964.

POOLE, WILLIAM FREDERICK. *An Index to Periodical Literature*. New York and London, 1853. Rev. ed. Boston, 1882. Supplements, Boston, 1888, 1895, 1897, 1903.

RUTLEDGE, ANNA WELLS, ed. *The Pennsylvania Academy of the Fine Arts, 1807–1870; The Society of Artists, 1800–1814; The Artists' Fund Society, 1835–1845*. Philadelphia: American Philosophical Society, 1955.

SHELDON, GEORGE W. *American Painters, with Eighty-three Examples of Their Work Engraved on Wood*. New York: Appleton, 1879.

————. *Hours with Art and Artists*. New York, 1882.

SWAN, MABEL M. *The Athenaeum Gallery: 1827–1873; The Boston Athenaeum As an Early Patron of Art*. Boston, 1940.

TUCKERMAN, HENRY T. *Artist-Life: or*

Sketches of Eminent American Painters. New York, 1847.

————. *The Book of the Artists: American Artist Life.* New York: Putnam's, 1867. Reprint. New York: James F. Carr, 1966.

Histories, Surveys, Critical Writings, and Catalogues

ADAMS, HENRY. *The United States in 1800.* Ithaca, N.Y.: Cornell University Press, 1955.

ALLOWAY, LAWRENCE. *Topics in American Art Since 1945.* New York: W. W. Norton, 1975.

Art in America (New York) 64, no. 1 (January-February 1976). Issue on American Landscape.

ASHTON, DORE. *The New York School: A Cultural Reckoning.* New York: The Viking Press, 1973.

Atlanta. The High Museum. *The Beckoning Land, Nature and the American Artist: A Selection of Nineteenth-Century Paintings* (exhibition catalogue). Text by Donelson F. Hoopes. 1971.

————. *The Düsseldorf Academy and the Americans: An Exhibition of Drawings and Watercolors* (exhibition catalogue). 1973.

BAIGELL, MATTHEW. *The American Scene: American Painting of the 1930s.* New York: Praeger Publishers, 1974.

BAUR, JOHN I. H. "American Luminism, A Neglected Aspect of the Realist Movement in Nineteenth-Century American Painting." *Perspectives USA,* no. 9 (New York) (Autumn 1954), pp. 90–98.

————. "Early Studies in Light and Air by American Painters." *Brooklyn Museum Bulletin* 9, no. 2 (Winter 1948).

————. *A Mirror of Creation—150 Years of American Nature Painting* (exhibition catalogue). Vatican City: The Vatican Museums, 1980. New York: Friends of American Art in Religion, 1980.

————. *Revolution and Tradition in Modern American Art.* Cambridge, Mass.: Harvard University Press, 1851.

BERMINGHAM, PETER. *American Art in the Barbizon Mood.* Washington, D.C.: National Collection of Fine Arts, Smithsonian Institution Press, 1975.

BILLINGTON, RAY A. *The Far Western Frontier, 1830–1860.* New York: Harper & Row, 1956.

BODE, CARL, ed. *American Life in the 1840's.* New York: Doubleday Anchor Books, 1964.

BORN, WOLFGANG. *American Landscape Painting: An Interpretation.* New Haven, Conn.: Yale University Press, 1948.

Boston. Museum of Fine Arts. *M. and M. Karolik Collection of American Paintings, 1815 to 1865.* Essay by John I. H. Baur. Introduction by Maxim Karolik, Foreword by G. H. Edgel. Cambridge, Mass.: Harvard University Press, 1949.

BOYLE, RICHARD J. *American Impressionism.* Boston: New York Graphic Society, 1974.

————. *In This Academy, 1805–1976.* Philadelphia: The Pennsylvania Academy of the Fine Arts, 1976.

BROWN, MILTON J. *American Art: Painting, Sculpture, Architecture, Decorative Arts, Photography to 1900.* New York: Harry N. Abrams, 1979.

————. *American Painting from the Armory Show to the Depression.* Princeton, N.J.: Princeton University Press, 1955.

————. *The Story of the Armory Show.* New York: The Joseph H. Hirschhorn Foundation, 1963.

BROOKS, VAN WYCK. *The Dream of Arcadia: American Writers and Artists in Italy, 1760–1915.* New York: E.P. Dutton, 1958.

————. *The Flowering of New England.* New York: E.P. Dutton, 1936. Reprint. New York: Dutton Paperbacks, 1952.

BRYANT, WILLIAM CULLEN. *The American Landscape* (Preface). New York: Elam Bliss, 1830.

————, ed. *Picturesque America.* New York, 1874.

Buffalo. Albright-Knox Art Gallery. *Heritage and Horizon: American Painting 1776–1976* (exhibition catalogue). 1976.

BURKE, EDMUND. *A Philosophical Enquiry into the Origin of Our Ideas of the Sublime and Beautiful.* London, 1757. 2d ed. London 1759. Annotated edition based on 2d ed. Edited by James T. Boulton. South Bend, Ind.: University of Notre Dame Press, 1968.

BURROUGHS, ALAN. *Limners and Likenesses: Three Centuries of American Painting.* Cambridge, Mass.: Harvard University Press, 1936.

CAFFIN, CHARLES HENRY. *The Story of American Painting.* New York: Frederick A. Stokes, 1907.

CHEVREUL, M. E. *The Laws of Contrast in Color: And Their Application to the Arts.* London, 1859.

CLARK, KENNETH. *Landscape into Art.* New York: Scribner's, 1950.

Cleveland Museum of Art. *The European*

Vision of America. Text by Hugh Honour. 1975.

COKE, VAN DEREN. *The Painter and the Photograph.* Albuquerque, N.M.: University of New Mexico Press, 1964.

CONRON, JOHN. *The American Landscape: A Critical Anthology of Prose and Poetry.* New York: Oxford University Press, 1974.

Crayon, The: A Journal Devoted to the Graphic Arts, and the Literature Related to Them. vols. 1–8. 1855–1861.

Detroit Institute of Arts, The. *The World of the Romantic Artist: A Survey of American Culture from 1800 to 1875* (exhibition catalogue). Text by Edgar P. Richardson. 1945.

Dial, The: A Magazine for Literature, Philosophy and Religion, 1840–44. Reprint. New York: Russell & Russell, 1961.

DICKASON, DAVID H. *The Daring Young Men: The Story of the American Pre-Raphaelites.* Bloomington, Ind.: Indiana University Press, 1963.

DOWNING, ANDREW JACKSON. *A Treatise on the Theory and Practice of Landscape Gardening.* Reprint. New York: Funk & Wagnall's, 1967.

EARLE, EDWARD W. *Points of View: The Stereograph in America—A Cultural History.* Rochester, N.Y., 1979.

EITNER, LORENZ. *Neoclassicism and Romanticism, 1750–1859.* 2 vols. Sources and Documents in the History of Art Series. Englewood Cliffs, N.J.: Prentice-Hall, 1970.

EMERSON, RALPH WALDO. *Emerson: A Modern Anthology.* Edited by Alfred Kazin and Daniel Aaron. Boston: Houghton Mifflin, 1958.

————. *The Journals and Miscellaneous Notebooks of Ralph Waldo Emerson.* Edited by William H. Gilman *et al.* 14 vols. Cambridge, Mass.: Belknap Press of Harvard University Press, 1960–1978.

————. *The Selected Writings of Ralph Waldo Emerson.* Edited by Brooks Atkinson. New York: Modern Library, 1950.

FLEXNER, JAMES THOMAS. *American Painting: First Flowers of Our Wilderness.* Boston: Houghton Mifflin, 1947.

————. *American Painting: The Light of Distant Skies, 1760–1835.* New York: Harcourt, Brace, 1954.

————. "George Washington as an Art Collector." *American Art Journal* 4, no. 1 (Spring 1972), pp. 24–35.

————. *Nineteenth-Century American Painting.* New York: Putnam's, 1970.

————. "Tuckerman's Book of the Artists." *American Art Journal* 1, no. 2 (Fall 1969), pp. 53–57.

————. *That Wilder Image: The Painting of America's Native School from Thomas Cole to Winslow Homer.* Boston: Little, Brown, 1962.

GELDZAHLER, HENRY. *American Painting in the Twentieth Century.* New York: The Metropolitan Museum of Art, distributed by New York Graphic Society, 1965.

————. *New York Painting and Sculpture, 1940–1970.* New York: E.P. Dutton, in association with The Metropolitan Museum of Art, 1969.

GERDTS, WILLIAM. "The Influence of Ruskin and Pre-Raphaelitism on American Still-Life Painting." *American Art Journal* 1, no. 2 (Fall 1969), pp. 80–97.

GILPIN, WILLIAM. *The Mission of the North American People, Geographical, Social and Political.* 2d ed. New York: W. W. Norton, 1948.

GOETZMANN, WILLIAM H. *Exploration and Empire: The Explorer and the Scientist in the Winning of the American West.* New York: Vintage Books, 1972.

GOMBRICH, ERNST H. *Art and Illusion: A Study in the Psychology of Pictorial Representation.* New York: Pantheon Books, 1960.

————. *Norm and Form.* New York: Phaidon, 1966.

GOODRICH, LLOYD. *A Century of American Landscape Painting, 1800–1900.* New York: Whitney Museum of American Art, 1938.

————. *What Is American in American Art.* New York: M. Knoedler & Co., 1971.

————, and BAUR, JOHN I. H. *American Art of Our Century.* New York: Praeger Publishers, 1961.

GREENBERG, CLEMENT. *Art and Culture: Critical Essays.* Boston: Beacon Press, 1961.

HAGEN, OSKAR. *The Birth of the American Tradition in Art.* New York: Scribner's, 1940.

HANDLIN, OSCAR. *Truth in History.* Cambridge, Mass.: Belknap Press of Harvard University Press, 1979.

HARRIS, NEIL. *The Artist in American Society: The Formative Years, 1790–1860.* New York: George Braziller, 1966. Reprint. New York: Simon & Schuster, 1970.

HARTMANN, SADAKICHI. *A History of American Art.* 2 vols. Boston: L.C. Page, 1902.

HAYDEN, FERDINAND V. *The Yellowstone National Park and the Mountain Regions of Idaho, Nevada, Colorado, Utah.* Boston: L. Prang & Co., 1876.

HERBERT, ROBERT L. *Barbizon Revisited.* Boston: Museum of Fine Arts, 1962.

HONOUR, HUGH. *The New Golden Land: European Images of America from the Discoveries to the Present Time.* New York: Random House, 1975.

————. *Romanticism.* New York: Harper & Row, 1979.

HOWAT, JOHN K. *The Hudson River and Its Painters.* New York: The Viking Press, 1972.

HUMBOLDT, ALEXANDER VON. *Cosmos: A Sketch of the Physical Description of the Universe.* Translated by E. C. Otté. 2 vols. New York: Harper & Bros., 1850–1859.

HUNTER, SAM, and JACOBUS, JOHN. *American Art of the 20th Century: Painting, Sculpture, Architecture.* New York: Harry N. Abrams, 1974.

HUSSEY, CHRISTOPHER. *The Picturesque.* Hamden, Conn.: Archon Books, 1967.

HUTH, HANS. *Nature and the American: Three Centuries of Changing Attitudes.* Berkeley: University of California Press, 1957.

IRVING, WASHINGTON. *A Tour on the Prairies.* 1835. Reprint. New York: Pantheon Books, 1967.

ISHAM, SAMUEL. *The History of American Painting.* New York: The Macmillan Company, 1936.

JARVES, JAMES JACKSON. *Art-Hints.* New York: Harper & Bros., 1855.

————. *The Art-Idea.* New York: Hurd & Houghton, 1864. Reprint. Edited by Benjamin Rowland, Jr. Cambridge, Mass.: Harvard University Press, 1960.

————. *Art-Thoughts: The Experiences and Observations of an American Amateur in Europe.* New York: Hurd & Houghton, 1969.

KANE, ELISHA KENT. *Arctic Explorations.* 2 vols. Philadelphia, 1856.

KANT, IMMANUEL. *The Critique of Judgment, 1790.* Translated by James Creed Meredith. Great Books of the Western World, 42. Chicago: University of Chicago Press, 1952.

KOUWENHOVEN, JAMES A. *Made in America.* New York: Doubleday & Co., 1948.

LANMAN, CHARLES. *Letters from a Landscape Painter.* Boston: J. Munroe & Co., 1845.

LARKIN, OLIVER W. *Art and Life in America.* New York: Holt, Rinehart & Winston, 1949.

LEWIS, RICHARD W. *The American Adam.* Chicago: University of Chicago Press, 1955.

LINDQUIST-COCK, ELIZABETH. *The Influence of Photography on American Landscape Painting, 1839–1980.* New York: Garland Publishing, 1977.

LIPMAN, JEAN. *American Primitive Painting.* London and New York: Oxford University Press, 1942.

————, and WINCHESTER, ALICE. *The Flowering of American Folk Art, 1776–1876.* New York: Whitney Museum of American Art, 1974.

————. *Primitive Painters in America.* New York: Dodd, Mead, 1950.

LITTLE, NINA FLETCHER. *American Decorative Wall Painting.* Sturbridge, Mass.: Old Sturbridge Village, 1952.

LUDLOW, FITZ HUGH. *The Heart of the Continent: A Record of Travel Across the Plains and in Oregon, with an Examination of the American Principle.* New York: Hurd & Houghton, 1870. Reprint. New York: AMS Press, 1971.

MARX, LEO. *The Machine in the Garden: Technology and the Pastoral Ideal in America.* New York: Oxford University Press, 1964.

MATTHIESSEN, F. O. *American Renaissance: Art and Experience in the Age of Emerson and Whitman.* New York: Oxford University Press, 1941.

MCCOUBREY, JOHN W. *American Art, 1700–1960.* Sources and Documents in the History of Art Series. Englewood Cliffs, N.J.: Prentice-Hall, 1965.

MILLER, LILLIAN B. *Patrons and Patriotism: The Encouragement of the Fine Arts in the United States, 1790–1860.* Chicago: University of Chicago Press, 1966.

MILLER, PERRY. *The American Transcendentalists: Their Prose and Poetry.* New York: Doubleday Anchor Books, 1957.

————. *Errand into the Wilderness.* New York: Harper & Row, 1964.

————. *The Life of the Mind in America, from the Revolution to the Civil War.* New York: Harcourt, Brace & World, 1965.

————. *Nature's Nation.* Cambridge, Mass.: The Belknap Press of Harvard University Press, 1967.

MONK, SAMUEL H. *The Sublime.* 1935. Reprint. Ann Arbor: University of Michigan Press, 1960.

MORISON, SAMUEL ELIOT. *The Oxford History of the American People.* 3 vols. New York: Oxford University Press, 1965.

MOURE, NANCY D. W. "Five Eastern Artists Out West." *American Art Journal* 5, no. 2 (November 1973), pp. 15–31.

MUIR, JOHN. *Our National Parks.* Boston: Houghton Mifflin, 1909.

MUMFORD, LEWIS. *The Brown Decades: A Study of the Arts in America 1865–1895.* New York: Dover Publications, 1931.

NASH, RODERICK. *Wilderness and the American Mind.* New Haven, Conn.: Yale University Press, 1967.

NEWHALL, BEAUMONT. *The Daguerreotype in America.* New York: Duell, Sloan & Pearce, 1961.

————. *The History of Photography from 1839 to the Present Day.* 4th, rev. ed. New York: The Museum of Modern Art, 1964.

New York. The Metropolitan Museum of Art. *American Paintings: A Catalogue of the Collection. Vol. I: Painters Born by 1815.* Text by Albert Ten Eyck Gardner and Stuart P. Feld. 1965.

————. *American Paintings: A Catalogue of the Collection. Vol. III: A Catalogue of Painters Born between 1846 and 1864.* Text by Doreen Bolger Burke. 1980.

————. *Era of Exploration: The Rise of Landscape Photography in the American West, 1860–1885.* Text by Weston J. Naef and James N. Wood. 1975.

————. *19th-Century America: Paintings and Sculpture; An Exhibition in Celebration of the Hundredth Anniversary* (exhibition catalogue). Texts by John K. Howat, John Wilmerding, and Natalie Spassky. 1970.

————. The Museum of Modern Art. *The Natural Paradise: Painting in America, 1800–1950.* Edited by Kynaston McShine. Essays by Barbara Novak, Robert Rosenblum, and John Wilmerding. 1976.

————. *The Photographer and the American Landscape* (exhibition catalogue). Text by John Szarkowski. 1963.

————. *Romantic Painting in America* (exhibition catalogue). Texts by James Thrall Soby and Dorothy C. Miller. 1944.

————. Queens County Art and Cultural Center. *19th Century American Landscape* (exhibition catalogue). Text by Mary David and John K. Howat. 1970.

————. Whitney Museum of American Art. *The 1930s: Painting and Sculpture in America* (exhibition catalogue). Text by William C. Agee. 1968.

————. *Turn-of-the-Century America.* Text by Patricia Hills. 1977.

NOBLE, LOUIS L. *After Icebergs with a Painter: A Summer Voyage to Labrador and New Foundland.* New York: Appleton, 1861.

————. *The Heart of the Andes.* Broadside. New York, 1859.

NOVAK, BARBARA. *American Painting of the Nineteenth Century.* New York: Praeger Publishers, 1969.

————. *The Arcadian Landscape: Nineteenth-Century American Painters in Italy.* Introduction by Charles C. Eldredge. Lawrence, Kans.: University of Kansas Museum of Art, 1972.

————. *Nature and Culture: American Landscape and Painting, 1825–1875.* New York: Oxford University Press, 1980.

NOVOTNY, FRITZ. *Painting and Sculpture in Europe, 1780–1880.* Pelican History of Art. Baltimore, Md.: Penguin Books, 1960.

NYE, RUSSEL B. *The Cultural Life of the New Nation, 1776–1830.* New York: Harper Torchbooks, 1960.

————. *Society and Culture in America, 1830–1860.* New York: Harper & Row, 1974.

O'DOHERTY, BRIAN. *American Masters: The Voice and the Myth.* New York: Random House, 1973.

PARRINGTON, VERNON L. *Main Currents of American Thought.* 2 vols. New York: Harvest Books, 1954.

Philadelphia. Philadelphia Museum of Art. *Philadelphia: Three Centuries of American Art* (exhibition catalogue). 1976.

PLEASANTS, J. HALL. "Four Late 18th Century Anglo-American Landscape Painters." American Antiquarian Society *Proceedings* 52 (1943), pp. 187–324.

Providence. Rhode Island School of Design. Museum of Art. *Selection VII—American Paintings from the Museum Collection, ca. 1800–1930* (exhibition catalogue). 1977.

PROWN, JULES D. *American Painting: From Its Beginnings to the Armory Show.* Cleveland, Ohio: World Publishing, 1969.

REINGOLD, NATHAN, ed. *Science in Nineteenth-Century America: A Documentary History.* New York: Hill & Wang, 1964.

RICHARDSON, EDGAR P. *American Romantic Painting.* Edited by Robert Freund. New York: E. Weyhe, 1944.

————. *Painting in America, From 1502 to the Present.* New York: Thomas Y. Crowell, 1965.

————, and WITTMAN, OTTO, JR. *Travellers in Arcadia: American Artists in Italy, 1830–1875* (exhibition catalogue). Detroit, Mich., and Toledo, Ohio: The Detroit Institute of Arts, Toledo Museum of Art, 1951.

RITCHIE, ANDREW C. *Abstract Painting and*

Sculpture in America. New York: The Museum of Modern Art, 1951.

ROSE, BARBARA. *American Art Since 1900: A Critical History.* New York and Washington, D.C.: Praeger Publishers, 1967. rev. ed., 1975.

————. *American Painting: The Twentieth Century.* Cleveland: World Publishing, 1969.

————. *Readings in American Art 1900–1975: A Critical History.* New York: Praeger Publishers, 1968. rev. ed., 1975.

ROSENBLUM, ROBERT. *Modern Painting and the Northern Romantic Tradition: Friedrich to Rothko.* New York: Harper & Row, 1975.

ROURKE, CONSTANCE. *The Roots of American Culture.* New York: Harcourt, Brace, 1942.

RUSKIN, JOHN. *The Art Criticism of John Ruskin.* Edited by Robert L. Herbert. New York: Doubleday Anchor Books, 1964.

————. *Modern Painters.* 5 vols. New York: John Wiley & Sons, 1868.

St. Louis. City Art Museum of St. Louis. *Mississippi Panorama* (exhibition catalogue). 1949.

SANDLER, IRVING. *The Triumph of American Painting: A History of Abstract Expressionism.* New York and Washington, D.C.: Praeger Publishers, 1970.

SANFORD, CHARLES L. *The Quest for Paradise: Europe and the American Moral Imagination.* Urbana, Ill.: University of Illinois Press, 1961.

San Francisco. M. H. de Young Memorial Museum. *American Art: An Exhibition from the Collection of Mr. and Mrs. John D. Rockefeller 3rd* (exhibition catalogue). Text by E. P. Richardson. 1976.

————, and California Palace of the Legion of Honor. *The Color of Mood: American Tonalism, 1880–1910* (exhibition catalogue). Text by Wanda M. Corn. 1972.

SCHLESINGER, ARTHUR M. *The Birth of the Nation.* New York: Alfred A. Knopf, 1968.

SEARS, CLARA ENDICOTT. *Highlights Among the Hudson River Artists.* Boston: Houghton Mifflin, 1947.

SHEPARD, PAUL. *Man in the Landscape.* New York: Alfred A. Knopf, 1967.

SMITH, HENRY NASH, ed. *Popular Culture and Industrialism, 1865–1890.* New York: Doubleday, Anchor Books, 1967.

————. *Virgin Land.* Cambridge, Mass.: Harvard University Press, 1970.

STALEY, ALLEN. *The Pre-Raphaelite Landscape.* London: Oxford University Press, 1973.

STEBBINS, THEODORE E., JR. *American Master Drawings and Watercolors. A History of Works on Paper from Colonial Times to the Present.* New York: Harper & Row, 1976.

————. *The American Study of Light, 1860–1875.* Cambridge, Mass.: Fogg Art Museum, Harvard University, 1966.

STEIN, ROGER B. *John Ruskin and Aesthetic Thought in America, 1840–1900.* Cambridge, Mass.: Harvard University Press, 1967.

————. *Seascape and the American Imagination.* New York: Clarkson Potter, in association with the Whitney Museum of American Art, 1975.

SWEET, FREDERICK A. *The Hudson River School and the Early American Landscape Tradition.* Chicago: The Art Institute of Chicago, 1945.

TAYLOR, JOSHUA. *America as Art.* Washington, D.C.: Published for the National Collection of Fine Arts by the Smithsonian Institution Press, 1976.

————. *The Fine Arts in America.* Chicago: University of Chicago Press, 1979.

THOREAU, HENRY DAVID. *The Journey of Henry D. Thoreau.* Edited by Bradford Torrey and Francis H. Allen. 2 vols. New York: Dover Publications, 1962.

————. *The Writings of Henry David Thoreau.* 20 vols. Boston: Houghton Mifflin, 1906.

TOCQUEVILLE, ALEXIS DE. *Journey to America* (1831). Translated by George Lawrence. Edited by J. P. Mayer. Garden City, N.Y.: Doubleday & Co., 1971.

TOWNSEND, FRANCIS G. *Ruskin and the Landscape Feeling.* Urbana, Ill.: University of Illinois Press, 1951.

TURNER, FREDERICK JACKSON. *Frontier and Section.* Englewood Cliffs, N.J.: Prentice-Hall, 1961.

UNRUH, JOHN D. *The Plains Across—The Overland Emigrants and the Trans-Mississippi West, 1840–60.* Urbana, Ill.: University of Illinois Press, 1978.

Utica, N.Y. Munson-Williams-Proctor Institute. *1913 Armory Show 50th Anniversary Exhibition* (exhibition catalogue). 1963.

VALSECCHI, MARCO. *Landscape Painting of the 19th Century.* Greenwich, Conn.: New York Graphic Society, 1971.

VOGEL, STANLEY N. *German Literary Influences on the American Transcendentalists.* New Haven, Conn.: Yale University Press, 1955.

Washington, D.C. National Collection of Fine Arts. *National Parks and the American Landscape* (exhibition catalogue). Texts

by William H. Truettner and Robin Bolton-Smith. 1972.

————. The National Endowment for the Arts and The Corcoran Gallery of Art. *Wilderness* (exhibition catalogue). 1971.

————. The National Gallery of Art. *American Light—The Luminist Movement 1850–1875.* Text by John Wilmerding *et al.* 1980.

————. Smithsonian Institution Traveling Exhibition Service. *American Art in the Making: Preparatory Studies for Masterpieces of American Painting, 1800–1900.* Essay by David Sellin. 1976.

WEIR, JOHN F. "American Landscape Painters." *New Englander* 32, no. 122 (January 1873), pp. 140–151.

WHITMAN, WALT. *Leaves of Grass.* Brooklyn, 1855. rev. ed., Philadelphia: David McKay, 1891–1892.

————. *The Portable Walt Whitman.* Selected and introduced by Mark Van Doren. New York: The Viking Press, 1945.

————. *Specimen Days.* 1882. Reprint. Boston: David R. Godine, 1971.

WILLIS, NATHANIEL PARKER. *American Scenery: or Land, Lake, and River.* London, 1840.

WILMERDING, JOHN. *American Art.* London and New York: Penguin Books, 1976.

————. *Fitz Hugh Lane.* New York: Praeger Publishers, 1971.

————, ed. *The Genius of American Painting.* New York: William Morrow, 1973.

————. *A History of American Marine Painting.* Salem, Mass.: Little, Brown, for Peabody Museum of Salem, 1968.

WOLFFLIN, HEINRICH. *Principles of Art History.* New York: Dover Publications, 1932.

Sources for Individual Artists

ALLSTON, WASHINGTON (1779–1843)

Allston, Washington. *Lectures on Art and Poems.* Edited by Richard Henry Dana, Jr. New York: Baker & Scribner, 1850. Reprint. New York: DaCapo Press, 1972.

Flagg, Jared B. *The Life and Letters of Washington Allston.* New York: Scribner's, 1892.

Gerdts, William, and Stebbins, Theodore E., Jr. *A Man of Genius: The Art of Washington Allston, 1779–1843* (exhibition catalogue). Boston: Museum of Fine Arts, 1979.

Richardson, Edgar P. *Washington Allston: A Study of the Romantic Artist*

in America. Chicago: University of Chicago Press, 1948. rev. ed., New York: Apollo Editions, 1967.

AVERY, MILTON (1893–1965)

Breeskin, Adelyn. *Milton Avery.* Washington, D.C.: National Collection of Fine Arts, 1969.

BELLOWS, GEORGE (1882–1925)

Young, Mahonri Sharp. *The Paintings of George Bellows.* New York: Watson-Guptill, 1973.

BIERSTADT, ALBERT (1830–1902)

Bierstadt, Albert. "Country Correspondence: Rocky Mountains, July 10, 1859." *The Crayon* 6 (September 1859), p. 287.

Hendricks, Gordon. *Albert Bierstadt: Painter of the American West.* New York: Harry N. Abrams, in association with the Amon Carter Museum, 1974.

————. "The First Three Western Journeys of Albert Bierstadt." *The Art Bulletin* 46, no. 3 (September 1964), pp. 333–365.

Lindquist-Cock, Elizabeth. "Stereoscopic Photography and the Western Paintings of Albert Bierstadt." *Art Quarterly* (Winter 1970), pp. 361–376.

BINGHAM, GEORGE CALEB (1811–1879)

Bloch, E. Maurice. *George Caleb Bingham, The Evolution of an Artist: A Catalogue Raisonné.* 2 vols. Berkeley & Los Angeles: University of California Press, 1967.

BIRCH, THOMAS (1779–1851)

Gerdts, William H. "Thomas Birch: America's First Marine Artist." *Antiques* 89, no. 4 (April 1966), pp. 528–534.

Thomas Birch, 1779–1851, Paintings and Drawings (exhibition catalogue). Philadelphia Maritime Museum, 1966.

BLAKELOCK, RALPH ALBERT (1847–1919)

Gebhard, David, and Stuurman, Phyllis. *The Enigma of Ralph A. Blakelock, 1847–1919* (exhibition catalogue). Santa Barbara: Art Galleries, University of California, 1969.

Geske, Norman A. *Ralph Blakelock, 1847–1919* (exhibition catalogue). Lincoln, Nebr.: University of Nebraska Art Association, 1974.

BRADFORD, WILLIAM (1823–1892)

Bradford, William. *The Arctic Regions.* Illustrated with Photographs Taken on an Art Expedition to Greenland, with Descriptive Narrative by the Artist. London, 1873.

Wilmerding, John. *William Bradford,*

1823–1892 (exhibition catalogue). Lincoln, Mass.: De Cordova Museum, 1969.

BRICHER, ALFRED THOMPSON (1837–1908)
Brown, Jeffrey R. *Alfred Thompson Bricher, 1837–1908* (exhibition catalogue). Indianapolis, Ind.: Indianapolis Museum of Art, 1973.

BROWN, GEORGE LORING (1814–1889)
Leavitt, Thomas W. *George Loring Brown, Landscapes of Europe and America, 1834–1880* (exhibition catalogue). Burlington, Vt.: Robert Hull Fleming Museum, 1973.

BURCHFIELD, CHARLES E. (1893–1967)
Baur, John I. H. *Charles Burchfield* (exhibition catalogue). New York: Whitney Museum of American Art, 1956.
————. *The Inlander: Life and Work of Charles Burchfield*. New York: Kennedy Galleries, Inc., 1982.
Charles Burchfield—His Golden Year—A Retrospective Exhibition of Watercolors, Oils and Graphics (exhibition catalogue). Tucson: University of Arizona Press, 1965.
Charles Burchfield—The Charles Rand Penney Collection. Text by Charles Rand Penney, Bruce W. Chambers, Joseph S. Czestochowski. Washington, D.C.: Smithsonian Institution Traveling Exhibition Service, 1978.
Trovato, Joseph S. *Charles Burchfield: Catalogue of Paintings in Public and Private Collections.* Utica, N.Y.: Museum of Art, Munson-Williams-Proctor Institute, 1970.

CALYO, NICOLINO (1799–1884)
"Cries of New York," *Connoisseur* 90, no. 376 (December 1932), pp. 420–421.

CATLIN, GEORGE (1796–1872)
Catlin, George. *Episodes from Life Among the Indians, and Last Rambles.* Edited by Marvin C. Ross. Norman, Okla.: University of Oklahoma Press, 1959.
————. *Letters and Notes on the Manners, Customs, and Conditions of the North American Indian, Written During Eight Years' Travel (1832–1839) Amongst the Wildest Tribes of Indians in North America.* 2 vols. London, 1844. Reprint. New York: Dover Publications, 1973.
Roehm, Marjorie, ed. *The Letters of George Catlin and His Family: A Chronicle of the American West.* Berkeley and Los Angeles: University of California Press, 1966.

CHAMBERS, THOMAS (c. 1808–after 1866)
Merritt, Howard S. "Thomas Chambers—Artist." *New York History* 37, no. 2 (April 1956).

CHASE, WILLIAM MERRITT (1849–1916)
Pisano, Ronald G. *William Merritt Chase* (exhibition catalogue). New York: M. Knoedler & Co., 1976.
Roof, Katherine Metcalf. *The Life and Art of William Merritt Chase.* New York: Scribner's, 1917.

CHURCH, FREDERIC EDWIN (1826–1900)
Bailey, W. P. "Mr. Church's Pictures—Cotopaxi, Chimborazo and the Aurora Borealis." *Art Journal* (London) 17 (September 1865), pp. 265–267.
Gardner, Albert Ten Eyck. "Scientific Sources of the Full-Length Landscape: 1850." *The Metropolitan Museum of Art Bulletin*, n.s., 4, no. 2 (October 1945), pp. 59–65.
Huntington, David C. *Frederic Edwin Church* (exhibition catalogue). Washington, D.C.: National Collection of Fine Arts, Smithsonian Institution, 1978.
————. "Landscape and Diaries: The South American Trips of F. E. Church." *The Brooklyn Museum Annual* 5 (1963–1964), pp. 65–98.
————. *The Landscapes of Frederic Edwin Church: Vision of an American Era.* New York: George Braziller, 1966.
Lindquist-Cock, Elizabeth. "Frederic Church's Stereographic Vision." *Art in America* (September–October 1973), pp. 70–75.
Stebbins, Theodore E., Jr. *Close Observation: Selected Oil Sketches by Frederic E. Church* (exhibition catalogue). Washington, D.C.: Cooper-Hewitt Museum of Decorative Arts and Design, Smithsonian Institution, 1978.

COLE, THOMAS (1801–1848)
Bryant, William Cullen. A Funeral Oration Occasioned by the Death of Thomas Cole, Delivered Before the National Academy of Design, New York, May 4, 1848. New York, 1848.
Cole, Thomas. "Essay on American Scenery." *The American Monthly Magazine*, n.s., 1 (January 1836), pp. 1–12. Delivered as a lecture in 1835.
Merritt, Howard S. *Thomas Cole* (exhibition catalogue). Rochester, N.Y.: Memorial Art Gallery of the University of Rochester, 1969.
Noble, Louis Legrand. *The Course of Empire, Voyage of Life and Other Pictures of Thomas Cole.* New York:

Cornish Lamport & Co., 1853. rev. ed. *The Life and Works of Thomas Cole.* New York, 1856. rev. ed. Edited by Elliot S. Vesell. Cambridge Mass.: Harvard University Press, 1964.

Powell, Earl A. "Thomas Cole and the American Landscape Tradition." *Arts Magazine* 52, no. 6 (February 1978), pp. 114–123; no. 7 (March 1978), pp. 110–117; no. 8 (April 1978), pp. 113–117.

CONE, MARVIN D. (1891–1965)

Marvin D. Cone—A Retrospective Exhibition. Catalogue by Joseph S. Czestochowski. Cedar Rapids, Iowa: Cedar Rapids Art Center, 1980.

CORNÈ, MICHELE FELICE (1752–1832)

Little, Nina Fletcher. *Michele F. Cornè* (exhibition catalogue). Salem, Mass.: Peabody Museum, 1972.

CROPSEY, JASPER FRANCIS (1823–1900)

Bermingham, Peter. *Jasper F. Cropsey, 1823–1900, Retrospective View of America's Painter of Autumn* (exhibition catalogue). College Park, Md.: University of Maryland Art Gallery, 1968.

Talbot, William S. *Jasper F. Cropsey, 1823–1900* (exhibition catalogue). Cleveland, Ohio: Cleveland Museum of Art, 1970.

DAVIES, ARTHUR B. (1862–1928)

Catalogue of a Memorial Exhibition of the Works of Arthur B. Davies. New York: The Metropolitan Museum of Art, 1930.

Czestochowski, Joseph S. *The Works of Arthur B. Davies.* Chicago: University of Chicago Press, 1979.

DOUGHTY, THOMAS (1793–1856)

Goodyear, Frank H., Jr. *Thomas Doughty, 1793–1856: An American Pioneer in Landscape Painting.* Philadelphia: Pennsylvania Academy of the Fine Arts, 1973.

DOVE, ARTHUR G. (1880–1946)

Haskell, Barbara. *Arthur Dove.* San Francisco: San Francisco Museum of Art, distributed by New York Graphic Society, 1974.

DUNCANSON, ROBERT S. (1821–1872)

McElroy, G. *Robert S. Duncanson, A Centennial Exhibition.* Cincinnati, Ohio: Cincinnati Art Museum, 1972.

DURAND, ASHER B. (1796–1886)

Durand, Asher B. "Letters on Landscape Painting." *The Crayon* 1 (January–June 1855), pp. 1–2, 34–35, 66–67, 97–98, 145–146, 209–211, 273–275, 354–466; 2 (July–December 1855), pp. 16–17.

Durand, John. *The Life and Times of Asher B. Durand.* New York: Scribner's, 1894. Reprint. New York: Da Capo Press, 1968.

Lawall, David B. *A. B. Durand, 1796–1886* (exhibition catalogue). Montclair, N.J.: Montclair Art Museum, 1971.

————. *Asher B. Durand: A Documentary Catalogue of the Narrative and Landscape Paintings.* New York: Garland Publishing, 1978.

DURRIE, GEORGE HENRY (1820–1863)

Hutson, Martha Y. *George Henry Durrie 1820–63, American Winter Landscapist: Renowned Through Currier and Ives.* Santa Barbara: The Santa Barbara Museum of Art and American Art Review Press, 1977.

EAKINS, THOMAS (1844–1916)

Goodrich, Lloyd. *Thomas Eakins: His Life and Work.* New York: Whitney Museum of American Art, 1933.

————. *Thomas Eakins: Retrospective Exhibition* (exhibition catalogue). New York: Whitney Museum of American Art, 1970.

Hendricks, Gordon. *The Life and Work of Thomas Eakins.* New York: Grossman Publishers, 1974.

EARL, RALPH (1751–1801)

Sawitsky, W. *Ralph Earl, 1751–1801* (exhibition catalogue). New York: Whitney Museum of American Art, 1945.

FISHER, ALVAN (1792–1863)

Vose, Robert C., Jr. "Alvan Fisher 1792–1863: An American Pioneer in Landscape and Genre." *Bulletin of the Connecticut Historical Society* 27, no. 4 (October 1962), pp. 97–129.

FISHER, JONATHAN (1768–1847)

Winchester, A. *Versatile Yankee, The Art of Jonathan Fisher, 1768–1847.* New York: Pyne Press, 1973.

GARBER, DANIEL (1880–1958)

Foster, Kathleen. *Daniel Garber 1880–1958* (exhibition catalogue). Philadelphia: Pennsylvania Academy of the Fine Arts, 1980.

GIFFORD, SANFORD R. (1823–1880)

Cikovsky, Nicolai, Jr. *Sanford Robinson Gifford (1823–1880)* exhibition catalogue). Austin, Tex.: University Art Museum of the University of Texas, 1970.

Weir, John F. *A Memorial Catalogue of the Paintings of Sanford Robinson Gifford, N.A.* New York: The Metropolitan Museum of Art, 1881.

Weiss, Ila Joyce. *Sanford R. Gifford.* New York: Garland Publishing, 1977.

HAMILTON, JAMES (1819–1878)

Jacobowitz, Arlene. *James Hamilton, 1819–1878, American Marine Painter* (exhibition catalogue). Brooklyn, N.Y.: The Brooklyn Museum, 1966.

HARTLEY, MARSDEN (1877–1943)

McCausland, Elizabeth. *Marsden Hartley.* Minneapolis: University of Minnesota Press, 1952.

Miller, D. *Lyonel Feininger and Marsden Hartley.* New York: The Museum of Modern Art, 1944.

HASELTINE, WILLIAM STANLEY (1835–1900)

Plowden, H. H. *William Stanley Haseltine, Sea and Landscape Painter.* London: Frederick Muller, 1947.

HASSAM, CHILDE (1859–1935)

Adams, A. *Childe Hassam.* New York: American Academy and Institute of Arts and Letters, 1938.

Williams, H. W. *Childe Hassam* (exhibition catalogue). Washington, D.C.: The Corcoran Gallery of Art. 1965.

HEADE, MARTIN JOHNSON (1819–1904)

Stebbins, Theodore E., Jr. *The Life and Works of Martin Johnson Heade.* New Haven, Conn.: Yale University Press, 1975.

HENRI, ROBERT (1865–1929)

Henri, Robert. *The Art Spirit.* New York, 1923. Reprint. New York: J. B. Lippincott, 1960.

Homer, William I. *Robert Henri and His Circle.* Ithaca, N.Y.: Cornell University Press, 1969.

HICKS, EDWARD (1780–1849)

Mather, E. P. *Edward Hicks, A Peaceable Season.* Princeton, N.J.: Princeton University Press, 1973.

HOMER, WINSLOW (1836–1910)

Beam, Philip. *Winslow Homer at Prout's Neck.* Boston: Little, Brown, 1968.

Downes, W. H. *The Life and Works of Winslow Homer.* Boston and New York: Houghton Mifflin, 1911.

Goodrich, Lloyd. *Winslow Homer.* New York: George Braziller, 1959.

————. *Winslow Homer* (exhibition catalogue). New York: Whitney Museum of American Art, 1973.

Hendricks, Gordon. *The Life and Works of Winslow Homer.* New York: Harry N. Abrams, 1979.

Wilmerding, John. *Winslow Homer.* New York: Praeger Publishers, 1972.

HOPPER, EDWARD (1882–1967)

Goodrich, Lloyd. *Edward Hopper.* New York: Harry N. Abrams, 1971.

Levin, Gail. *Edward Hopper.* New York: Whitney Museum of American Art, 1980.

HUNT, WILLIAM MORRIS (1824–1879)

Hunt, William Morris. *Talks on Art.* Compiled by H. M. Knowlton. 1st ser. Boston: Houghton Mifflin, 1875; 2d ser. Boston: Houghton Mifflin, 1884.

Knowlton, H. M. *The Art and Life of William Morris Hunt.* Boston: Houghton Mifflin, 1900.

HUNTINGTON, DANIEL (1816–1906)

Catalogue of Paintings by Daniel Huntington, N.A., Exhibiting at the Art Union Building. New York, 1950.

INNESS, GEORGE (1825–1894)

Cikovsky, Nicolai, Jr. *George Inness.* New York: Praeger Publishers, 1971.

————. *The Paintings of George Inness* (exhibition catalogue). Austin, Tex.: Art Museum of the University of Texas, 1975.

Inness, George, Jr. *The Life, Art and Letters of George Inness.* New York: Century Company, 1917.

Ireland, LeRoy. *The Work of George Inness, An Illustrated Catalogue Raisonné.* Austin, Tex.: University of Texas Press, 1965.

JOHNSON, EASTMAN (1824–1906)

Baur, John, I. H. *Eastman Johnson, 1824–1906: An American Genre Painter* (exhibition catalogue). New York: The Brooklyn Museum, 1940. Reprint. New York: The Brooklyn Museum, 1969.

Hills, Patricia. *Eastman Johnson* (exhibition catalogue). New York: Whitney Museum of American Art, 1972.

KENSETT, JOHN F. (1816–1872)

Howat, John K. *John Frederick Kensett, 1816–1872* (exhibition catalogue). New York: American Federation of Arts, 1968.

Johnson, Ellen. "Kensett Revisited." *The Art Quarterly* 20, no. 1, (Spring 1957), pp. 71–92.

Siegfried, Joan C. *John F. Kensett, A Retrospective Exhibition* (exhibition catalogue). Saratoga Springs, N.Y.: Skidmore College, 1967.

LA FARGE, JOHN (1835–1910)

Cortissoz, Royal. *John La Farge: A Memoir and a Study.* Boston and New York: Houghton Mifflin, 1911.

LANE, FITZ HUGH (1804–1865)

Wilmerding, John. *Fitz Hugh Lane.* New York: Praeger Publishers, 1971.

————. *Fitz Hugh Lane, 1804–1865, American Marine Painter.* Salem, Mass.: Essex Institute, 1964.

————. *Fitz Hugh Lane, the First Major Exhibition* (exhibition catalogue). Lincoln, Mass.: De Cordova Museum, 1966.

————. *Paintings by Fitz Hugh Lane* (exhibition catalogue). Rockland, Me.: William A. Farnsworth Library and Art Museum, 1974.

LAWSON, ERNEST (1873–1939)
Karpiscak, A. L. *Ernest Lawson 1873–1939*. Tucson: University of Arizona Press, 1979.

MARIN, JOHN (1870–1953)
Reich, Sheldon. *John Marin: A Stylistic Analysis and Catalogue Raisonné*. 2 vols. Tucson: University of Arizona Press, 1970.

MARTIN, HOMER DODGE (1836–1897)
Mather, Frank Jewett, Jr. *Homer Martin, Poet in Landscape*. New York: Privately printed, 1912.
Meyer, Ann Nathan. "Homer Martin: American Landscape Painter." *International Studio* 35, no. 140 (October 1908), pp. 255–262.

MILLER, ALFRED JACOB (1810–1874)
Ross, Marvin C. *The West of Alfred Jacob Miller*. Norman, Okla.: University of Oklahoma Press, 1951.

MORAN, THOMAS (1837–1926)
Wilkins, Thurman. *Thomas Moran: Artist of the Mountains*. Norman, Okla.: University of Oklahoma Press, 1966.

MORSE, SAMUEL F. B. (1791–1872)
Larkin, Oliver W. *Samuel F. B. Morse and American Democratic Art*. Boston: Little, Brown, 1954.
Morse, E. L., ed. *Samuel F. B. Morse, His Letters and Journals*. 2 vols. Boston and New York: Houghton Mifflin, 1914.

MOUNT, WILLIAM SIDNEY (1807–1868)
Frankenstein, Alfred. *William Sidney Mount*. New York: Harry N. Abrams, 1975.

MURPHY, JOHN FRANCIS (1853–1921)
Clark, Eliot J. *J. Francis Murphy*. New York: Privately printed by Frederic Fairchild Sherman, 1926.

O'KEEFFE, GEORGIA (b. 1887)
Goodrich, Lloyd, and Bry, Doris. *Georgia O'Keeffe*. New York: Whitney Museum of American Art, 1970.
O'Keeffe, Georgia. *Georgia O'Keeffe*. New York: The Viking Press, 1976.

PARRISH, MAXFIELD (1870–1966)
Ludwig, Coy. *Maxfield Parrish*. New York: Watson-Guptill, 1973.

POLLOCK, JACKSON (1912–1956)
O'Connor, Francis V., and Thaw, Eugene V. *Jackson Pollock—A Catalogue Raisonné of Paintings, Drawings and Other Works*. New Haven, Conn.: Yale University Press, 1978.

PORTER, RUFUS (1792–1884)
Lipman, Jean. *Rufus Porter, Yankee Pioneer*. New York: Clarkson N. Potter, 1968.

PRENDERGAST, MAURICE (1859–1924)
Green, Eleanor. *Maurice Prendergast Art of Impulse and Color* (exhibition catalogue). College Park, Md.: University of Maryland Art Gallery, 1976.
Rhys, H. H. *Maurice Prendergast, 1859–1924*. Cambridge, Mass.: Harvard University Press, 1960.

RANGER, HENRY WARD (1858–1916)
Daingerfield, Elliott. "Henry Ward Ranger, Painter." *The Century* 97 (November 1918), pp. 82–89.

RICHARDS, WILLIAM TROST (1833–1905)
Ferber, Linda S. *William Trost Richards, American Landscape and Marine Painter, 1833–1905* (exhibition catalogue). Brooklyn, N.Y.: The Brooklyn Museum, 1973.

ROBINSON, THEODORE (1852–1896)
Baur, John I. H. *Theodore Robinson, 1852–1896*. Brooklyn, N.Y.: The Brooklyn Museum, 1946.
Johnston, Sona. *Theodore Robinson, 1852–1896* (exhibition catalogue). Baltimore, Md.: The Baltimore Museum of Art, 1973.

ROTHKO, MARK (1903–1970)
Selz, Peter. *Mark Rothko* (exhibition catalogue). New York: The Museum of Modern Art, 1961.

RYDER, ALBERT P. (1847–1917)
Goodrich, Lloyd. *Albert Pinkham Ryder*. New York: George Braziller, 1959.

SALMON, ROBERT (c. 1775–c. 1845)
Wilmerding, John. *Robert Salmon, Painter of Ship and Shore*. Boston and Salem, Mass.: Peabody Museum, 1971.

SARGENT, JOHN SINGER (1856–1925)
Ormond, Richard. *John Singer Sargent: Paintings, Drawings, Watercolors*. New York: Harper & Row, 1970.

SHAW, JOSHUA (c. 1777–1860)
Shaw, Joshua. *Picturesque Views of American Scenery*. Philadelphia, 1820–1821.

SHEELER, CHARLES (1883–1965)
Dochterman, L. *The Quest of Charles Sheeler*. Iowa City, Iowa: University of Iowa Press, 1963.
Friedman, Martin *et al*. *Charles Sheeler* (exhibition catalogue). Washington, D.C.: National Collection of Fine

Arts, Smithsonian Institution, 1968.

SLOAN, JOHN (1871–1951)

Bullard, E. John, and Scott, D. *John Sloan* (exhibition catalogue). Washington, D.C.: National Gallery of Art, 1976.

SMIBERT, JOHN (1688–1751)

The Notebook of John Smibert. Boston: Massachusetts Historical Society, 1969.

SONNTAG, WILLIAM L. (1822–1900)

Moure, Nancy. *William Sonntag: Artist of the Ideal*. Los Angeles: Goldfield Galleries, 1980.

SPENCER, NILES (1893–1952)

Freeman, R. B. *Niles Spencer* (exhibition catalogue). Lexington, Ky.: University of Kentucky Art Museum, 1965.

STILL, CLYFFORD (b. 1904)

Thirty-Three Paintings in the Albright-Knox Art Gallery. Buffalo, N.Y.: The Buffalo Fine Arts Academy, 1966.

Clyfford Still. San Francisco: San Francisco Museum of Modern Art, 1976.

SUYDAM, JAMES AUGUSTUS (1819–1865)

Baur, John I. H. "A Tonal Realist: James Suydam." *The Art Quarterly* 13, no. 3 (Summer 1950), pp. 221–227.

TACK, AUGUSTUS VINCENT (1870–1949)

Augustus Vincent Tack, 1870–1949: Twenty-six Paintings from The Phillips Collection (exhibition catalogue). Austin, Tex.: University of Texas Art Museum, 1972.

TRYON, DWIGHT W. (1849–1925)

White, Nelson C. *Dwight W. Tryon: A Retrospective Exhibition*. Storrs, Conn.: University of Connecticut Museum of Art, 1971.

TWACHTMAN, JOHN (1853–1902)

John Henry Twachtman (exhibition catalogue). Cincinnati, Ohio: Cincinnati Art Museum, 1966.

VEDDER, ELIHU (1836–1923)

Soria, Regina. *Elihu Vedder: American Visionary Artist in Rome, 1836–1923*. Rutherford, N.J.: Fairleigh Dickinson University Press, 1970.

———, et al. *Perception and Evocation—The Art of Elihu Vedder*. Washington, D.C.: National Collection of Fine Arts, 1979.

WEIR, J. ALDEN (1852–1919)

J. Alden Weir—Centennial Exhibition. New York: American Academy and Institute of Arts and Letters, 1952.

WEIR, JOHN F. (1841–1926)

Sizer, T., ed. *The Recollection of John Ferguson Weir, 1869–1913*. New York and New Haven: Yale University Press, 1960.

WHISTLER, JAMES ABBOTT MCNEILL (1834–1903)

Pennell, Elizabeth R., and Pennell, Joseph. *The Life of James McNeill Whistler*. 2 vols. London and Philadelphia: J.B. Lippincott, 1908.

Sweet, Frederick A. *James A. McNeill Whistler* (exhibition catalogue). Chicago: The Art Institute of Chicago, 1968.

Whistler, James A. McNeill. *The Gentle Art of Making Enemies*. London and New York, 1890. Reprint. New York: G.P. Putnam's, 1925.

WHITTREDGE, THOMAS WORTHINGTON (1820–1910)

Baur, John I. H., ed. *The Autobiography of Worthington Whittredge*. 1942. Reprint. New York: Arno Press, 1969.

Dwight, Edward H. *Worthington Whittredge (1820–1910), A Retrospective Exhibition of an American Artist* (exhibition catalogue). Utica, N.Y.: Museum of Art, Munson-Williams-Proctor Institute, 1969.

WOOD, GRANT (1892–1942)

Czestochowski, Joseph S. *John Steuart Curry and Grant Wood—A Portrait of Rural America*. Columbia, Mo., and London: University of Missouri Press, 1981.

Dennis, James M. *Grant Wood: A Study in American Art and Culture*. New York: The Viking Press, 1975.

WYANT, ALEXANDER H. (1836–1892)

Alexander H. Wyant, 1836–1892 (exhibition catalogue). Provo, Utah: University of Utah Museum of Art, 1968.

WYETH, ANDREW (b. 1917)

Corn, Wanda. *The Art of Andrew Wyeth*. Greenwich, Conn.: New York Graphic Society, 1973.

McCord, David, and Sweet, F. A. *Andrew Wyeth* (exhibition catalogue). Boston: Museum of Fine Arts, 1970.

Index

Page references for illustrations are in **boldface** *type.*

JOSEPH S. CZESTOCHOWSKI is executive director of the Cedar Rapids Museum of Art. He is the author of numerous articles that have appeared in the *American Art Journal* and of the following books: *The Combined Works of Arthur B. Davies* (1980), *John Steuart Curry and Grant Wood: A Portrait of Rural America* (1981), *Contemporary Polish Poster Art* (1979), and *94 Prints by Childe Hassam* (1980). At present, he is continuing his research on several twentieth-century American artists and organizing a major exhibit of the Pre-Raphaelite tradition in American art.